M000029287

CONNECTICUT SOFTBALL LEGEND
JOAN JOYCE

TONY RENZONI | *Foreword by Jane Blalock*

Best Wishes

Joan Joyce

THE
History
PRESS

Published by The History Press
Charleston, SC
www.historypress.com

Copyright © 2019 by Anthony J. Renzoni
All rights reserved

First published 2019

Manufactured in the United States

ISBN 9781467142670

Library of Congress Control Number: 2019939726

Notice: The information in this book is true and complete to the best of our knowledge. It is offered without guarantee on the part of the author or The History Press. The author and The History Press disclaim all liability in connection with the use of this book.

All rights reserved. No part of this book may be reproduced or transmitted in any form whatsoever without prior written permission from the publisher except in the case of brief quotations embodied in critical articles and reviews.

Joan Joyce is the real deal, a fierce competitor and one of the greatest athletes and coaches in sports history. Tony Renzoni's moving tribute to Joan shows us why she is a champion in sports and in life.
—BILLIE JEAN KING, *sports icon and equality pioneer*

Joan Joyce is truly the greatest female athlete in sports history. And a great coach as well. Tony Renzoni's well-researched book is a touching tribute to this phenomenal athlete. I highly recommend this book!
—BOBBY VALENTINE, *former MLB player and manager, current athletic director at Sacred Heart University (Fairfield)*

Joan Joyce has to be one of the most incredible female athletes of all time. She has left an indelible mark on women's athletics—creating a legacy that has been instrumental in bringing women's athletics into the public spotlight.
—*Connecticut Women's Basketball Hall of Fame, 1994*

We both started out really young and we stuck with it and made something of our lives. With great admiration, Brian. PS: Joan, Let's have a re-match someday, bowling for dollars!
—BRIAN HYLAND, *singer, songwriter, publisher, international recording artist*

There are fascinating human beings, then there's Joan Joyce. For my money, there's never been a more talented, more accomplished, more transcendent female athlete than Joan. She captured the imagination of young girls, women AND men alike before the advent of the twenty-four-hour news cycle, the sports-only television networks and social media. What couldn't she do? The greatest softball player who ever lived. Represented the United States on the hardwood in basketball. The least number of putts ever in a professional round of golf. Not to mention nine NCAA Regional appearances as the head softball coach of Florida Atlantic University (that's how I know her best). I've never met a better storyteller than Joan because, well, she lived all of her stories! I feel fortunate to know the single most influential and unique female athlete who has ever walked the planet…Joan Joyce.
—KEN LAVICKA, *ESPN, Voice of FAU*

As a young man participating in athletics in school I can only marvel at the accomplishments of our girl, Joan Joyce. Her list of participation & accolades in athletics are the stuff of dreams to me! God bless and keep her, and her life as teacher and role model.
—Johnny Mathis, *Grammy-nominated recording artist*

Is Joan Joyce the greatest athlete ever from the great city of Waterbury, Conn.? You bet. *Is Joan Joyce Connecticut's greatest female athlete? Absolutely*—by a city and country mile. *Is Joan Joyce the greatest female athlete of all time, period? Tony Renzoni sets out to prove just that in* Connecticut Softball Legend Joan Joyce
—Joe Palladino, Waterbury Republican-American

The story is all true. Joan Joyce was a tremendous pitcher, as talented as anyone who ever played. [responding to a newspaper account of his early 1960s match-ups against Joan Joyce]
—Ted Williams, *Hall of Famer and Boston Red Sox great, December 30, 1999*

Opposite: Waterbury Town Plot girls' softball team. *Left to right*: Margaret Cilfone (pitcher), coach Henry "Duke" Delpo (coach), Mary (Augelli) Renzoni (first base). Waterbury, Connecticut. *Author's collection*.

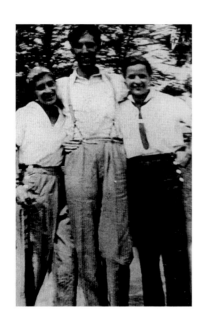

This book is dedicated to my mom,
Mary (Augelli) Renzoni—my favorite
first baseman.

CONTENTS

Opposite: Jane Blalock, Joan Joyce, LPGA. *Courtesy of Joan Chandler.*

FOREWORD

It is a privilege and honor to write the foreword for this book about my good friend Joan Joyce.

I first met Joan at the Houston Astrodome on December 21, 1974. Joan and I participated in the Superstars competition in Houston that was filmed by ABC TV and aired on January 19, 1975.

I was aware of Joan's amazing talent and her phenomenal career. What I discovered immediately was her wonderful personality, her sense of humor and her very unassuming nature. Joan is a very charismatic person and someone you just want to be around. We became very good friends from our time in Houston to the present.

Joan and I furthered our friendship when we both played on the LPGA golf tour. Shortly after the Superstars competition, Joan began taking up golf in a serious manner. As I watched her on the golf course early on, Joan's athleticism became instantly apparent. She picked up the golf game so very quickly. That was phenomenal, since most of the golfers I'm aware of began their golf career at the very early age of ten or eleven. Remarkably, Joan hadn't received a golf lesson until she was thirty-five years old. She had the perfect temperament for golf, the ideal attitude. I knew the athletic talent

was there, and she had a mechanically sound golf swing. But I was really amazed at Joan's natural touch on the green. You can't really teach someone to putt. She had such great feel and finesse.

After closely watching her golf game in 1975, I encouraged Joan to pursue a golf career on the LPGA tour. Fortunately, she took my advice and joined the LPGA in 1977. I was so happy and proud of Joan when, in 1982, she broke the LPGA and PGA record for fewest putts (seventeen) in a golf round, a record that still stands today.

Like so many others, I am in total awe of the career that Joan has had on the softball field. I could not even try to list all of her softball accomplishments, but luckily, for all of us, those achievements are thoroughly covered in this book. I had the good fortune of watching Joan pitch for the Connecticut Falcons, and it was amazing to see professional batters swinging fruitlessly at her pitches. You can see the frustration on their faces after trying to hit a softball that must have looked like a blur to them. The Connecticut Falcons were made up of many players from the Brakettes organization. It is a known fact that the Brakettes are the greatest dynasty in women's softball history. Throughout the Brakettes' history one fact stood out to me—they know how to win. And knowing the makeup of the Connecticut Falcons it seemed to me that this winning tradition would continue. For this reason, I jumped at the chance to become a co-owner of the Falcons. And win, they did!! In each of the four years of the Women's Professional Softball league's existence, the Falcons took home the championship crown. The Connecticut Falcons carried on the winning tradition that began with the formation of the Raybestos Brakettes by William Simpson back in 1947. And the player most responsible for the success of this dynasty is Joan Joyce, considered by experts and fellow players alike (teammates as well as rivals) to be the greatest pitcher in the history of women's softball.

Other athletes would be quite satisfied to have the kind of career that Joan has had on the softball field and the golf course. But not Joan. There wasn't a sport around that Joan, in time, could not master.

Take, for instance, basketball. Even with her enormous success in softball, Joan has always said that basketball was her favorite sport. She was a star on every basketball team she was associated with, beginning with her freshman year at Waterbury's Crosby High School. Each team that she played on counted on Joan to be its high scorer, and Joan did not disappoint. In an era that did not have the three-point shot, Joan set the AAU National Tournament single-game record by scoring sixty-seven points in 1964. She was also a basketball official at a very high

level. For all her amazing achievements as a basketball player, coach and referee, Joan was inducted into the Connecticut Women's Basketball Hall of Fame in 1994.

Joan was also a star volleyball player. In 1968, she formed a United States Volleyball Association team called the Connecticut Clippers. Joan was the player-coach of the team and traveled extensively with the Clippers, participating in a number of USVA national tournaments. She received numerous accolades during her volleyball career and even became a highly regarded volleyball official. It only stands to reason that Joan would be included in the Volleyball Hall of Fame, which became a reality when she was inducted in 2000.

Athletes like Joan Joyce come along only once in a lifetime. She has been a true pioneer of women's sports, a fantastic role model and an inspiration to so many young girls (and boys). Joan's entire career, beginning at a very early age, has been a pursuit of excellence. Throughout her life, she has demanded nothing short of perfection for herself and always challenges other players (both as a teammate and as a coach) to play at their very best and, if possible, to achieve that same level of excellence.

I am very thankful to Tony Renzoni, author of this book, for his wonderful tribute to the most amazing athlete of our time. I know that Tony has spent many hours researching thousands of archives for this book. His passion, love of the game and commitment to pay overdue tribute to Joan has certainly shown through. I highly recommend this heartwarming tribute to "the greatest female athlete in sports history" and my dear friend—Joan Joyce.

—Jane Blalock,
LPGA Tour player, LPGA Legends Hall of Fame
and CEO, JBC Golf Inc.

ACKNOWLEDGEMENTS

This book has been a labor of love. I am blessed to have so many friends, relatives and schoolmates who, over the years, have stood by me during this wonderful journey. Grateful acknowledgements to: Joan Joyce, Jane Blalock, Billie Jean King, Debbie Chin, Colleen Renzoni, Dr. Kerry Renzoni, Abigail Fleming, Blaise Lamphier, Bob Baird, Bobby Valentine, Brian Hyland, Bruce Loman, Carol Hutchins, Carol Spanks, Chan Walker, Christina Sutcliffe, Ellen Malloy, Harlan Gage, Jackie Ledbetter, Jerry DiPietro, Joan Chandler, Joe Amarante, Joe Blacker, Joe Joyce Jr., Joe Marra, Joe Palladino, John Stratton, Johnny Mathis, Joyce Compton, Justin Johnson, Katrina McCormack, Ken LaVicka, Linda Bozzuto, Linda Finelli, Mary Ellen Blacker, Mary Lou Pennington, Michele Smith, Mike Kinsella, Pat Jordan, Patricia Lenti-Crane, Sal DiStasio, Stormy Irwin, Sr. Pat McCarthy. Special thanks to Kathy Gage for all her support and for providing so many wonderful photos.

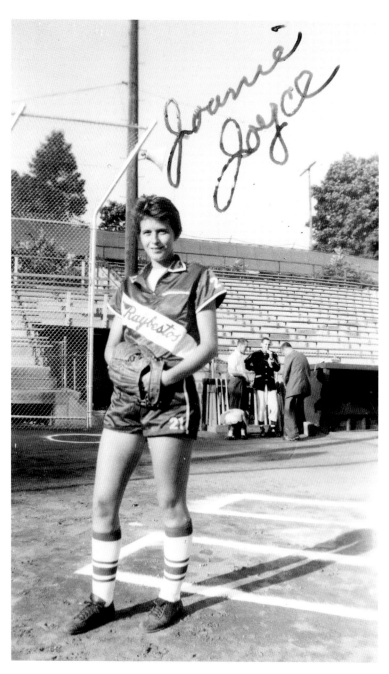

Joanie Joyce. *Courtesy of Brakettes Softball Photo Archive.*

INTRODUCTION

J oan Joyce has long been considered the greatest female athlete in sports history. This sentiment has been echoed by many in the sports industry, historians, teammates, rivals, journalists and fans.

In her prime, Joan was the most feared female pitcher in fast-pitch softball. She was revered by her opponents as well as her teammates. Her pitching success against several of Major League Baseball's greatest hitters gave her further recognition throughout the United States and the rest of the world. But her athletic accomplishments were not limited to the sport of softball. As you will soon see, Joyce excelled in a variety of sports, setting records all along the way. And, most overlooked, Joan has been an extremely successful coach and referee.

At a time when the sports world was dominated by male athletes, Joan stood out as an equal. Her goal in life was to be one of the best athletes, male or female. By all measures, she achieved that goal and has earned a place among sports elites.

Keep in mind that Joan Joyce grew up at a time when females were banned from male-dominated sports and most professional sports. Many of her achievements were accomplished on an amateur level against very stiff competition. However, this in no way diminishes her amazing accomplishments. Once Joan finally became a professional fast-pitch softball player in 1976 for the Connecticut Falcons, she was just as dominant a player as she was on an amateur level. Most people who have witnessed Joan's performance in all sports she was engaged in will testify that she would do

very well, indeed, if she were allowed to play on a professional level with her male counterparts.

Over the years, certain women have achieved fame and success in individual sporting events (tennis, track and field, etc.). But Joan Joyce was a multidimensional athlete. Joan was a groundbreaking athlete whose dominance in team sports such as softball, volleyball and basketball gave rise to women who dreamed of expanding their participation in a variety of sports. Because of Joan Joyce, pitching mounds were extended by four feet, golfers were required to hit their shots farther, golf courses were marked differently and opponents as well as teammates were inspired to play harder. But most of all, because of Joan Joyce, boundaries were broken. Young girls growing up can now see themselves achieving fame and success as a member of a team sport and not just individual sporting events. Because of athletic pioneers like Joan Joyce, women now have the chance for identification with a team and for work opportunities as coaches, administrators, broadcasters and endorsements after their playing careers.

In terms of excellence in a diversity of sports, Joan is in an elite class, with only the legendary 1930s great Babe Didrikson (Zaharias) being mentioned in the same category. Didrikson excelled in golf, basketball and track and field. Joyce not only dominated the world of fast-pitch softball but also was a star athlete in basketball, volleyball, golf and bowling. Like Didrikson, Joan took up golf later in life. Joyce began playing golf seriously at age thirty-seven, while Babe was twenty-four when she began. And, like Didrikson, Joan has always believed that there was no sport that, in time, she could not excel in. In making a comparison between these two great athletes, one important, and often overlooked fact that distinguishes Joan from Babe Didrikson is that Joan has had an extremely successful thirty-four-year career as a referee, an eighteen-year career as a golf coach and, most noteworthy, a successful and highly regarded softball coaching career—sixty years and counting!

I had the good fortune of watching Joan pitch with the Brakettes a number of times. I was in complete awe as I watched Joanie pitch using her famed "slingshot" delivery. She would hurl the softball with such force that at the end of each pitch, her momentum would cause her to hop to her left toward first base. At times, I felt sorry for the batters, who seemed to swing at her pitches when the ball was already in the catcher's glove. One batter after another would flail at the pitched ball, which to them must have looked like one big blur. As one frustrated batter was heard to say after batting against Joyce, "It would help if I was able to see the ball!"

Joan's career statistics are staggering and speak for themselves. She hurled 150 no-hitters, 50 perfect games, a career ERA of .090 and over 10,000 strikeouts, just to name a few. The stats and records she set in other sports are equally impressive, including an AAU basketball record of 67 points in one game and an amazing LPGA and PGA record of just 17 putts in a round of golf. Unlike many other famous athletes, she has both a league and a stadium named after her. Incredibly, Joan has been inducted into 19 halls of fame, including one that honored her for twenty-four years as a very successful softball coach at Florida Atlantic University. In a historic duel, Joyce easily overmatched the great Ted Williams on several occasions, earning Williams's lifelong respect.

Joan has left an indelible mark on women's athletics. Throughout her playing and coaching career, Joan has been a champion of women in sports. She has created a legacy that has been a major contribution in bringing women's athletics into the public spotlight.

This book traces the life and career of the legendary Joan Joyce, the teams she played on and those she has coached. It includes numerous in-depth interviews, including a detailed and fascinating interview with Joan. This book has been approved and endorsed by Joan Joyce.

Throughout the writing stages of my book, I went through an exhaustive amount of research and tried to be as thorough and accurate as possible. I can honestly say that this entire book-writing process has been a labor of love for me.

During Joan's playing days, the media outlets that covered sports figures like Joan were quite different than they are today. She did receive adequate newspaper coverage but very little exposure from other media. (There was no ESPN in her day.) Also, as I have come to find out, Joan had no interest in promoting herself like many of her contemporaries or athletes today. Thus, Joan is not the household name that she should be.

My goal is to encourage all of you to learn more about the amazing journey of this sports phenom who is known by so many experts and fans alike as "The Greatest Female Athlete in Sports History."

I hope this book will, in a small degree, help in that respect as I pay tribute to this amazing athlete and wonderful person—our Joanie Joyce.

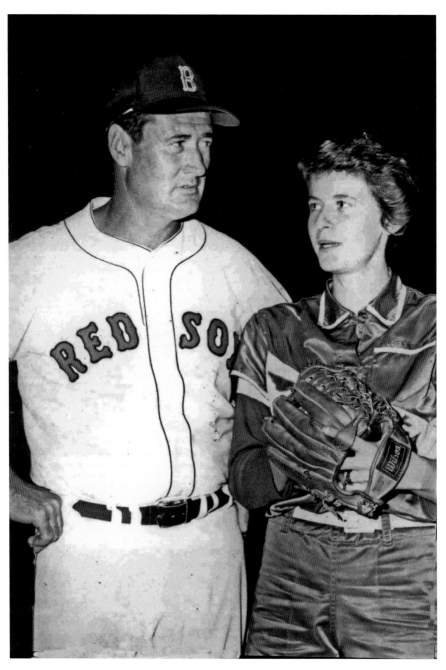

Historic face-off between Ted Williams and the "teenage girl" Joan Joyce, Municipal Stadium, Waterbury, Connecticut. *Courtesy of Joan Chandler.*

"HISTORY IN THE MAKING"

Joan Joyce vs. Ted Williams, Part 1

The crowd began to chant, "Joanie, Joanie, Joanie!"

On a warm August night at Municipal Stadium in Waterbury, Connecticut, an overflow crowd of over seventeen thousand fans turned out to witness a long awaited matchup pitting baseball's greatest hitter against a fiery young pitching phenom, barely out of her teens. Because of the overflow, the fans stood ten rows deep on the side of the field to witness this matchup. You could feel the tension in the air as the fans realized that this would surely be an exciting and memorable event. The crowd came to witness history in the making.

Before making her entrance onto the field, Joan Joyce went over to the side of the dugout where her coach had lined up six softballs for Joan to choose from. Coach Stratton would do this before each game that Joan pitched, and this occasion was no different. Joan would hold each softball in her hand to determine which ball she preferred for that particular game. She was particularly interested in the seams on the ball. Unlike the softballs manufactured today, each softball at that time seemed to have different, unique seams. Some seams on softballs were not as pronounced as others, making it more difficult to make the ball move in the way Joan desired. This was very important to pitchers, especially pitchers of her caliber. As she examined one ball after the other, Joan would say out loud, "This one is a no-hitter, this one is a perfect game." For this occasion, Joan chose the "perfect game" ball.

Joan Joyce came out first, decked out in her Brakettes uniform, wearing number 21 on her back. The uniform was red in color with a white banner and the word *Raybestos* across the top. Her stirrups were red with white stripes, and her cleats were black. As she approached the pitcher's mound, Joan received a thunderous ovation from her hometown fans, reaching a crescendo as she stepped on the pitcher's mound. The crowd began to chant, "Joanie, Joanie, Joanie!" In a few short years, the Waterbury, Connecticut native had become a softball phenom, already beginning to reach legendary status. Joyce began by throwing several soft throws, then a few curves, followed by her famed rise ball. The curves and rise balls caused some oohs and ahhs from the fans. Meanwhile, Ted Williams stood on the sideline, keenly focused not on the pitcher but on the movement of the softballs as they made their journey to home plate. As he kept watching, he visualized in his mind the timing of his swing to hit the curve and the rise ball, to the point that he knew he had timed it exactly. What he was not aware of was that Joan purposely left out her famed drop ball in her warmup repertoire. It was too early to show Ted that pitch.

After Joan's warmup, Williams began his walk to home plate. He too received a hero's welcome by the enormous crowd. Williams wore his famous number 9 Red Sox uniform. And he brought with him one of his trusty bats. As he approached the batter's box, Ted Williams was thinking of giving his fans a thrill by hitting several balls against the outfield wall or perhaps hitting a homer or two. After all, it was Williams who was the last .400 hitter, who had a career batting average of .344 and who on his very last at-bat hit a home run at Fenway Park, thus culminating a magnificent career in grand fashion.

It mattered very little to Ted that the pitcher stood only forty feet away, as opposed to baseball's sixty feet, six inches. Likewise, he wasn't fazed by the fact that the pitcher would be throwing a softball underhanded. Williams's "batting eye" was so keen that he was known to actually see the label of the ball as it approached home plate. A larger softball only meant that it would be a much bigger target for the "Splendid Splinter." And the fact that the pitcher, to him, was just a "teenage girl" further added to his belief that he would have no trouble belting some solid hits to live up to his other nickname, "The greatest hitter who ever lived."

The two had met previously (in May 1961) at a different fundraiser and at a different ballpark. Joan was a twenty-year-old upcoming star who was just beginning to gain national attention. On that day, Williams easily hit off the young pitcher. In fact, every batter she faced hit her fairly well. But

Williams knew in his heart that on that day she was letting the batters hit the ball, since she was nursing a sore shoulder at the time. So, while he was quite confident of repeating his successful hitting against this pitcher, he knew full well that he had never faced the young pitcher at her best. He had never faced the *real* Joan Joyce.

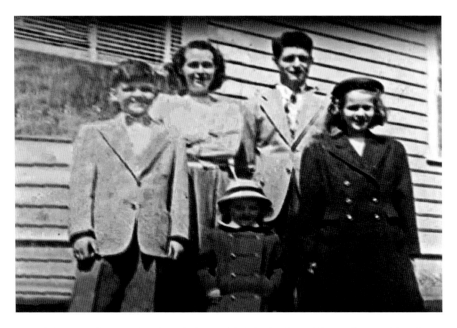

Joan (*right*), Mom, Dad, brother, sister, in front of their Tudor Street House. *Courtesy of Joan Joyce.*

2

GROWING UP

Growing up, I dreamed of becoming an expert carpenter.

The constant pounding of the softball against the outside wall of the ranch house on Tudor Street proved too much for Jean Joyce to deal with. Finally, Jean opened the door and yelled out, "Joanie, please find another place to practice pitching, you're giving me a headache with all the noise!" "Ok, Mom, I'll practice in the backyard." Eight-year-old Joan noticed a wall in her backyard and drew a strike zone on it to practice her pitching. Years later, Joan remarked, "I would practice all day long throwing the ball against the wall in the back of the house. I didn't need a catcher, so that helped. I would practice until I got really tired late each day." Thus began the meteoric rise to superstardom of the world's premier women's softball pitcher—Joan Joyce.

Joan was born and raised in Waterbury, Connecticut. She was the eldest child of Joe and Jean Joyce. Her father worked at Scovill's factory in Waterbury, and her mother worked at Waterbury's Chase Brass & Copper Company. Joan's mom and dad worked different shifts so that one of them would be home with the three children.

Joan attended Webster Elementary School on Easton Avenue in Waterbury. When she was old enough, Joan would walk to school every day, as the school was located only a couple of minutes from her home. When she was twelve years old, she walked past a carpenter who was beginning

Early childhood photo of Joan Joyce in Waterbury, Connecticut. *Courtesy of Joan Joyce.*

Joan Joyce's house that she helped build on Tudor Street, Waterbury, Connecticut. *Courtesy of Joan Joyce.*

to build a house on Tudor Street, near where she lived. Joan explains what happened next:

> When I was in eighth grade at Webster School, I actually helped a fellow build a house, about three or four houses up the street. For a time growing up, I wanted to be a carpenter. I was walking by, and this guy was building this house. And, of course, nosey me asked the fellow if he needed help. So it ended up that it was this seventy-five-year-old carpenter and myself who built the house. I did everything. I put roofs on, I put tiles in the bathrooms, everything. And so, my parents ended up buying the house that the guy and I built....For helping to build the house, the contractor (Tommy Garafola) gave me a beautiful bicycle, which I loved. I would ride my bike around the neighborhood.

Impressed by the quality of her work and her dedication, the contractor offered her a job, but she was unable to accept the offer. It would surprise some that, despite being exposed to a variety of sports at an early age, a preteen Joan never dreamed of being a baseball star but rather wanted to be an expert carpenter.

After graduating from Webster school in the spring of 1954, Joan attended Waterbury's Crosby High School that September. As early as her freshman year in Crosby, Joyce was voted "Most Athletic." She became a star almost immediately on Crosby's basketball team and was named captain of the basketball squad in her junior and senior years at Crosby. She participated in other extracurricular activities, such as being a member of the Crosby High School German Club. Joan graduated from Crosby High School in 1958.

Joan Joyce's mom and dad watching Joan pitch, 1977. *Courtesy of Joan Chandler.*

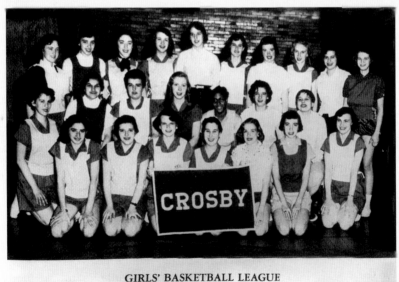

Top: Joan Joyce attended Crosby High School (Waterbury, Connecticut) from 1954 to 1958. *Bottom*: Crosby High School basketball team 1955 (freshman year). Joan Joyce top row, right. *Crosby Yearbook, author's collection.*

Joan Joyce MOST ATHLETIC Virgil Frank

Left: Joan chosen "Most Athletic" at Crosby High School (Waterbury, Connecticut), 1955. *Crosby Yearbook, author's collection*.

Below: Crosby High School basketball team, 1957 (junior year). Team captain Joan Joyce, second row fourth from left. *Crosby Yearbook, author's collection*.

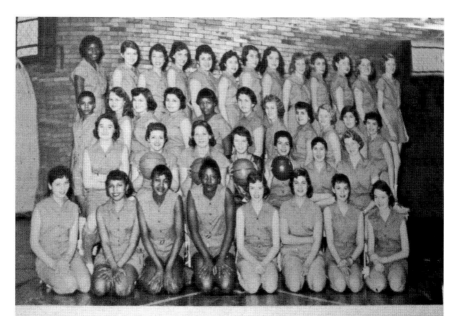

First Row, Left to Right: Lucia Clapps; Earline Turner; Joyce Watts; Shirley Hardison; Beth Terrill; Cynthia March; Diane Padula; Sandy Gough. Second Row, Left to Right: Ginta Vaitkus; Marsha May, Captain; Carol Membrino, Captain; Joan Joyce, Captain; Annette Addona, Captain; Mary Brandvein; Mariann Croft. Third Row, Left to Right: Joan Bacon; Julie Strumski; Diane Sasso; Theresa Aizzi; Juanita Brown; Rosanne Dacaiazzo; Rachele Doyon; Barbara Gentile; Brenda Lursen; Jacqueline Lombardo; Joanne Bernardi. Fourth Row, Left to Right: Rita Johnson; Sandra Bartuski; Ann Mancino; Lucy Mancino; Nancy Mancini; Joan Giusto; Rosanne Martino; Mary Ann Topek; Marilyn Yurgaitis; Anita Briotti; Judy Block; Arlene Galvin; Joy Znoiebel.

Joan was a member of the German Club at Crosby High School (Waterbury, Connecticut), 1957 (junior year). Joan is in bottom row, fourth from left. *Crosby Yearbook, author's collection.*

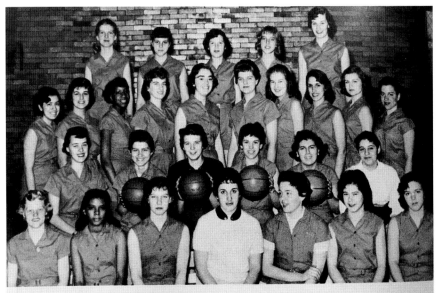

First Row, Left to Right: Brenda Larsen; Joan Bacon; Lynne Hancock; Nancy Mancini; Judith Block; Barbara Bellott; Frances Laone.

Second Row, Left to Right: Patricia Shook; Sandra Bartuski, captain; Joan Joyce, captain; Joanne Berardi, captain; Jacklyn Lombardo, captain; Patricia Granato.

Crosby High School basketball team, 1958 (senior year). Team captain, Joan is second row third from left. *Crosby Yearbook, author's collection.*

"My Dad was my biggest fan." *Courtesy of Joan Joyce.*

Fourteen-year-old Joan Joyce on the Raybestos Brakettes team, 1955. *Courtesy of Brakettes Softball Photo Archive.*

FROM "BONESY" TO "CANNONBALL" TO "SOFTBALL LEGEND"

Girls are not allowed to play in the Little League.

When they were little kids, Joan and her brother, Joe Jr., accompanied their dad to all his softball and basketball games. According to Joan, "Immediately after my father's softball games, Joe and I would run onto the softball diamond to play catch. The same was true for his basketball games. Whenever there was a time out, Joe and I would be the very first to run out onto the court to grab one of the basketballs so we could shoot hoops." Joe Sr. was an outstanding and well-respected amateur softball and basketball player. He played third base for the Waterbury Bombers fast-pitch softball team and played for a number of basketball teams. Joan loved being in a gym or on a softball field and was a keen observer. "I had very good role models very early on," she said about her father and his teammates. It was her dad who first taught Joan how to play softball and basketball at the age of seven. She then began to get tips from her dad's teammates. All the while, Joan observed, very closely, the team members in both sports and how they played the game. At age eight, Joan began playing team softball, initially in the grasshopper league.

When Joan was twelve years old, she practiced baseball with her brother's all-boy Little League baseball team during the team's practice sessions at Waterbury's City Mills Park. At the request of the team, Joan played in a Little League game, where she hit a triple and a double on her first two at-bats. It was there that Joan got her first taste of sexism when

an administrator informed her after the game that "girls are not allowed to play in the Little League."

Thus ended Joan's brief but impressive Little League baseball experience. At the time, many felt that banning Joan from playing Little League was simply a fear of her showing up the boys. But Joan was not fazed by being barred from baseball simply because she was a girl. Like so many instances in her life and career, Joyce turned a negative into a positive. Undaunted by the Little League ban, Joan began playing a lot of organized softball at Waterbury's Fulton Park. Her Fulton Park team would play the other teams from all the Waterbury parks. "That's where I began pitching, although at the time the games were slow-pitch."

One of Joan's first influences in the sport of softball was Tony Marinaro, who also happened to be the family's mailman. Tony was a pitcher on the Waterbury Bombers fast-pitch softball team, the same team that Joan's dad played on. Joan helped Tony on the mail route, and in exchange, Tony would play catch with Joan and gave her some valuable tips on pitching. It was Marinaro who first informed Joan about the Raybestos Brakettes, the famed fast-pitch softball team from Stratford, Connecticut. Joyce had never heard of the team. And it was Tony who urged her to try out for the Brakettes.

At Tony's request, Joan tried out and made the Raybestos Brakettes—at age thirteen. "When I joined the Brakettes, I was a tall, skinny kid. Coach Stratton used to call me 'Bonesy' because I was so skinny. Actually, he still calls me that today. I guess the name stuck."

A fateful event occurred when Joan was sixteen years old, and it would alter Joan's pitching career forever. John "Cannonball" Baker, a pitcher who competed against the Raybestos men's fast-pitch softball team, happened to be up on a ladder putting up a few decorations for a Raybestos game. Cannonball looked down and noticed Joan Joyce warming up using the "windmill" pitching delivery. Baker yelled down, "Hey, have you ever tried using the 'slingshot' delivery?" When Joan yelled up that she never heard of that delivery, Cannonball proceeded to come down from the ladder and showed her how to use the slingshot. Ever the fast learner, Joan learned to perfect the slingshot delivery almost immediately. This was a career-altering event: using this new delivery, Joan was able to pitch with a great deal of accuracy and power. The slingshot became Joan's signature pitch and a pitch she used to perfection throughout her career. Using her slingshot pitching delivery, she became almost unhittable. On Friday June 7, 1957, sixteen-year-old Joan pitched a no-hitter for the Raybestos Brakettes against Waterbury's Libra AA. Joan became a pitching phenom at an early age.

Left to right: Tony Marinaro, Ike Icavone, Joan Joyce, Joe Byrne. Pitchers on Waterbury Bombers. *Courtesy of Joan Joyce.*

One year later, another fateful event occurred for Joan Joyce. On Friday September 5, 1958, the Raybestos Brakettes were locked in a major struggle with California's Fresno Rockets in the final and deciding game of the Women's National Championship. The championship game was played in front of an overflow crowd of fifteen thousand fans at Raybestos Memorial Field. The Fresno Rockets were a powerful team and three-time national champions who were defending their 1957 championship. The Brakettes, however, felt good about their chances of winning the championship mainly because they had their ace pitcher, "Blazing Bertha" Ragan on the mound. In the top of the third inning, with the score knotted at 0–0, Ragan ran off the mound to field a bunt by Fresno's Dot Stolze and severely sprained a muscle in her hip. The injury was so bad that Ragan had to be rushed to nearby Bridgeport Hospital. The players and the fans were stunned. Suddenly, panic set in. A decision had to be made as to who would relieve Ragan. Joan Joyce, who had just turned eighteen years old the previous month, was called in from first base to the pitching mound. As Joan tells it, "The coach put his arm around me and said go in and just do the best you can." It was a logical choice: four days earlier, Joyce pitched a no-hitter against a Detroit team in her only previous tournament start. However, Joan had never pitched in a national championship game.

The hope was that Joyce would keep the game close until the Brakettes' bats came alive. In the first two innings, the Rockets were hitless but saw their opportunity batting against this young eighteen-year-old "kid." Undaunted, Joyce retired the first ten batters that she faced, including seven strikeouts. The next batter (Terry Urrutia) became the lone Fresno batter to reach base off Joyce when she walked with two outs in the sixth inning. Joyce then retired the next Fresno batter (Marylin Sypriano) to end the sixth. The Rockets' hitters were completely baffled by the power and accuracy of Joyce's slingshot delivery.

As the seventh and final inning approached, the score was still deadlocked at 0–0. In the top of the seventh, the Brakettes team captain Mary Hartman laced a two-strike pitch deep into the right field corner. As Hartman raced around third base heading for home, the stadium shook with a thunderous applause from the Brakettes' fans. Hartman's dramatic, "storybook" inside-the-park home run gave the Brakettes a slim 1–0 lead. In the bottom of the seventh and final inning, Joyce faced the heart of the Rockets squad—first baseman Gloria May, team MVP (and future hall of famer) catcher Kay Rich and third baseman Jeanne Contel. May grounded weakly to second baseman Brenda Reilly for the first out. Rich struck out. Finally, Contel drove a ball deep to center field, and Edna Fraser caught the ball at the centerfield fence for the third and final out. The Brakettes, behind Joyce's amazing no-hitter, won their first national championship.

In the 1958 championship tournament, Joan Joyce pitched two no-hitters, walking only two and striking out nineteen batters. Bertha Ragan won the tournament MVP award. For their tournament achievements, Joyce and Bertha Ragan were presented gifts from local shops such as Bridgeport's Artic Sports Shop.

This 1958 championship game was the beginning of Joyce's pitching dominance. The win also marked the beginning of the Brakettes' dominance in women's fast-pitch softball.

Incidentally, Stratford's Raybestos Cardinals won the men's 1958 World Championship Title. On Monday September 22, 1958, thousands of fans lined the streets and also the Municipal Green in Stratford, as the town celebrated the 1958 championships of both the Raybestos Brakettes and Raybestos Cardinals. Following a parade, ceremonies were held on the Stratford Green. It was noted that this was the first time in softball history that two world championship titles were won by eastern teams and the first time that two teams sponsored by one organization won world titles.

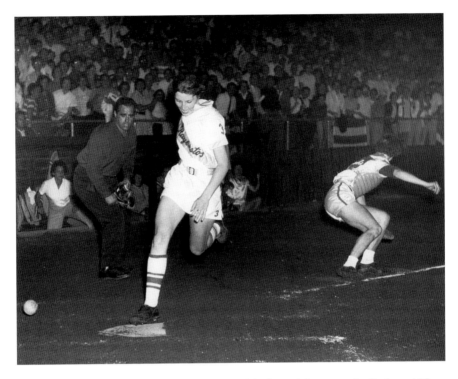

Friday September 5, 1958. A very memorable inside-the-park home run by Brakettes' Mary Hartman. *Courtesy of Brakettes Softball Photo Archive.*

Perseverance and stamina were hallmarks of Joan Joyce's pitching. These trademarks were on full display on September 3, 1961, when Joan pitched three straight games in *one* memorable day, with the final game being a classic contest in women's softball history. The games were played in Normandale Park in Portland, Oregon. At stake was the national championship in which the Brakettes were defending champions and hoped to win their fourth consecutive championship title. In the first game, Joan came on in relief and pitched the last 7 and 2/3 innings of a 13-inning contest and prevailed over pitching ace Marion "Foxy" Fox and her Toronto women's team. Joan and the Brakettes won the game 3–0. Toronto's Marion Fox was a very "colorful" figure. Even though she played in fast-pitch games, Foxy never wore a glove. She claimed that wearing a glove would put her off-balance. In the 1951 Ontario finals championship game, Foxy pitched the complete game and won the title for her Toronto team—all while wearing a cast on her broken ankle. On another occasion, Foxy decided to sit out a game and instead go out to dinner. After dinner, Foxy figured she would drive by Coxwell

Stadium (Toronto) to see how her team was faring. When she saw that her team was losing by a run, Foxy decided to get in the game and pitch for the Toronto team—while wearing a dressing gown.

The late afternoon game saw Joyce pitch the full seven innings, hurling a one-hitter against a then undefeated Whittier (CA) Gold Sox team and winning 2–0.

In the night game, the Brakettes faced the Whittier team once again for the championship in an epic contest. In the championship game, Joyce faced pitching ace and future hall of famer Louise "Lou" Albrecht in a classic marathon duel.

The batting lineup for the Brakettes in the championship game was as follows: catcher Macchietto, shortstop Mulonet, second baseman Dixon, pitcher Joyce, third baseman Ottaviano, right fielder Dowling, left fielder DeLuca, center fielder Fraser, first baseman Reilly.

The batting lineup for the Whittier team in the championship game was as follows: right fielder Riley, left fielder Jaragie, center fielder May, pitcher Albrecht, shortstop Backus, catcher Lee, second baseman Ambord, first baseman Barmore, third baseman Domham, pinch hitter Noland.

The game was scoreless leading into the 15th inning. With one out in the 15th, Joyce singled. Marie Ottaviano popped out to the first baseman. Mary Dowling then doubled into the gap in left-center field, driving Joyce home with the first run of the game. Ann DeLuca flied out to right field to end the inning for the Brakettes. In the bottom of the 15th, Sherry Noland walked and raced to second on a passed ball. Joyce then struck out Darleen May and Albrecht. With Sharron Backus up, the pitch count was 1-2. The Brakettes were one strike away from winning their fourth straight championship. Backus had different ideas and lined the 1-2 pitch for a base hit into right field, scoring Noland and tying the score at 1–1. As Joan Joyce recalled, "I threw Sharron a drop ball, down and away. It was a good pitch, and she managed to hit it off the top of her bat and poked the ball into right field for a single. She didn't try to do too much with that pitch, which was the right thing to do." And so the stage was set for the fateful 19th inning. In the bottom of the 19th, Joyce retired the first two batters. Then outfielder Coleen Riley singled into left field. The speedy Riley proceeded to steal second and then third base. Joan Joyce finishes the story: "I had the batter Noland on a 1-2 count, ready to strike her out and end the inning. I decided to throw the next pitch inside to get her out. The batter backed away from the pitch but, as luck would have it, the ball grazed her bat and the ball rolled out to fair territory. The problem

was that the ball landed in a perfect spot down the first base line where none of us were able to retrieve it in time to get the runner out from third. Tough way to lose a 19-inning game, especially for the championship. But that's softball!" With that play, Whittier won the game and the 1961 championship 2–1. Joan Joyce won the Most Valuable Player in the 1961 tournament. The championship game took four hours and fifteen minutes to complete and lasted until 3:30 a.m. Joyce struck out forty batters in the 19-inning game. In total, Joan pitched 33 2/3 innings and struck out sixty-seven batters in a twelve-hour span—all in one memorable day! Despite her loss, Joan Joyce's gutsy performance that day was the talk of the entire softball world. Newspapers across the country hailed Joan's heroics as "one of the most gallant exhibitions in women's softball history."

Joan Joyce has always said that striking out Ted Williams was probably the event that first got her the attention of sports fans. That may very well be the case. However, it was Joanie's gutsy performance on September 3, 1961 (along with her 1958 championship-saving no-hitter) that really won the hearts and minds of her fans all over the world, especially in Connecticut.

In a few short years, Joan Joyce had become a softball legend.

In September 1963, Joan moved to California, where she enrolled at Chapman College in Orange. While at Chapman, Joyce played for the great Orange Lionettes women's fast-pitch softball team. Joan led the Orange Lionettes to the 1965 softball title. Ironically, while still with the Lionettes, Joan pitched against the Raybestos Brakettes.

Joan Joyce was involved in yet another marathon classic on Monday, August 17, 1964. Joyce pitched a full twenty-nine-inning game in a 1–0 win for Joan and the Orange Lionettes. The game pitted the Lionettes against California's Whittier Gold Sox softball team in the finals of the Far West Regionals. In her incredible pitching performance, Joyce struck out thirty-nine batters. The game featured a pitching match between Joyce and Whittier ace pitcher Louise Mazzuca (future hall of famer). This marathon contest lasted until 3:00 a.m. the next morning. The game put Joyce and the Lionettes into the Women's World Softball tournament, which began four days later at Orlando's Tinker Field (Florida).

Pitching for the Orange Lionettes, Joyce hurled a no-hitter against her former team the Raybestos Brakettes on Friday, August 21, 1964. Joan dueled former teammate and Brakettes pitching ace Bertha Ragan Tickey for all seven innings and won the contest 2–0. The only time Joyce ran into a bit of trouble was in the bottom of the seventh. With one out, Micki Macchietto and Carol LaRose walked to put runners on first and second. However, the

next two batters (Shirley Topley and Laura Malesh) both grounded into infield outs to end the game.

Joan graduated from Chapman College in 1966. She returned to Connecticut in September 1966 and stayed for a time with her parents on Tudor Street in Waterbury. Joan rejoined the Raybestos Brakettes in 1967, leading the Brakettes as a pitcher and as a hitter. She recorded her fourth straight no-hitter on August 1, 1968.

Joan was thrilled to be back in her hometown when she appeared with her Brakettes team for a benefit game on Wednesday, August 6, 1969, at Waterbury's Municipal Stadium. Receiving a very loud ovation from her hometown fans, Joan pitched a two-hitter against the New Jersey Schaeferettes and won the second game of a doubleheader by the score of 4–0. Incidentally, Joan's brother, Joe, played in the first game for the Waterbury All-Stars, a team composed of players selected from Waterbury's softball leagues.

One of the questions that Joan has been asked repeatedly over the years is, "What was the speed of your pitches?" It is a question that Joyce says, in all honesty, she cannot answer with certainty, especially since radar guns were not available at that time. Joan does point to a study done at Long Beach State College that concluded that she threw a softball equivalent to a 119-mile-per-hour baseball, in terms of reaction time. The one thing that she can say with certainty is that she was able to throw a softball very fast and, more importantly, make the ball rise or fall dramatically. As a way of demonstrating the batter's reaction time to her pitches, Joan will snap her fingers and say, "That is how much time the batter has to react to the pitches." Because of the speed, power and movement of Joyce's pitches, catching for her was a daunting task. When asked about catching for Joyce, Brakettes catcher Claire Beth "C.B." Tomasiewicz once remarked, "It's hard to learn to handle Joan. She throws so hard and the ball moves so much. She always knows what she wants to throw. It's a matter of knowing how her mind works." C.B. got her chance to catch Joan as a result of attending a softball clinic. She was a sophomore at Weston High School (Weston, Connecticut). Joan Joyce, who had officiated some of C.B.'s basketball games at Weston High, chose her to catch some demonstration pitches. When asked what her first experience was like catching Joyce's pitches, C.B. responded, "Really scary." Tomasiewicz says she caught in "self-defense" but did well enough to earn a tryout with the Brakettes. And if catching Joan's drop ball wasn't difficult enough, consider the fact that most catchers on women's fast-pitch softball teams did not wear shin

guards or foot guards. Catchers wore knee pads but otherwise no real protection. Joyce's drop ball was so devasting and moved so dramatically injuries were bound to occur. As Joan recalls, "Up until the mid-seventies, most catchers wore knee pads but no shin or foot guards. We lost a catcher for the year when a foul tip from a drop ball broke her foot."

In her only loss in the 1976 season, Joan came on as a pinch hitter in the 7th inning and homered to tie the score. She stayed in the game as a relief pitcher and ultimately lost the game on a dropped fly ball in the 11th inning. That was her only defeat in 59 decisions during the 1975 and 1976 seasons. In her pitching career, Joan posted numerous strings of scoreless innings pitched (for example, 123 consecutive scoreless innings in 1971 and 229 scoreless innings in the 1975–76 seasons).

In addition to her dominance as a pitcher, Joan also was an outstanding hitter. She had a career batting average of .327. Her highest single-season batting average was .406 in 1973. Joan was a six-time Brakettes team batting champion. She also was the National Tournament Batting Champion in 1971, with a batting average of .467.

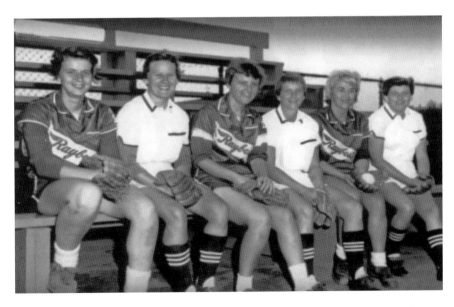

Brakettes' Joan Joyce (*left*), Rusty Abernethy (*third from left*) and Bertha Ragan Tickey (*fifth from left*). *Courtesy of Joan Joyce.*

Marion Fox, 1961. *Courtesy of Brakettes Softball Photo Archive.*

Catcher Barbara Clark on deck. Note: Catchers wore knee pads in lieu of shin guards. *Courtesy of Brakettes Softball Photo Archive.*

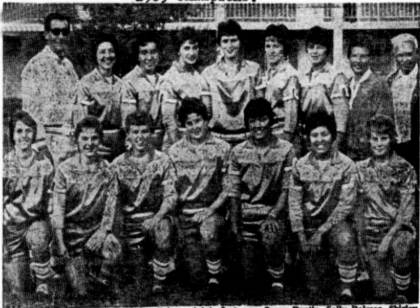

Orange Lionettes.....
Pacific Coast Women's Softball League
1965 Champions!

The team includes (left to right), first row—Susan Dustin, Sally Palmer, Shirley Smith, Sharron Backus, Sharon Iriye, Cecilia Ponce and Rose Adams; back row—Frank Clarelli, coach; Odette Griffin, Nancy Ito, Lou Albrecht, Joan Joyce, Shirley Topley, Carol Spanks, Johnna Moore, manager, and Carl Cowles, business manager.

Above: Joan (*top row, fifth from right*) leads Orange Lionettes to the 1965 championship. *Courtesy of Softball National News by Stormy Irwin.*

Right: Chapman College, '66. *Chapman College Yearbook, author's collection.*

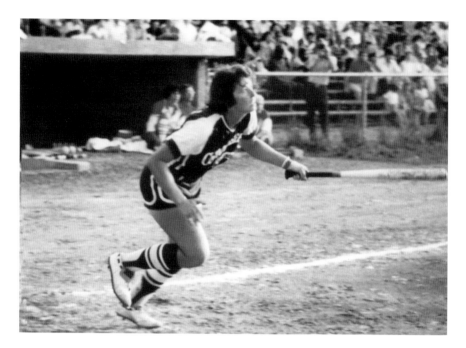

Joan watches her home run clear the fence. *Courtesy of Joan Chandler.*

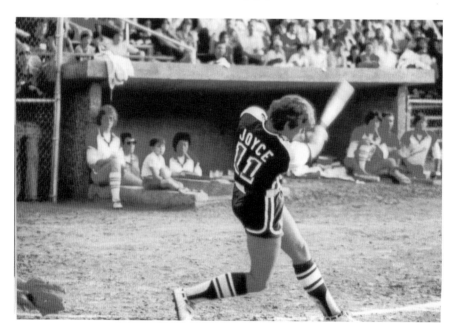

Joan at bat. *Courtesy of Joan Chandler.*

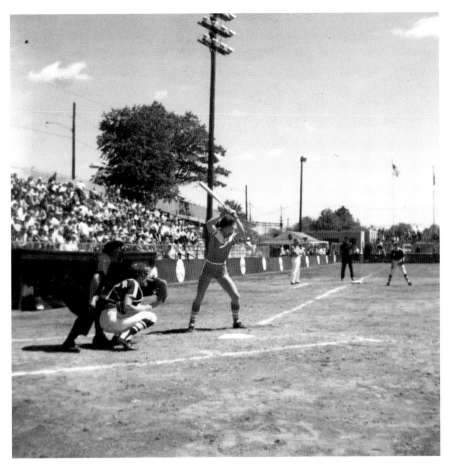

"Carol Spanks (of the Orange Lionettes) was my toughest out." *Courtesy of Brakettes Softball Photo Archive.*

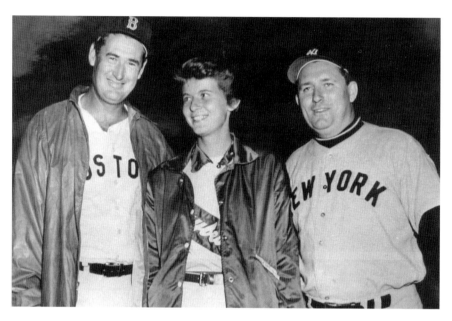

Left to right: Ted Williams, Joan Joyce, Spec Shea (New York Yankees). *Courtesy of Joan Chandler.*

"HISTORY IN THE MAKING"

Joan Joyce vs. Ted Williams, Part 2

Ted turned back to me and asked, "How'd you throw that curveball?" So I took the ball from my glove and demonstrated how I gripped and spun it. He looks at me and says, "You know, girls aren't supposed to know that." I looked at him and I said, "Well, this girl does know that."
—*Joan Joyce*

After the August date was set for the historic matchup, Ted Williams arrived for a luncheon to kick off the big occasion. Joyce's coach sat next to Ted. Among the things Williams told him was that he didn't like high, tight inside pitches. "So my coach comes to me and tells me about Ted's comment," Joyce said. "I looked at him and said, 'Ted is just trying to set me up, because he knows you'll come back and tell me.' So I said, 'He's *not* going to get a high, inside pitch. He's got the best eyes in baseball. If he's going to hit me, he's going to have to hit my drop ball, which is down and away.'"

Williams thought for sure he had "conned" the young pitcher into thinking that pitches high and inside were his Achilles heel. Like Ted, everyone in the stadium anticipated seeing some well-hit balls, even against such a great strikeout pitcher. Everyone, that is, except the pitcher herself.

Just before her windup, Joanie gave a smile to Ted, and he responded with a big grin. And then it came—the drop ball. Williams took a vicious cut but missed the ball completely. His smile disappeared, and for a brief moment, he seemed perplexed. The ball was delivered in an entirely

different location than he anticipated, It came in powerful, down and away, and seemed to "drop off the table." In that brief moment, Ted knew he was up against an extraordinary pitcher. He sensed it immediately. The great ones do. Next came the curve, again down and away. Ted took a mighty swing, to no avail. He finally saw the rise ball on the next two pitches, but they were too far away off the plate. Joan followed up with drop balls, all over the plate, but down and away. Always down and away. The only contact Williams could make with the ball were a couple of foul tips straight back against the backstop. After repeatedly swinging and missing her pitches, he realized it was futile. He then tipped his hat as a sign of respect for Joan Joyce and walked away from home plate to an appreciative applause.

The balls thrown came whipping in at a speed Williams wasn't prepared for. Joyce says her pitches, from some forty feet away, were in the 70s range (and moved dramatically)—and a test later conducted at Long Beach State College calculated the baseball reaction time to be the equivalent of 119 miles per hour. Essentially, Williams would have to start his swing at the very moment she released the ball to have a prayer of hitting it.

Joan explains her encounter with Ted Williams this way: "I had him up there for ten to fifteen minutes, and he fouled off three pitches straight back," Joyce said. "And finally, he threw the bat down and said, 'I can't hit her.' I gave him some rise balls, but they were out of the zone and I knew he wouldn't swing at those because his eyes were so good. Then, I went to my drop ball. He swung—and missed—repeatedly. You know, I had really mixed emotions about the encounter. I thought, 'Maybe I should have let him hit a couple—just for the show.' But I was too competitive. I've always said that if my mother put a bat in her hands and came up to hit, I'd have to strike her out, too."

Joan recalls an interesting discussion the two had after one of their encounters. As Joan recollects: "After one of our events, several of us were walking down a path. Williams seemed very quiet and in deep thought. Finally, Ted turned back to me and asked, "How'd you throw that curveball?" So I took the ball from my glove and demonstrated how I gripped and spun it. He looks at me and says, 'You know, girls aren't supposed to know that.' I looked at him, and I said, 'Well, this girl does know that.'"

On Friday August 5, 1966, Joyce and Williams met on the diamond for the very last time. This occurred several weeks after Williams was enshrined in the Hall of Fame in Cooperstown. It was another sell-out and overflow event at Waterbury's Municipal Stadium, and it almost didn't

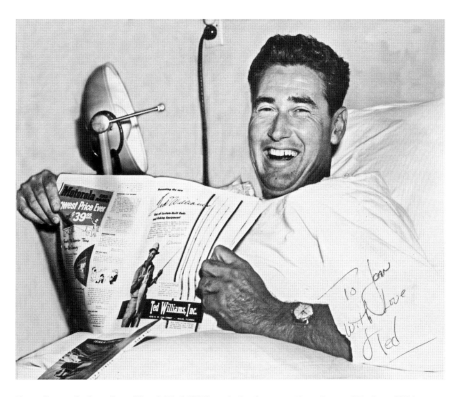

From fierce rival to close friend. Ted Williams's fond note to Joan Joyce. "To Joan With Love, Ted." *Courtesy of Joan Joyce.*

happen. Joyce recalled, "I was in Orange, California, nursing a knee injury I had suffered playing softball. I was out for a month. I told the people at the Jimmy Fund Benefit that I was unable to make the exhibition. When Ted found out he told the officials that he wasn't going unless I go. So they put a lot of pressure on me to attend. In fact, Williams wanted me to call him personally to confirm, which I did. So, I got on a plane and flew to Waterbury for the exhibition game, sore knee and all." But once again, Williams was unable to hit any of Joyce's pitches, except for a couple of foul tips.

Williams was in awe of Joan's talent and sang her praises in a December 30, 1999 article by Tom Yantz of the *Hartford Courant* newspaper. Williams was quoted as saying, "Joan Joyce was a tremendous pitcher, as talented as anyone who ever played."

Years after her encounters with Ted Williams, Joyce met a man who fished with Williams in the Florida Keys. The man said he had once asked

Williams to name the toughest pitcher he ever faced. "And he said, 'You won't believe this, but it was a teenage girl.'" Joyce laughs at the story. She takes it as high praise from a man whose lasting respect she had earned with her burning desire to be the best. After their encounters on the ballfield, Joyce and Williams became close friends, with mutual respect and a common bond.

THE HISTORY OF SOFTBALL

A Game for Everyone

The origins of softball can be traced back to the 1880s. The sport was actually invented in 1887 in Chicago, Illinois, initially as an indoor game similar to baseball. Softball was invented even before the advent of basketball (1891) and volleyball (1895). George Hancock is credited as the inventor of softball. At the time, Hancock was a reporter for the Chicago Board of Trade. Hancock, along with a group of other men (including Yale and Harvard alumni) were at Chicago's Farragut Boat Club (3016 Lake Park Avenue), closely following the very popular Yale-Harvard football game, which was transmitted by telegraph. The football game was played on Thursday, November 24, 1887, at the Polo Grounds Stadium in New York. (Yale won 17–8.) After the game, Hancock encouraged the men there to participate in a game of indoor baseball, using a rolled-up boxing glove as a ball and a broken broomstick as a bat. Thus, the first known "softball" game was played at the Farragut Boat Club on November 24, 1887 (Thanksgiving Day). The Farragut Club soon adopted rules of this "baseball-like" game. In Chicago's Farragut Club rules, no glove was needed since the "ball" was soft and rather large (sixteen inches in circumference). For this reason, many Chicagoans refer to this brand of the game as "mushball."

Meanwhile, hundreds of miles away in Minneapolis, Minnesota, a lieutenant fireman by the name of Lewis Rober was also contemplating an indoor baseball game. He envisioned a new recreational game—a variation of baseball—for the firemen to play in between emergency calls. Rober's

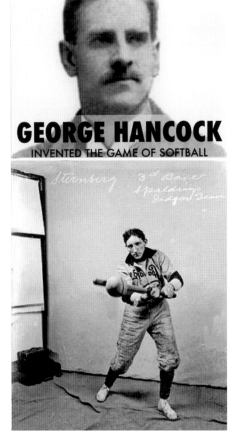

GEORGE HANCOCK
INVENTED THE GAME OF SOFTBALL

Top: George Hancock. *Public domain, author's collection*; *Bottom*: Chicago indoor baseball ("mushball"), circa 1897. *Public domain.*

game differed from baseball in that a larger and softer ball (twelve inches) was used rather than baseball's nine-inch ball. Like Hancock's game, pitchers delivered the ball underhanded to the batter. Also similar to Hancock's, Rober's version utilized a smaller field ("diamond").

In 1895, Rober decided to bring his version of the game outdoors for his fellow firemen and others to play. Rober named his team the Kittens. Thus, at that time, the game was referred to as "kitten ball," one of many names used to describe the game of softball in the early days. Rober helped form a league, and regular games were held between the Kittens (Engine 19), the Rats (Engine 9), the Wales (Engine 4), the Salisburys (mattress factory), the Pillsburys (flour mills) and the Central Avenues.

Unlike the sixteen-inch ball that eventually became part of the Farragut Club rules, the size of the ball in Rober's version was twelve inches, which became the adopted standard softball size. It is purported that Rober was unaware of the Farragut rules. Although it was eight years after Hancock's Thanksgiving Day 1887 game, Rober has also been credited as the inventor of the game of softball.

In the formative years, the game was referred to by a number of names, including "indoor baseball," "kitten ball," "diamond ball," "mush ball," "lemon ball" and "pumpkin ball." In 1926, the name "softball" was coined.

In 1931, Baseball Commissioner Kenesaw Mountain Landis banned women from professional baseball. Landis claimed that baseball was too strenuous for women. Thus, women turned to softball as a means of recreation.

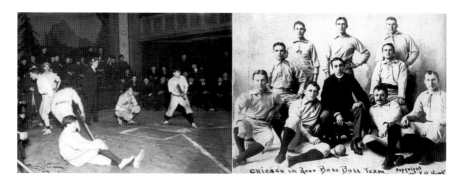

Left: Indoor baseball; *Right*: Softball team, 1880s. *Public domain.*

At the 1933 World's Fair in Chicago, the current form of softball was on display when the first organized softball tournament was held. The World's Fair, known as "A Century of Progress International Exposition," ran throughout 1933 and into 1934 to celebrate Chicago's centennial. The *Chicago American* newspaper made note of this new sport played at the World's Fair: "It is the largest and most comprehensive tournament ever held in the sport that has swept the country like wildfire." The men's softball tournament finals featured J.L. Friedman of Chicago against Briggs Beautyware of Detroit, with the Chicago team winning the title. The first national softball tournament of the Industrial League was won by the J.J. Gillis Company team in 1933.

From 1887 through 1935, a plethora of different softball rules were established in various parts of the United States. During this period, there were no unified, consistent set of softball playing rules. In 1936, the International Joint Rules Committee on Softball (IJRC) standardized the rules of softball, unifying softball regulations throughout the United States and throughout the world.

During the formative years of softball, the standard uniform for women was a dress (or outside "bloomers") and shoes. In 1955, the standardized uniform changed to shorts and a T-shirt.

The role of women in softball's history cannot be overlooked. In the 1800s and early 1900s, professional sports, like football and baseball, were thought to be too rough for women and only suitable for men. At a time when hardly any competitive sports were open to women, softball provided an important option for female athletes. Indeed, since the inception of softball, women were welcomed to play. Because it was a community sport and an amateur sport, it was much more accessible to women. Women realized it was the

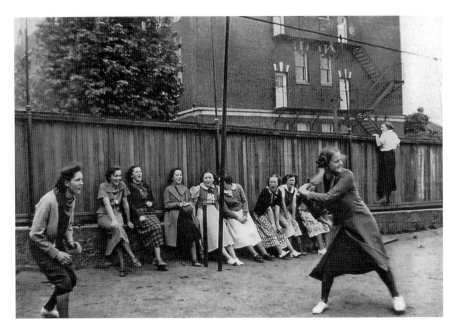

During softball's formative years, the standard "uniform" for women was a dress (or outside "bloomers") and shoes. *Public domain.*

closest they would come to playing professional baseball, which excluded women athletes. Eventually, female athletes not only participated in large numbers but also became a dominate force in the sport of softball. Female athletes received a boost when Title IX was passed on June 23, 1972, a law that guarantees that women in federally funded schools receive opportunities in sports that are equal to those enjoyed by men.

In the entire history of women's softball, the Brakettes of Stratford have stood head and shoulders above all other teams. So much so that the town of Stratford, Connecticut, has been known as the "Softball Capital of the World" and the "Mecca of Women's Softball."

WOMEN'S SOFTBALL WORLD CHAMPIONSHIPS

The Women's Softball World Championship is a fast-pitch softball tournament for women's national teams. The tournament has been sanctioned by the World Baseball Softball Confederation (WBSC). The

WBSC was originally known as the International Softball Federation (ISF). The WBSC regulates rules of play in the United States and in many other countries.

The first ISF Women's World Championship was held in Melbourne, Australia, in 1965. The United States was represented by the Brakettes of Stratford, Connecticut. Notably, Australia dealt the heavily favored U.S. women's team a stunning defeat by the score of 1–0. In all likelihood, the result would have been different had Joan Joyce been on that team. As mentioned previously, Joan was pitching in Orange, California, at that time. Actually, a non-ISF women's "world championship" tournament had taken place in 1952 and 1953 in Australia. Participants were Canada and the USA.

The Brakettes went into the 1974 Women's World Tournament with their sights clearly set on bringing the world championship crown to the United States, which had never won the title. To accomplish this goal, the Brakettes knew they had to defeat several powerful teams, including Australia and Japan.

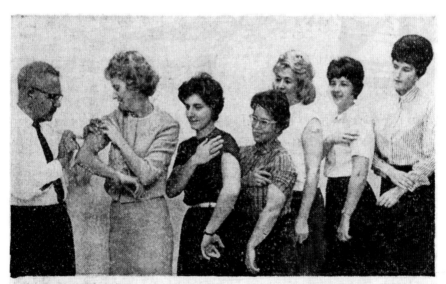

BRAKETTES 'NEEDLED' FOR WORLD TRIP—The Raybestos Brakettes, in preparation for the International Tournament in Melbourne, Australia, and a subsequent trip around the world receive a series of inoculations from Dr. George E. Roberge, plant physician. The club departs on Feb. 6. Left to right, Dr. Roberge, Millie Dubord, Ann DeLuca, Edna Fraser, Bertha Tickey, Beverly Danaher and Brenda Reilly.

Brakettes receive shots prior to 1965 Australia World Tournament. *Courtesy of Joan Chandler.*

For the first time, the tournament was played in the United States, before sold-out crowds at Stratford's Raybestos Memorial Field. The throngs of fans began gathering early before each contest to cheer on their home club, the Brakettes.

The tournament began on Thursday August 8, 1974, with the Brakettes (representing USA) facing New Zealand. Joan Joyce pitched a brilliant one-hitter, retiring seventeen of the first eighteen batters she faced. The only hit off Joyce was a single in the bottom of the sixth inning by New Zealand's Sylvia McCuws. The Brakettes went on to win their next five games in convincing fashion and entered the playoffs with a 6-0 record.

The first game of the playoffs pitted Joyce against an offensive powerhouse Australian team (August 14, 1974). As Joan recalls, "They had some awesome hitters, like they were beating teams 10–0." But then again, they had never faced a pitcher like Joan Joyce. The Australian batters were completely stymied by the Brakettes' phenom. Joyce struck out every batter she faced except one, who walked. The first fifteen batters struck out against Joyce. Australia finally got a runner on when Merilyn Pitts walked. But even that was short-lived; Pitts was picked off at first. Joyce then proceeded to strike out the final five batters to complete her masterful no-hitter. Amazingly, there were only two foul balls, and the Australian team did not hit one fair ball all game.

Australia earned another chance at Joyce and the Brakettes (but probably wished that hadn't) by virtue of a 3–0 victory over the Netherlands. This time, the Australian batters were unable to reach base at all during the entire game, as Joan pitched another gem—a perfect game.

So now the stage was set for the much-anticipated championship final on Friday, August 16, 1974, between the Brakettes (USA) and a much-heralded Japan team. Joan Joyce dueled Japanese star Miyoko Naruse, who was 3-0 in tournament play. Naruse also brought a .367 batting average to the final game. The Japanese team entered the championship game as defending champion and, like the Brakettes, were previously unbeaten in the tournament.

Japan's players tried to distract her by wearing helmets at the plate in an era when they weren't worn in the women's game. The tactic backfired. "You want to distract me? I don't think so," Joan thought to herself.

In a remarkable show of utmost respect for the dominance of Joan Joyce on the mound, *every* Japanese batter (with the exception of Naruse) tried to bunt against Joan. The only hit off Joyce was a bunt blooper over Joan's head by left fielder Hiroko Masubuchi. The only other Japanese batter to get on base reached on an error.

In the fourth inning, with the score knotted at 0–0 and the bases loaded, second baseman Willie Roze laced a double to right-centerfield, scoring Kathy Elliott and Joyce. Following that, with Sharron Backus at the plate, Naruse threw a wild pitch, scoring Cec Ponce for the third and final run of the game. That was all the scoring that the USA team needed, as they won the championship game behind Joan's one-hitter by the score of 3–0. The USA team completed a nine-game sweep of the tournament rivals. Not only were they unbeaten, but they were also unscored-on.

After the championship game, the Japanese captain remarked, "It is no shame to lose to the best and most powerful, strongest team in the world."

The Brakettes became the first USA team to capture the Women's World Championship. Joan's performance in this tournament was truly spectacular, and the records she set were staggering, including most strikeouts (76), lowest earned run average (0.00), most consecutive

World Champion Brakettes, 1974. Joan Joyce on bottom row, fourth from left. *Courtesy of Jim Fetter.*

scoreless innings (36), most no-hitters (3) and most perfect games (2). Joyce allowed only two hits in her five appearances in the tournament. Also, USA Brakettes outscored their opponents 75–0, and their batting average was .356.

Since their first world championship title, the Brakettes have won the world championship eleven times from 1974 to 2018, including seven consecutive world titles. The next highest world title wins go to the Japanese team, which won the championship three times.

USA Softball Association

In 1933, the Amateur Softball Association (ASA) was formed. The ASA assembled a meeting known as the International Joint Rules Committee on Softball (IJRC). Effective January 1, 2017, the organizational and trade name was changed from Amateur Softball Association to "USA Softball."

USA Softball is the national governing body for the United States softball team. The organization oversees more than 170,000 amateur teams, 2.5 million players and 500,000 coaches. It is the largest USA adult Softball program. USA Softball provides competition programs for adults including fast-pitch, slow-pitch and modified-pitch for men and women. According to the Team USA website, the Mission of USA Softball is to "develop, administer and promote the sport of softball to provide opportunities for participation and the best possible experience for those involved."

In 1996, the USA Softball women's national team became the first American softball team to compete in the Olympics. The U.S. team has been dominant in international play. For instance, the U.S. team took the gold medal in three straight Olympics and seven straight world championships.

Basic Differences between Softball and Baseball

The official rules of softball were developed very early in the history of the game. The rules were eventually spelled out by the International Softball

Federation (ISF). These rules showed some similarities to the game of baseball. For example, like baseball, the rules called for nine players on the field at one time. The players take the positions of pitcher, catcher, first baseman, second baseman, shortstop, third baseman and three outfielders (right fielder, left fielder and center fielder). Note: Slow-pitch softball rules allow for a fourth person in "short" ("shallow") outfield.

Unlike baseball, softball is a seven-inning sport, as opposed to baseball's nine innings. The team with the most runs at the end of the seventh inning is named the winner. Like baseball, if the teams are tied at the end of regulation play, the game can go into extra innings until the tie is broken.

In softball, the distance between bases is sixty feet as opposed to baseball's ninety feet. The shorter distance speeds up base-running and fielding. Another crucial difference is that in softball, the distance between pitcher's mound and home plate is shorter (forty feet in softball vs. sixty feet, six inches in baseball). The distance in softball was originally thirty-eight feet but then moved to forty feet. The shorter distance results in much less reaction time by the batter.

Another distinction between softball and baseball is that the pitcher delivers the pitch underhanded, as opposed to baseball's overhanded pitches. Also, softball utilizes a larger (twelve-inch) and softer ball as opposed to baseball's (nine-inch) hard ball.

SLOW-PITCH VS. FAST-PITCH SOFTBALL

Softball can be played using the fast-pitch or slow-pitch methods. Basically, slow-pitch and fast-pitch are played by the same rules. However, there are several major differences, and a few are cited as follows.

Slow-pitch is an alternative to the fast-pitch method and appeals to millions of people mainly for fun and recreational purposes. Across the United States and in many other parts of the world, slow-pitch games are played every day, in a rather informal manner. Sometimes co-ed softball teams are formed, underscoring the equality of the sexes in the sport. There are father-son leagues, mother-daughter leagues, "beer" leagues, Boy Scout/Girl Scout leagues, pick-up leagues and leagues sponsored by recreation departments. However, there are slow-pitch tournaments and leagues in which the game is played in a more serious, business-like manner (for example, the WSL Slow-Pitch League).

In slow-pitch, the pitcher delivers the ball to the batter at a slow, moderate speed. The pitched ball is delivered in an underhand, "lob" fashion. The pitched ball is meant to be hit by the batter. Thus, the emphasis is placed on hitting. With this in mind, teams are composed of ten players, as opposed to nine players in fast-pitch softball. The additional tenth softball player is usually a "short fielder," meaning the player is positioned behind or to either side of second base (or shortstop) in the "short" ("shallow") outfield. With the batter encouraged to hit the ball, emphasis is also placed on the fielders, since they will have many more opportunities to field the ball than fielders in fast-pitch ball games.

There are other differences between slow-pitch and fast-pitch games. In slow-pitch, there are rules governing the "arc" of the pitch and speed of the pitch. There are several other differences (for example, bunting and base stealing are usually not allowed in slow-pitch). Slow-pitch games normally result in many more runs than fast-pitch.

In fast-pitch, the emphasis is more on the pitcher. Unlike slow-pitch, the pitcher makes every effort for the batter *not* to hit the ball and to get the batter out, preferably by strikeout. The batter is faced with pitches that are delivered underhand but in a very fast and complex manner (drop ball, rise ball, knuckle ball and so forth). Bunting and base stealing are allowed. Because the pitcher is normally the dominant player, fast-pitch usually results in low-scoring games. Unlike slow-pitch, only nine players are allowed on the field (similar to baseball).

FAST-PITCH DELIVERY STYLES

In fast-pitch softball, the pitcher usually delivers the ball to the batter utilizing one of three methods:

Windmill Delivery—The pitcher whirls her arm straight up over her shoulder as far as the arm can go and all the way back with speed and force in a large circle.

Slingshot Delivery—This is the pitching delivery that Joan Joyce used to perfection. Unlike the over-the-top windmill style, the slingshot delivery started with Joyce's right hand outstretched high behind her to the stretching point, then whipping the ball past her hip with speed and force.

Figure-Eight Delivery—Perhaps the most difficult to master of all three basic pitching deliveries. The ball hand moves backward quickly but then moves in a figure-eight pattern.

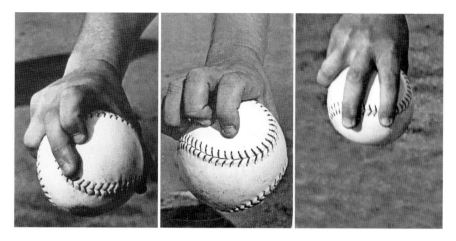

Three types of pitches, *left to right*: rise ball, knuckle ball, drop ball. *Courtesy of* Winning Softball, *by Joan Joyce and John Anquillare. Used with permission from Joan Joyce.*

Fast-pitch hurlers normally deliver "rise" balls and "drop" balls. For this reason, the hitter usually stands farther forward in the batter's box than in baseball. The reason for this is that the batter tries to swing at the ball before the ball makes its upward or downward break over the plate.

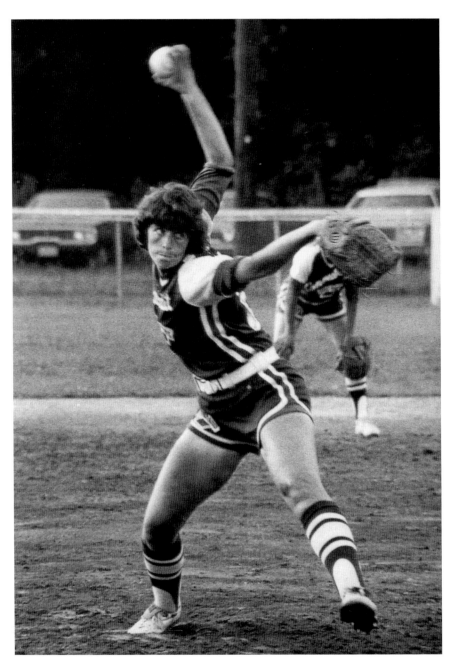

Joan Joyce's look of determination. The most dominating women's softball pitcher in history. *Courtesy of Joan Chandler.*

6

THE "SLINGSHOT"

She would make that ball move like nobody else. Riser, drop, curve and sometimes
change up. All effective and all devasting.
—John Stratton, longtime Brakettes coach and manager.

When Joan was in her early teens, she pitched using the windmill delivery. But she was not comfortable using that pitching method. As Joan explains,

> *I was wild and would actually hit batters. I hated it. Once I was taught the "slingshot" method, I began practicing this new delivery for twenty to thirty minutes, until I got comfortable. It didn't take long for me to adapt to that delivery method. As soon as I changed to the "slingshot," it was a totally different world. That one year, it was unbelievable the difference in my pitching. I was now able to pitch the ball with total accuracy and I was able to generate a lot more power using the slingshot. Such a great feeling to be in total control of all my pitches.*

Joan demonstrating her famed "slingshot" delivery, 2011. *Courtesy of Kathy Gage.*

The following sequence demonstrates Joan Joyce's famed slingshot pitching delivery. *Courtesy of Joan Chandler.*

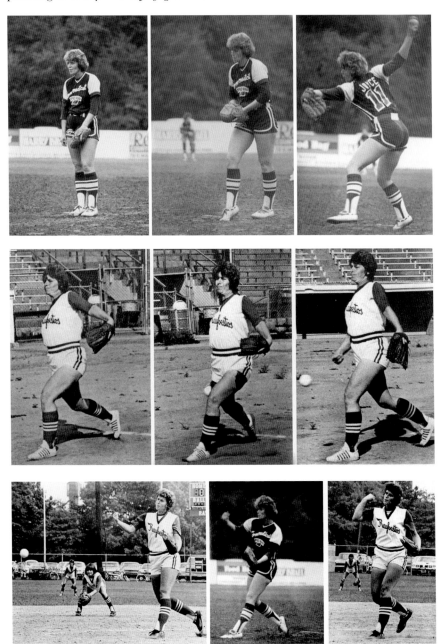

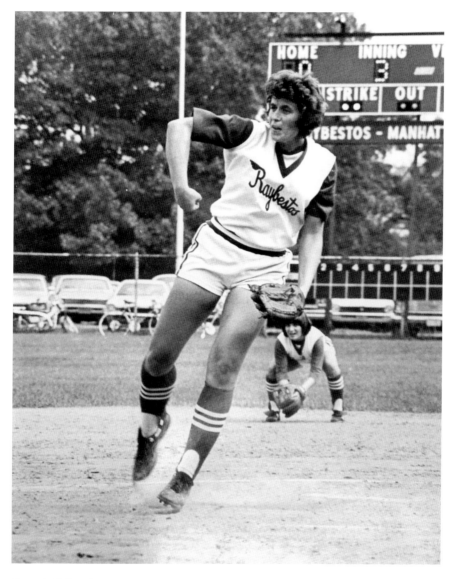

Curve ball. Joan Joyce's arm position when throwing a curve. *Courtesy of Joan Chandler.*

Brakettes pitchers, 1967. *Left to right*: Joan Joyce, Donna Hebert, Bertha Ragan Tickey, Donna Lopiano. *Courtesy of Jim Fetter*.

THE GREATEST DYNASTY IN WOMEN'S SOFTBALL HISTORY

Brakettes softball has been the barometer for measuring the sport's success
—brakettes.com

The Brakettes of Stratford, Connecticut, have been the most dominant team in women's softball history. Recognized for many years as the number-one fast-pitch team in the history of women's softball, they are often referred to as "the greatest dynasty in women's softball history." Their team dynasty has spanned the last seven decades. Since 1958, Brakettes softball has been the barometer for measuring the success of the sport of women's softball. The Brakettes fast-pitch softball team has always been synonymous with softball excellence. In addition, the town of Stratford, Connecticut, has long been considered the "mecca of fast-pitch softball."

The Brakettes were formed in 1947. At that time, the team was known as the Raybestos Girl All-Stars, organized by William S. Simpson. Simpson was the general manager of the Raybestos Division of Raybestos-Manhattan Inc., which sponsored the team. In their first year of existence, the team compiled a 16-4 record and made it to the state tournament quarter-finals. In 1948, the team changed its name to the Raybestos Brakettes (a.k.a. the Brakettes). The team derived its name from the Stratford Raybestos plant, which produced brake linings for automobiles and trucks.

In the 1950 national fast-pitch tournament, the Brakettes won their very first tournament game, beating San Antonio (TX) by the score of 2–1. In the 1953 national tournament in Toronto (Canada), the Brakettes finished

as quarter finalists. At this tournament, Stamford's Dena Kuczo (outfielder) became the first of many Brakettes to be selected to an All-Star team.

The Brakettes began to gel in 1956 when Bertha Ragan, the nation's No. 1 pitcher at the time, came east to join the Brakettes. Bertha was a star pitcher for California's Orange Lionettes. Ragan's addition and the emergence of a fifteen-year-old phenom from Waterbury, Connecticut, by the name of Joan Joyce, were the foundation of a dynasty in the making.

Finishing the season with a 38-5 record, the Brakettes won the 1956 National Girls' Softball League title and their seventh North Atlantic Regional crown (fourth consecutive title) to earn a berth in the World Tournament in Clearwater, Florida. Bertha Ragan pitched every inning of all six games, and the Brakettes finished fourth. The Brakettes came very close to moving up even further in the 1956 tournament, as all of their games were extremely close. They beat Fort Worth (TX) 2–0 and then lost to Kansas City (KS) 3–2. The next four games all went extra innings. The Brakettes won three straight nine-inning thrillers, beating New Orleans 3–2; defeating Lancaster (PA) 4–3; and Portland (OR) 4–3. The sixth game was a seventeen-inning marathon in which the Brakettes were ousted by California's Buena Park Lynx by the score of 1–0. For her great showing, Ragan captured the tournament's Most Valuable Player award and was chosen as an All-American. Catcher "Micki" Macchietto received honorable mention all-star acclaim. Fifteen-year-old Joan Joyce finished the season with a 4-1 overall record.

It was in 1958 that the Brakettes began their dominant softball dynasty. In that year, the Brakettes won their first national championship. The final championship game featured California's Fresno Rockets against the Raybestos Brakettes of Stratford. The Fresno Rockets were a powerhouse team, and they entered the tournament as defending champions. The final and deciding game was held on Friday September 5, 1958, at Raybestos Memorial field before a sold-out crowd of fifteen thousand cheering fans. The starting lineup for the Brakettes (in order of appearance) was: "Micki" Macchietto (catcher), Beverly Mulonet (shortstop), Joan Joyce (first base), Joan Kammeyer (right field), Marie "Jo-Jo" Ottaviano (third base), Joan Wallace (second base), Mary Hartman (left field), Edna Fraser (center field), Bertha Ragan (pitcher) and Brenda Reilly (second base, pinch hitter). Fresno's lineup included Terry Urrutia (second base), Marilyn Sypriano (shortstop), Gloria May (first base), Kay Rich (catcher), Jeanne Contel (third base), Ginny Busick (pitcher), Pat Richmond (right field), Dottie Stolze (center field) and Veryl Ward (left field).

The Fresno Rockets were a very impressive team and three-time national champions. They came into the final championship game as the defending champions, having won the title in 1957. This was a much-anticipated game featuring two major superstars and an upcoming superstar who was creating a lot of buzz, especially in Connecticut.

The Fresno Rockets were led by superstar Kay Rich, who was a versatile player, starring at shortstop, catcher and first base. Kay appeared in eight ASA national championships in which she batted .371 and had a fielding percentage of .974. Kay Rich was named as an All-American eight times and was MVP in 1954.

The Brakettes, however, felt good about their chances of winning the championship, mainly because they had their ace pitcher, "Blazing Bertha" Ragan, on the mound. The Brakettes also featured a teenage phenom by the name of Joan Joyce.

Joyce began the game at first base. When Ragan injured herself running to field a bunt with one out in the top of the third inning, it was Joan Joyce who came to the rescue to replace Ragan on the mound for the remainder of the game. Undaunted by the fact that she had never pitched in a national championship game, Joyce came on in relief and dazzled the Fresno's players by pitching a very impressive no-hitter for the final innings. The Brakettes won the game and the championship 1–0, courtesy of a dramatic solo inside-the-park home run by Mary Hartman in the seventh inning. Bertha Ragan was voted the MVP of the tournament. After the game, World All-Star selections went to Micki Macchietto, Beverly Mulonet and Bertha Ragan. All-Star Honorable Mention selections went to Jo-Jo Ottaviano, Joan Kammeyer and Joan Joyce. The 1958 national championship was the first of many for the Brakettes. Most notably, the 1958 championship game raised national awareness and acclaim for the young Brakettes phenom Joan Joyce.

The following year, Edna Fraser's bases-loaded single led the Brakettes to the 1959 National Championship title. In that tournament, the Ragan-Joyce duo pitched six straight shutouts. In the championship game, Ragan dueled Louise Mazzucca in a 0–0 tie leading to the ninth inning. Suddenly, Fraser's run-scoring single led to the Brakettes' championship title. The following year, the Brakettes posted six straight playoff victories. Ragan outdueled Mazzucca in the championship game, and the Brakettes won the 1960 championship and their third straight national title.

In the 1961 national tournament, Joan Joyce turned in one of the most spectacular performances in the history of women's softball. As noted earlier,

Brakettes, 1958. *Courtesy of Brakettes Softball Photo Archive.*

Joyce pitched an unbelievable 33 2/3 innings and struck out 67 batters—all in one unforgettable day. The third game that day turned out to be a grueling 19-inning contest that didn't end until 3:30 am the next day. A fluke "hit" by the Whittier Gold Sox batter pushed across the winning run for the California team. In the epic 19-inning game, the Brakettes outhit the Whitter team but stranded 18 batters in the contest. It was a heartbreaking game for the Brakettes, especially for Joyce, who struck out 40 batters in that one contest. For her heroics, Joyce was awarded the MVP of the tournament. Two years later, the Brakettes won the 1963 crown and their fourth national championship title by virtue of Micki Macchietto's dramatic inside-the-park home run against Portland (OR) in the eighth inning.

The Brakettes, minus Joan Joyce, set off on a forty-two-thousand-mile worldwide tour in 1965. Representing team USA, the Brakettes were upset by team Australia in the first ISF Women's World Championship, which was held in Melbourne, Australia. As part of the tour, the Brakettes also played in Holland, Calcutta, Paris, Formosa, New Delhi, Frankfurt, London and Hong Kong. While in Australia and Holland, the Brakettes conducted softball clinics.

After an outstanding career with both the Orange Lionettes and the Brakettes, Bertha Ragan (Tickey) announced that she would retire after the

1967 season. The announcement was made on October 7, 1966, during an Exchange Club luncheon in which Bertha Ragan was the featured speaker. At the luncheon, Bertha reminisced about her childhood in Dinuba, California: "I lived on a farm with six brothers, and the nearest girl was ten miles away. So I played a lot of baseball with the boys and learned how to be competitive at a young age." The pitching staff of Ragan, Joyce, Donna Lopiano and Donna Hebert in the mid-1960s was widely recognized by softball experts at the time as the greatest mound staff in women's softball history.

The amazing Brakettes posted an unprecedented 57-0 record in 1971, en route to the team's eighth national title. As former Brakette Linda Finelli recalled,

> *1971 was my rookie year with the Brakettes. We had an awesome team and finished with an undefeated 57-0 record that season. I met Joan Joyce when I was twelve years old and living in Waterbury. Joan was kind enough to drive me to Brakettes games in Stratford. I always dreamed of playing with the Brakettes. My dream did come true when I was twenty years old, making the team and playing with Joan and the Brakettes from 1971 through 1974. Those were truly magical years for me. It doesn't get any better than that! I feel blessed to have played with the best.*

The team had their remarkable winning streak of 72 straight victories snapped early in 1972.

On Saturday, June 17, 1972, the Brakettes set off to participate in the first Intercontinental Women's Softball championship, which took place in Reggio Calabria, Italy. The tournament, which was held between June 18, 1972, and June 25, 1972, was similar to the Pan Am games and was a forerunner to the upcoming International Women's World Championship tournament, which took place in 1974. The Brakettes won the 1972 Championship title on Sunday, June 25, 1972.

Varner Stadium (constructed 1934) in Orlando, Florida, was the first U.S. facility built specifically for softball. It was at this stadium that the Brakettes sought to win their fourth straight national title in 1974, before a sold-out crowd. However, the path to winning the 1974 championship was difficult. The Brakettes had found themselves in the losing bracket and desperately needed two straight wins against a tough Sun City Saints team. Enter Joan Joyce. The Brakette phenom was called upon to pitch both ends of a twin bill—and the "Waterbury Wizard" delivered in grand fashion. The comeback began with Joyce leading the Brakettes to a 1–0 win over Sun City

in a contest that lasted fifteen innings. The Brakettes' Irene Shea tripled in the fifteenth inning, and Kathy Elliot followed with a single to drive in the only run of the game. This set up the championship game on Saturday, August 31, 1974, between the same two teams.

In the pressure-packed championship game that same day, Joan came through again. Joyce pitched brilliantly to lead the Brakettes to another 1–0 win against Sun City. Peggy Kellers singled home Willie Roze in the tenth inning to score the only run in that contest to win the championship for the Brakettes. With everything on the line and in a high-pressure situation, Joan Joyce pitched twenty-five scoreless innings that one day.

All told, Joyce pitched a total of seventy scoreless innings in the national tournament. The only run scored on her was on a disputed interference play against the Indianapolis Comets in their game on August 27, 1974. The interference call was made in the fifth inning when Diane Bremermann of the Comets collided with Irene Shea while rounding third base. Even though Bremermann was called out at home plate, the umpire ruled interference against Shea, allowing the winning run to score. After that one run was scored, Joan pitched sixty consecutive scoreless innings, culminating with her outstanding performance in the championship game. For her amazing achievements in the 1974 national tournament, Joan Joyce earned the Most Valuable Player award.

The national championship tournaments of the 1960s and 1970s hosted by the Brakettes in Stratford, Connecticut, were the most successful ASA tournaments, averaging seventy thousand fans and establishing Stratford as the "Capital of the Softball World." As of this writing, the Brakettes have won a total of thirty-six national championships. This includes twenty-eight National ASA Championships, including eight straight (1971 through 1978), plus eight WMS (Women's Major Softball) National Championships (2010–2016, 2018). The thirty-six national championship wins are a feat unparalleled in sports history—it can be argued that the Brakettes are perhaps the greatest organized sports franchise in history. Their thirty-six ASA/WMS National Championships even surpass MLB's New York Yankees, which have a total of twenty-seven World Series titles. During the period from 1958 to 1993, the Brakettes were out of the championship round only twice, winning twenty-three national titles and placing second eleven times during that period.

While the Brakettes' success drew some players from out of state, there have been many home-grown Connecticut players who played for the team in the 1950s, '60s and '70s, including Joan Joyce (Waterbury), Donna

Lopiano (Stamford), Linda Finelli (Waterbury), Carol LaRose (New Britain), "Micki" Macchietto Stratton (Middletown), Beverly Mulonet (Wolcott), Ann DeLuca (West Haven), Marie Ottaviano (Stamford), Gladys Crespo (Bridgeport), Peggy Kellers (Stratford), Mary and Madeline Hartman (New London), Willie Roze (Hamden), Edna Fraser (Guilford), Barbara Abernethy (Bridgeport) and Joan Wallace (Stratford).

In 2016, the Brakettes organization celebrated their seventieth season of competition. The most recent Brakettes women's softball teams, under the guidance of manager John Stratton, also have had a great deal of success. The Brakettes finished the 2018 regular season with a 40-3 record. Between 2010 and 2016, the Stratford club won seven straight Women's Major Softball (WMS) championships.

The Brakettes have played throughout the entire United States and have toured over twenty-five countries, where the players and coaches worked as ambassadors of women's softball, holding instructional clinics in the hope of spreading the sport of softball across the globe.

With a 91 percent winning percentage (3,895 wins, 405 losses), 3 World Championships, 36 National ASA/WMS Championships, 23 National Hall of Fame members and 11 Olympians, the Brakettes are clearly the no. 1 name in women's fast-pitch softball history.

Brakettes manager John Stratton and associate head coach Kristine Botto Drust. *Courtesy of Kathy Gage.*

Left to right: Joan Joyce, Jim Bouton and Frank Gifford (NY Giants star and CBS broadcaster) during filming of a televised special. *Courtesy of Brakettes Softball Photo Archive.*

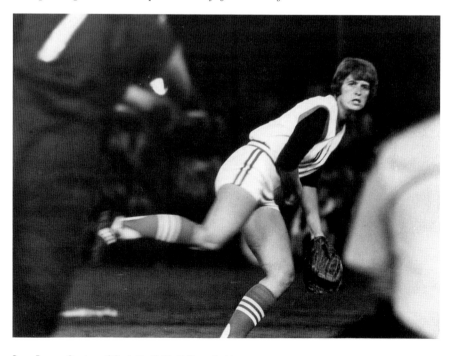

Joan Joyce. *Courtesy of Brakettes Softball Photo Archives.*

Left: Brakettes in Paris, June 1972, en route to the Intercontinental Women's Softball championship in Reggio Calabria, Italy. *Courtesy of Linda Finelli*. *Right*: Brakettes touring the Caribbean. *Brakettes Softball Photo Archive*.

Brakettes participated in many softball clinics. Bill Keeson (*left*), Micki Macchietto Stratton (*third from right*), Joan (*second from right*), Vin Cullen (*right, Brakettes coach*). *Courtesy of Brakettes Softball Photo Archive*.

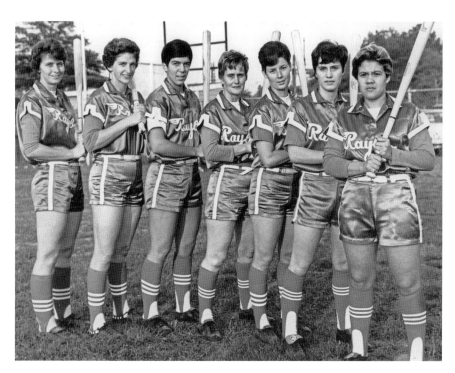

Brakettes batters. *Left to right*: Joan, Lou Albrecht, Donna Lopiano, Carol LaRose, Sharron Backus, Debbie Paul, Glades Crespo. *Courtesy of Brakettes Softball Photo Archive.*

Brakettes owner William Simpson (*standing, fourth from right*) treated his team to a two-day stay in Las Vegas after winning the national championship. Joyce is seated third from left. *Courtesy of Brakettes Softball Photo Archive.*

The crowd awaiting national champions Raybestos Brakettes, 1958. *Courtesy of Brakettes Softball Photo Archive.*

Left: Brakettes land via Canada Airlines as part of a tour. *Right*: Brakettes on way to Clearwater, Florida, for the 1956 World Tournament; *left to right*, Bertha Ragan Tickey, Mary Jane Hagan, Ann Adams, Brenda Reilly, Joan Joyce, Joan Kaymmayer. *Both courtesy of Brakettes Softball Photo Archive.*

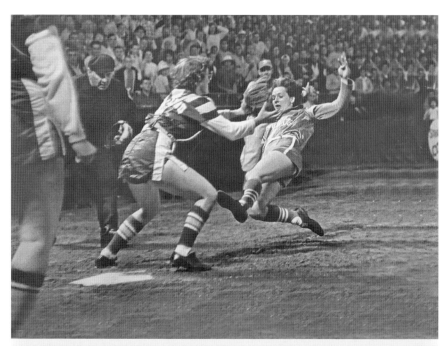

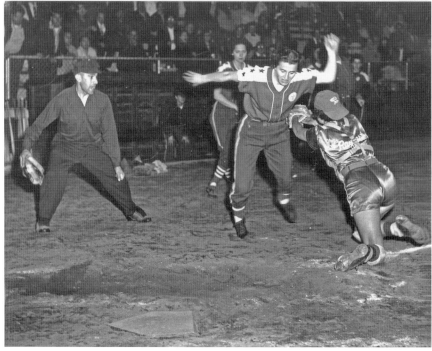

This page, top: Brakettes, 1947. Note: At that time, pitchers would dress all in black. *Courtesy of Annette Verespy Kalafus.* Bottom: Brakettes, 1956. *Courtesy of Brakettes Softball Photo Archive.*

Opposite: Micki Macchietto sliding home (*top*) and tagging runner out at home plate (*bottom*). *Both courtesy of Brakettes Softball Photo Archive.*

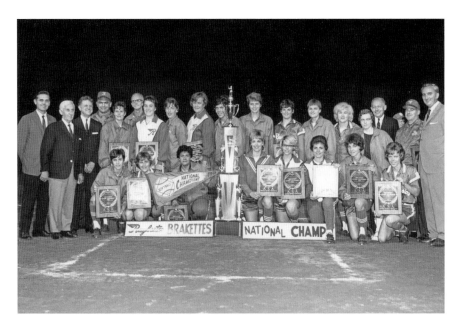

Brakettes, 1968 champions. *Courtesy of Jim Fetter.*

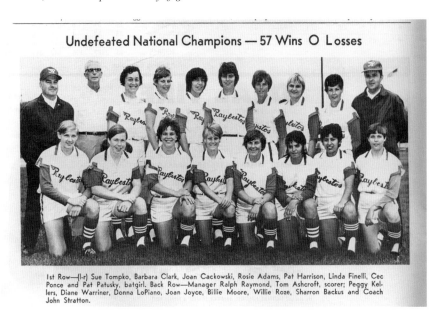

Brakettes undefeated, team photo 1971. *Courtesy of Brakettes Softball Photo Archive.*

Powerhouse Orange Lionettes 1970, Brakettes rivals, featuring Nancy Welborn and Nancy Ito. *Courtesy of Softball National News, photo by Stormy Irwin.*

RAYBESTOS ROBINS

1961–1971

The Raybestos Robins were the farm team of the Brakettes in the 1960s and '70s. The team played in the Connecticut Girls (Women's) Softball League. The Robins were made up of mostly area high school talent, given excellent instruction and prepared to play for the Brakettes when needed.

The Raybestos Robins who were called up to play for the Raybestos Brakettes include: Pat Balazsi; Elaine Biercevicz, Joan Bonvicini, JoAnn Cackowski, Barbara Clark, Linda Finelli, Lou Gecewicz, Karen Hovan, Peggy Kellers, Debbie Paul, Frances Spellman, Barbara Stawski, Stephanie Tenney, Sue Tomko and Cathy Turnbull.

RAYBESTOS CARDINALS

The Men's Raybestos team of Stratford won the national tournament in 1955, 1958, 1969, 1970, 1972 and 1976. The team were runners-up in 1956, 1962 and 1971. The Cardinals featured the very talented pitcher Johnny Spring.

After the Raybestos plant closed, the men's softball team eventually moved to Franklin, Illinois.

RAYBESTOS MEMORIAL FIELD AND FRANK DELUCA HALL OF FAME FIELD

From 1947 to 1987, the Brakettes played at Raybestos Memorial Field in Stratford, Connecticut. In 1988, the Brakettes moved to a Stratford field named after the Avco Lycoming, Textron Lycoming and AlliedSignal factories in the town. This field was then renovated in 1997 and renamed the Frank DeLuca Hall of Fame Field. The seating capacity is 1,880.

Frank "Hooks" DeLuca was a pitcher for the men's slow-pitch team in Stratford, Connecticut. He was a graduate of Harding High School (Bridgeport, Connecticut). DeLuca was a member of Harding High's Hall of Fame. The team was sponsored by Stratford's Avco Lycoming factory. DeLuca was inducted into the National Softball Hall of Fame in 1974.

Frank DeLuca Hall of Fame Field was host to the ASA Women's Major Fastpitch championship tournaments in 1993, 1996, 1999, 2002 and 2005. In addition, DeLuca Field and the Brakettes hosted the USA Olympic Teams in the summers of 2000, 2004 and 2008. Overflow crowds of 3,500 for each event cheered on their Olympic home teams. Also, DeLuca Field is home to a number of other softball teams, leagues and tournaments.

Joan standing in front of scoreboard at Raybestos Memorial Field. *Courtesy of Joan Joyce.*

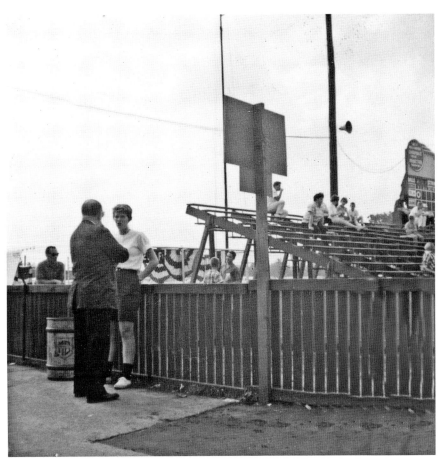

Above: Joan Joyce at Raybestos Memorial Field (Stratford, Connecticut) in August 1962. *Courtesy of Brakettes Softball Photo Archive.*

Left: Joan and Brakettes coach John Stratton behind DeLuca Field. *Courtesy of Brakettes Softball Photo Archive.*

Left: Joan Joyce watching Brakettes at DeLuca Field (Stratford, Connecticut), 2005. *Courtesy of Kathy Gage.*

Below: Brakettes' National Softball Hall of Fame members. *Courtesy of Kathy Gage.*

Brakettes Hall Of Famers attending 2011 Reunion

Top Row: Joan Joyce, Barbara Reinalda, Pat Dufficy, Peggy Kellers

Bottom Row: Diane Schumacher, Micki Stratton, Willie Roze, Rosie Adams, Lou Albrecht

NATIONAL SOFTBALL HALL OF FAME

USA Softball owns and operates the National Softball Hall of Fame, dedicated on May 26, 1973, in Oklahoma City. The Hall of Fame has 337 members, including players, managers, umpires and others.

The Brakettes of Stratford, Connecticut, are well represented in the National Softball Hall of Fame. The following is a list of members of Brakettes who have been inducted into the Softball Hall of Fame:

Inducted	Name	Hometown	Position	Played for Brakettes
1969	Rosemary "Micki" Stratton	Stratford, CT	Catcher	1956–65
1972	Bertha Ragan Tickey	Dinuba, CA	Pitcher	1956–68
1975	Kathryn "Sis" King	Cincinnati, OH	Outfield	1965–67
1976	Pat Harrison	Vancouver, B.C., Canada	Outfield	1964–72
1981	Shirley Topley	Hondo, Alberta, Canada	First Base	1963–64
1983	Joan Joyce	Waterbury, CT	Pitcher	1954–63, 67–75
1983	Donna Lopiano	Stamford, CT	Pitcher	1963–72
1985	E. Louise Albrecht	Illmo, MO	Pitcher	1969
1985	Sharron Backus	Anaheim, CA	Shortstop	1969–75
1985	Willie Roze	Hamden, CT	Outfield	1966–75
1986	Peggy Kellers	Stratford, CT	Catcher	1964–74
1987	Rose Marie "Rosie" Adams	Escondido, CA	Second Base	1971–74
1992	Diane Schumacher	West Springfield, MA	First Base	1976–86
1996	Kathy Arendsen	Zeeland, MI	Pitcher	1978–92

Inducted	Name	Hometown	Position	Played for Brakettes
1997	Gina Vecchione	New Rochelle, NY	Outfield	1978–89
1999	Barbara Reinalda	Lakewood, CA	Pitcher	1976–94
2005	Pat Dufficy	Trumbull, CT	Utility	1977–83, 85–95, 97
2006	Sheila Cornell	Phelan, CA	First Base	1988–94
2006	Dot Richardson	Orlando, FL	Shortstop	1984–94
2009	Allyson Rioux	Stamford, CT	Second Base	1979–88
2011	Lori Harrigan	Las Vegas, NV	Pitcher	1993–94
2013	Lisa Fernandez	Long Beach, CA	Pitcher / Third Base	1990–94
2015	Sue Enquist	San Clemente, CA	Meritorious Service	1976–81

Brakettes non-players inducted are: William S. Simpson (Brakettes' founder), Vincent "Wee" Devitt (manager '62–'67), Joseph T. Barber (former general manager), and Ralph Raymond (manager '68–'94). Also, Bob Baird (general manager) received the Connecticut Hall of Fame Service Award in 2017.

TO TELL THE TRUTH

My name is Jean Joyce.

On Tuesday, November 19, 1974, Joan Joyce appeared on the hit CBS TV show *To Tell the Truth*. At the introduction of the show, the host mentioned several of Joan's achievements in softball. He could not possibly detail all of her accomplishments—after all, it was only a half-hour show.

Joan recalls several funny occurrences when she was on the show: "When the announcer asked 'What is your name please,' the two 'imposters' and I were all supposed to answer 'My name is Joan Joyce.' However, the first person must have been nervous because she answered the question 'My name is Jean Joyce.' The other 'imposter' and I looked at each other and quickly figured out we both better answer the same way and state our first name as Jean instead of Joan. Otherwise, we would have immediately given away the secret that she was an imposter. Ironically, my mom's name was Jean."

Joan explained further, "Before the show aired, I was told that I had to 'tell the truth' for each question asked. [The imposters were allowed to lie.] The question that won the game for me was 'Do you ice your arm after every game?' I told the truth that I never iced my arm after the games. Well, the panelists all eliminated me as the real person, because they each said they didn't know how a pitcher could throw that many pitches and *not* ice their arm. So they incorrectly picked one of the imposters as the 'real' Joan Joyce."

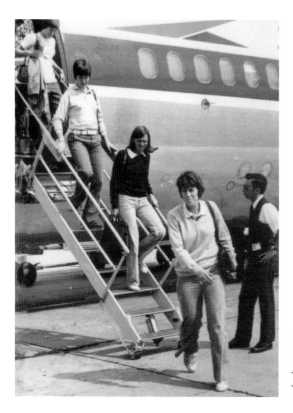

The Falcons have landed. *From top to bottom*: Snooki Mulder, Joyce Compton, Jane Blalock, Joan Joyce. *Courtesy of Joan Chandler.*

Joan further explains, "Joe Garagiola was the host on the show. Joe was a major league catcher for the St. Louis Cardinals and other teams. After I was finally identified as the 'real' Joan Joyce, Garagiola said he brought his catcher's mitt to the show and asked if he could catch a few of my pitches. Because I was in a pants suit and also in a studio, I decided to let up on my pitches. He then asked me 'Joan, what pitch are you going to throw?' I told him he had a choice of either a rise ball or a drop. He told me to throw my rise ball. I almost killed him with the pitch! He fell over backwards trying to catch the pitch and the ball went off his glove and flew towards the cameramen! He then went over and got his catcher's mask and asked me to throw him another rise ball. The next pitch knocked him over again! I had fun on that show."

THE FALCONS HAVE LANDED

Our strong points are pitching, hitting, and fielding.
Our strength is that we have very few weaknesses, and we win.
—Irene Shea, Connecticut Falcons, 1976–79

At last! In a historic chapter in women's sports, the Women's Professional Softball league (WPS) was formed in 1976 by co-founders Billie Jean King, Joan Joyce and Dennis Murphy.

As part of the WPS, Connecticut saw the formation of its first professional softball team for women, the Connecticut Falcons. The player-coach of the Falcons was their superstar, Joan Joyce. Joan was also co-owner of the team along with Jane Blalock and Billie Jean King. NBC and ESPN (Bristol, CT) televised several of the Falcons' games. The Falcons practice field was in Plainville, Connecticut, and the players worked out for four hours three days a week. The home office of the Connecticut Falcons was in Meriden, Connecticut.

The Connecticut Falcons teams included such standout players as: Joan Joyce, Willie Roze, Sue Tompko, Claire Beth "C.B." Tomasiewicz, Kathy Neal, Joyce Compton, Donna Terry, Sandy Fischer, Cecilia Ponce, Snooki Mulder, Fran Sarullo, Irene Shea, Lucille "Lu" Cecewicz, Sandra Hamm, Annette Fortune, Judy Martino, Sharron Backus, Kathy Elliott Kryger, Kathy Stilwell, Karen Gallagher, Kathy Veroni, Gloria Becksford, Rayla Jo Allison, Barbara Iverson, Audrey "Audi" Kujala, Margaret Rebenar, Jackie Ledbetter, Linda McMorran, Ginny Walsh and Brenda Reilly (coach).

The WPS league consisted of a number of powerhouse teams and many future hall of famers. Sandy Fischer once summed up her experience as a Connecticut Falcon and the WPS this way: "It was a magical time in the history of women's sports. We were playing with the best of the best."

The one player who rose above everyone else and earned the respect of her teammates, rivals and coaches was Joan Joyce. In recognition of Joan's pitching dominance, a WPS league decision was made to move the pitching mound back four feet. This was known as the "Joan Joyce Rule." The rationale behind the league's decision to extend the pitching mound to forty-four feet (as opposed to forty feet) was that by doing so, Joyce would be more "hittable," thus providing an opportunity for other teams to score runs against Joyce and possibly create more parity in the league. But Joan welcomed this challenge. Once she adapted to the mound change, Joyce was just as dominant as when she was a Brakettes pitcher.

Behind Joan Joyce's brilliant pitching, the Connecticut Falcons won the WPS league championship in *all* four years of the league's existence.

The Falcons take the field. *Courtesy of Joan Chandler.*

Falcons' Joan Joyce at bat, with hall of famer Nancy Ito behind the plate. *Courtesy of Joan Joyce.*

Falcons' introduction. *First row, left to right*: Billie Jean King, John Salerno, Joan Joyce; *second row*: unidentified, Fred Landau, Dick Iradi, Joe Joyce Jr. *Courtesy of Joan Chandler.*

Joan discusses Falcons team strategy with coach Brenda Reilly. *From the* New Haven Register.

Joan Joyce was head and shoulders above everyone else in the Women's Professional Softball league. *Courtesy of Joan Chandler.*

Top: Joan slides safely into third base. *From* Winning Softball *by Joan Joyce and John Anquillare; used with permission from Joan Joyce. Bottom*: Falcons' Kathy Stilwell flying into second base. *Courtesy of Joan Chandler.*

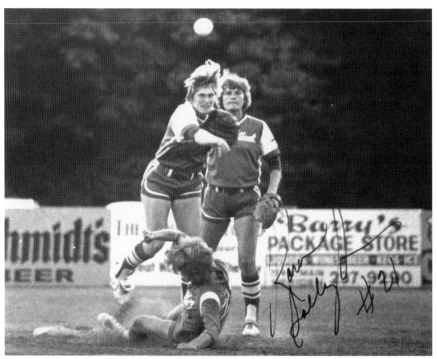

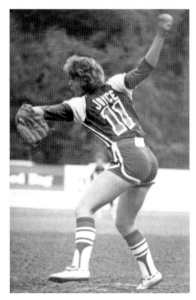

Top: Falcons' Karen Gallagher (*throwing*), Willie Roze (*background*). *Courtesy of Joan Chandler.*
Bottom, left: Joan Joyce as a Connecticut Falcon. *Courtesy of Joan Chandler.*
Bottom, right: Joan Joyce pitching, no. 11. *Courtesy of Joan Chandler.*

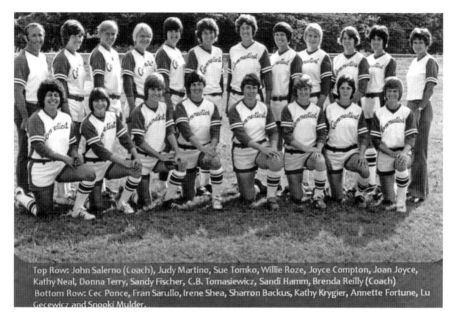

Top Row: John Salerno (Coach), Judy Martino, Sue Tomko, Willie Roze, Joyce Compton, Joan Joyce, Kathy Neal, Donna Terry, Sandy Fischer, C.B. Tomasiewicz, Sandi Hamm, Brenda Reilly (Coach)
Bottom Row: Cec Ponce, Fran Sarullo, Irene Shea, Sharron Backus, Kathy Krygier, Annette Fortune, Lu Gecewicz and Snooki Mulder.

Connecticut Falcons, 1976. *Courtesy of Joan Chandler.*

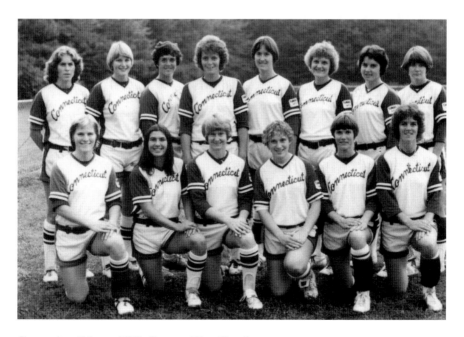

Connecticut Falcons, 1979. *Courtesy of Joan Chandler.*

The Connecticut Falcons at the Great Wall of China. *Courtesy of Joan Chandler.*

TO CHINA WITH GLOVE

This is more than a sporting event, this is a matter of history.
—John Salerno, former general manager of the Connecticut Falcons and first
commissioner of the Women's' Professional Softball League

THE CONNECTICUT FALCONS
HISTORIC TRIP TO CHINA

John Salerno, the general manager of the Connecticut Falcons at the time, sent a letter in 1977 to the All-China Sports Federation proposing that the Connecticut Falcons visit China for an exhibition series. He did not receive a response to this or subsequent letters. Suddenly, in March 1979, Salerno was notified that the Falcons were invited to China to play a half-dozen "friendship games." And so, on Monday, May 14, 1979, the three-time world champion Connecticut Falcons softball team left San Francisco and embarked on a fourteen-day, six-game goodwill tour of China. The team's sponsor was Bic Pens, with headquarters in Milford, Connecticut, and Brenda Reilly was the Falcons coach. Prior to leaving for China, the Falcons team was able to practice for only two days.

During the fourteen-day period, the Falcons played games against skillful Chinese teams in Peking (Beijing) and Lanzhou (Lanchow). The fifteen-member Falcons were the first professional U.S. athletic team ever invited to compete on the mainland. With the temperature staying in the

90s, games were played in front of crowds of forty-five thousand, and thousands of other fans had to be turned away. *People* magazine sent a reporter to China to cover the Falcons games. The team's motto was "To China with Glove."

To herald the Falcons' entrance onto the playing field, the stadium's PA system blared out "The Wedding March" ("Here Comes the Bride") instead of the U.S. National Anthem. The signature music was subsequently changed to "Auld Lang Syne" and "The March of the Toy Soldiers." There appeared to be some reluctance to play the U.S. National Anthem. A very excited translator introduced Joan Joyce to the 45,000 fans as "the President of the United States." She quickly corrected Joyce's introduction as the "Vice-Premier of Softball." The Falcons not only competed in softball against Chinese teams but also played friendly games of basketball while in China. Just as important, the Connecticut Falcons served as ambassadors for their country, spreading good cheer and sharing their knowledge of American sports during clinics in China.

All six contests were won by the Falcons, but the games were fairly close. The games played were as follows:

- Falcons beat the Peking team 3–1. Game played in Peking (Beijing). In this game, the Falcons were losing 1–0 going into the final seventh inning, when Joyce began a rally leading to a 3–1 Falcons win.
- Falcons beat the Tientsin team 8–2.
- Falcons beat the Chinese All-Stars 3–0.
- Falcons beat the Lanzhou (Lanchow) team 3–2. Game played in Lanzhou (Lanchow).
- Falcons beat the Shanghai team 3–1. Game played in Lanzhou (Lanchow).
- Falcons beat the Chinese National All-Star team 1–0. Game played in Lanzhou (Lanchow).

The Connecticut Falcons played their final game in China on Friday, May 25, 1979. In this game, Joan Joyce barely missed pitching a perfect game against the Chinese National All-Star team in Lanzhou (Lanchow) China. The only batter to reach base for the Chinese team was by a walk in the third inning. The no-hit game was played in front of an overflow crowd of forty-five thousand in Lanzhou. It was the final contest of the Connecticut Falcons' two-week tour of China.

Once the China tour was completed, the Connecticut Falcons returned to the United States on Monday, May 28, 1979. The team landed in St. Louis, Missouri, where they began defense of their WPS title beginning on Wednesday, May 30, 1979.

China welcomes the Connecticut Falcons, May 1979. *Courtesy of Joan Chandler.*

Falcons entering the stadium in China before a throng of fans. *Courtesy of Joan Chandler.*

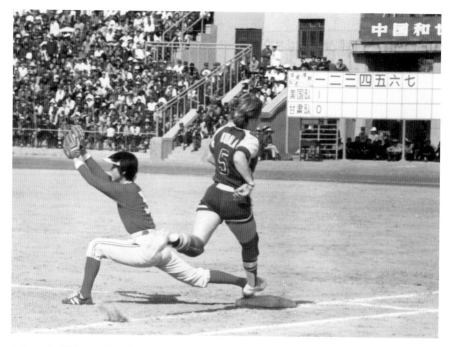

Falcons in China, safe at first. *Courtesy of Joan Chandler.*

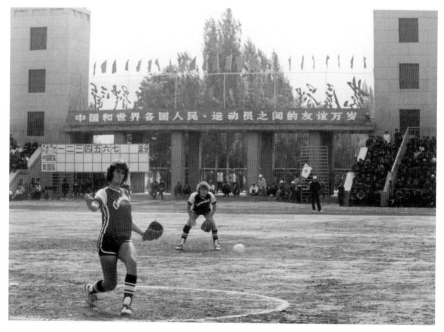

Joan Joyce pitching in China. *Courtesy of Joan Chandler.*

Joan at Great Wall of China. *Courtesy of Joan Chandler.*

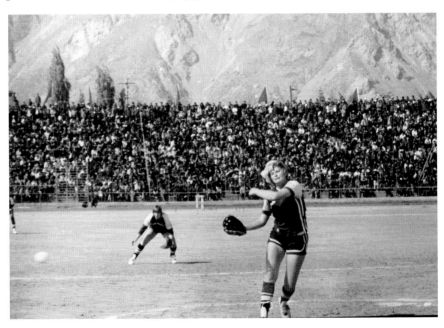

Sandy Fischer. In China, the Falcons played in front of massive crowds of fifty to sixty thousand fans. *Courtesy of Joan Chandler.*

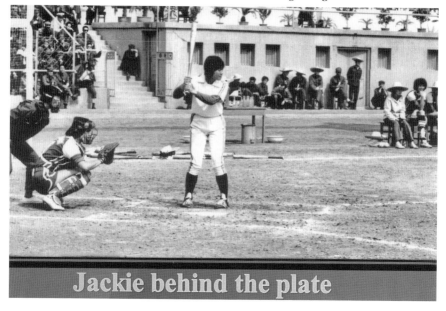

Jackie behind the plate

Above: Falcons in China (catcher Jackie Ledbetter). *Courtesy of Joan Chandler.*

Left: Connecticut Falcons. Softball at Great Wall of China. *Courtesy of Joan Chandler.*

Joan and Snooki Mulder at the Great Wall of China. *Courtesy of Joan Chandler.*

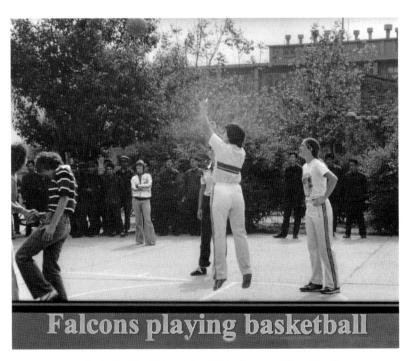

Falcons playing basketball in China, May 1979. *Courtesy of Joan Chandler.*

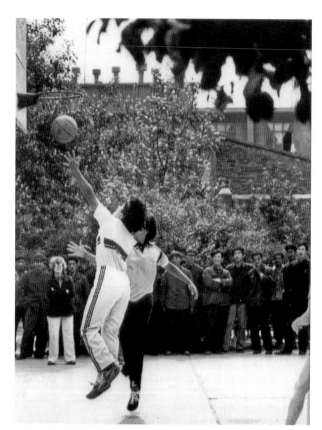

Right: Falcons shooting hoops against hometown rivals in China. *Courtesy of Joan Chandler*.

Below: Joan walking the Great Wall of China. *Courtesy of Joan Chandler*.

Left: Joan Joyce and coach Brenda Reilly in China. *Courtesy of Joan Chandler.*

Below: The Connecticut Falcons and the Chinese teams. *Courtesy of Joan Chandler.*

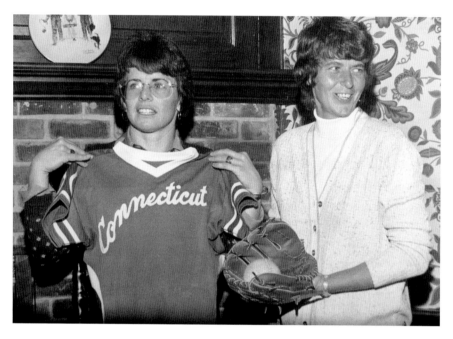

Billie Jean King and Joan Joyce introducing the WPS league and the Connecticut Falcons, April 1976. *Courtesy of Joan Chandler*.

THE WPS PAVES THE WAY

WPS is the first women's professional league, and the first to be owned by women athletes. I guess we're pioneers. We're working to pave the way for girls and women in years to come.
—*Billie Jean King, tennis great and co-founder of the WPS*

The Women's Professional Softball League (WPS or IWPS) was formed in 1976. The co-founders of WPS were tennis star Billie Jean King, pitching icon Joan Joyce and sports entrepreneur Dennis Murphy. The formation of the league was announced by Billie Jean at a press conference on April 6, 1976, in Meriden, Connecticut.

According to the WPS 1976 pamphlet: "The WPS is the first opportunity for women to perform as professionals on a team basis, the first chance to reap the rewards professional male athletes have enjoyed since Babe Ruth made our national pastime. Women's Professional Softball stands at the forefront of that new coming generation. If we may steal a line from the Virginia Slims: 'You really have come a long way, Baby!'" The 1976 pamphlet further states that the formation of the WPS league aims to "revolutionize the concept of sports [for women], offering women equality as athletes."

In that same WPS press conference, Billie Jean King stated, "It's not only the first women's professional league, and the first to be owned by women athletes, but it is also the future of sports for women....We're not only working for ourselves but to pave the path for girls and women in years to come."

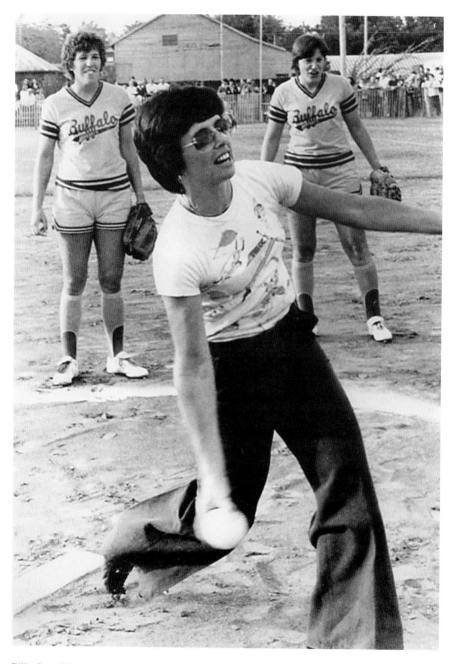

Billie Jean King throws out first pitch to open up the WPS season. *Courtesy of Joan Chandler.*

The WPS began as a two-division league consisting of ten teams. The Eastern League consisted of the Connecticut Falcons, the Buffalo Breskis (Bisons), the Chicago Ravens, the Michigan Travelers and the Pennsylvania Liberties. The Western League consisted of the San Diego Sandpipers, the San Jose Sunbirds (Rainbow), the Santa Ana Lionettes, the Southern California Gems and the Phoenix/Arizona Bird. Several other teams joined the league in the following years, including the Bakersfield Aggies, the St. Louis Hummers, the Edmonton Snowbirds and the New York Golden Apples.

Each team played a 120-game schedule (60 home and 60 away games), including 60 doubleheaders. The season lasted from May until September, concluding with championship playoffs and the World Series. The first WPS games were played on May 28, 1976: Michigan vs. Southern California, Pennsylvania vs. Chicago, Santa Ana vs. Connecticut and San Jose vs. Connecticut. The first All-Star game was played on July 28, 1976, in Michigan.

As a sign of the times, player contracts ranged from $1,000 to $3,000 per year.

The First Women's Professional Softball (WPS) World Series, 1976

The culmination of the first Women's Professional Softball season was the 1976 World Series. On August 22, 1976, the Connecticut Falcons qualified for the WPS World Series after sweeping the Chicago Ravens in three straight games, winning the Eastern League title. Their opponents were the San Jose Sunbirds. The Sunbirds won the Western League playoff series by sweeping the Santa Ana Lionettes in three straight games. The first three games of the World Series took place at Falcon Field in Meriden, Connecticut. The next two games, if needed, would be played at San Jose's stadium.

Connecticut and San Jose both led their divisions since the beginning and swept through their respective division playoffs in three straight games. Therefore, it was fitting that they would meet in the first WPS World Series. They had met eight times during the regular season, each team winning four games. Previously, they met for the 1975 ASA National Championship. At the time, San Jose was known as the Santa Laurels, with the Falcons winning the championship title.

The standouts for the Sunbirds were centerfielder Diane Kalliam, pitcher Charlotte Graham and Mary Lou Pennington. The team played all four years that the league was in existence.

Game 1—Connecticut 3, San Jose 0

Falcon Field (Meriden, Connecticut) was the site of game 1 of the 1976 WPS World Series. Joan Joyce was the starting pitcher for the Falcons. Her regular season record was 39-2, plus she had a win and a save in the playoffs. Charlotte Graham, owner of a 23-11 mark for the season and a playoff win, took the mound for San Jose. Both pitchers allowed an average of less than one run per game for the entire season.

Diane Kalliam led the game off with a single, but then she was quickly thrown out at second base by the Falcons catcher Judy Martino. Then Joan Joyce went to work and retired seventeen San Jose batters in a row. The only other hit Joyce allowed was Kalliam's second hit in the seventh. Joan helped her own cause by lining a two-run double into the left field corner in the fourth. The Falcons added another run in the fifth. The Falcons went on to win the first WPS World Series game 3–0, behind Joan Joyce's two-hit gem.

Game 2—Connecticut 4, San Jose 2

In game no. 2, lefty Sandy Fischer faced off against the Sunbirds' Bonnie Johnson. Fischer won 11 games during the regular season and posted an earned run average (ERA) of 1.01. Johnson had a 25-8 record for the season and an impressive 0.80 ERA.

The Falcons wasted no time in scoring their first run when Irene Shea homered over the right field fence in the first inning. In the fourth inning, Snooki Mulder singled home Judy Martino and Kathy Stillwell. Several innings later, Kathy Krygier doubled home Sharron Backus in the bottom of the sixth to increase the Falcons lead to 4–0. San Jose mounted a rally in the top of the seventh. Carol Salsbury and Mary Lou Pennington singled, and both runners scored on a wild throw to first base off the bat of Marilyn Burnett. However, Fischer settled down and retired eight of the next nine batters. This gave the Falcons a 4–2 win and a 2-0 game lead in the series.

Game 3—Connecticut 2, San Jose 1

Joan Joyce took the mound again for the Falcons in game 3 of the World Series. Her opposing pitcher was Marilyn Burnett. After Burnett was called for an illegal pitch in the bottom of the first inning, Manager Laura Malesh called in her ace Charlotte Graham in this important game for San Jose.

With the score knotted at 0–0 in the bottom of the fifth, Snooki Mulder lifted a long fly ball to centerfield scoring Backus, who was on third base. The Sunbirds tied the score at 1–1 on a home run by Cyndi Lilock.

A wild throw to home plate by a Sunbird infielder scored the winning run for the Falcons. The Connecticut Falcons won the game 2-1. The Falcons left for California with a comfortable 3-0 lead in the best-of-seven series.

Game 4—Connecticut 3, San Jose 0

Game no. 4 was played at San Jose Municipal Stadium with Fischer on the mound for Connecticut, facing the Sunbirds' Bonnie Johnson. In a nail-biter, the game went into extra innings with the score locked at 0–0. The Falcons' bats finally came alive in the top of the tenth inning. Willie Roze singled home two runners, and the Falcons added another run. The Sunbirds were retired in order in the bottom of the tenth, resulting in a 3-0 win. More importantly, the Falcons won the 1976 WPS World Series in four straight games, to become Connecticut's first world champions in any sport.

Just as she had been on hand for the first, historic pitch back on May 28 in Buffalo, Billie Jean King was in San Jose to present the Championship Cup to the Connecticut Falcons, her "favorite softball team."

Top: Joan proudly displays the 1976 champions banner. *Bottom*: Joan at podium after the Connecticut Falcons won the first Women's Professional Championship in 1976. *Both courtesy of Joan Chandler.*

WOMEN'S PROFESSIONAL SOFTBALL (WPS) WORLD SERIES, 1977

A Second Straight Falcons' Championship

The Connecticut Falcons finished the 1977 WPS regular season in first place with a 51-30 record. Their opponents in the 1977 World Series were the Santa Ana Lionettes.

Game 1—Santa Ana 7, Connecticut 3

Falcons' ace Joan Joyce started against her former Brakettes' teammate Donna Lopiano. Uncharacteristically, Joyce suffered her first ever World Series defeat as the Lionettes prevailed 7–3. Meanwhile, Lopiano scattered seven hits in pitching the distance. Debbie Van Deusen was the hitting star for the Lionettes, driving in four runs with a home run, a double and a single in five at-bats. Vickie Shneider also had three hits, including a double, in five at-bats.

Joyce Compton, Willie Roze and Audi Kujala combined for the Falcons' seven hits. Compton had two doubles and a single, Roze slammed a double and single to drive in a run and Kujala chipped in with a pair of singles. With their win, Santa Ana took a 1-0 lead in the series.

Game 2—Connecticut 4, Santa Ana 2

Joan Joyce was the hitting star in game 2, when she blasted a home run and a double, driving in three runs. Sandy Fischer and Donna Terry combined for a ten-hit, 4–2 victory and knotted up the series at one game apiece.

Game 3—Connecticut 5, Santa Ana 1

In game 3, Joan Joyce returned to her brilliant form, pitching a four-hit gem. Joyce also helped herself at the plate with a two-run single in the bottom of the second. The Falcons added three more runs in the fourth. Joan Joyce pitched the distance, allowing only a single run. With the win, the Falcons took a 2-1 series lead.

The Connecticut Falcons celebrating after winning the Women's World Championship. *Courtesy of Joan Chandler.*

Game 4—Connecticut 1, Santa Ana 0

Charlotte Graham and the Santa Ana Lionettes kept game 4 close by virtue of Graham's five-hitter. However, Donna Terry matched Graham with her own five-hitter and the Falcons managed to finally score a run leading to a 1–0 win and a championship.

WOMEN'S PROFESSIONAL SOFTBALL (WPS) WORLD SERIES, 1978

A Third Straight Falcons' Championship

The two-time defending champion Connecticut Falcons clinched the regular-season WPS crown with an outstanding 69-19 record. Their opponents for the 1978 WPS World Series were the St. Louis Hummers.

Game 1—Connecticut 5, St. Louis 2

The Falcons ace Joan Joyce took the mound in game 1, with another outstanding regular season record (18-1 regular, 0.69 ERA). Her opponent was Cindy Henderson of the Hummers, who had a great 22-8 record during the regular season.

Leadoff batter Kathy Stilwell got things started for the Falcons with a first-inning home run. The Falcons added another run in the third inning when Karen Gallagher singled home Audi Kujala. The Hummers answered with solo homers in the fourth and fifth innings by Pat Guenzler and Charlene Sennewald, tying the score at 2–2. The tie proved short-lived, however, as the Falcons scored three runs in the bottom of the sixth inning. In the inning, Willie Roze blasted a two-run triple to score Linda McMorran and Joyce. Roze then scored on a wild pitch by Henderson. Joyce pitched a strong four-hitter, striking out six while only allowing one walk.

Joan Joyce's performance allowed the Falcons to take a 1-0 lead in the series.

Game 2—Connecticut 3, St. Louis 1

The Falcons' Margaret Rebenar faced off against Margie Wright of St. Louis in game 2 of the World Series. Rebenar posted an 11-5 regular season record with a 1.77 ERA. Wright had a very fine 20-11 record in the regular season.

Singles by Willie Roze and Jackie Ledbetter in the second inning gave the Falcons a 1–0 lead. The Hummers bounced back to deadlock the score in the fourth when Bethel Stout singled and came all the way around to score on an infield error off the bat of Nancy "Boomer" Nelson.

Singles by Donna Terry and Joan Joyce, along with a St. Louis infield error, provided Rebenar with a 3–1 cushion.

As a result of the win, the Falcons took a 2-0 lead in the series.

Game 3—Connecticut 4, St. Louis 2

Game 3 was a must-win for the St. Louis Hummers. A loss would give the Falcons the 1978 World Series Championship. For this important game, St. Louis gave the ball to their ace Cindy Henderson. The Falcons countered

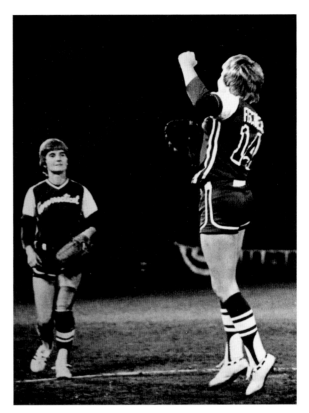

Right: A jubilant Sandy Fischer (*pitcher*) celebrates after posting the last out of the 1978 WPS World Series. Falcons' Irene Shea on left. *Courtesy of Joan Chandler.*

Below: Falcons, 1978. *Courtesy of Joan Chandler.*

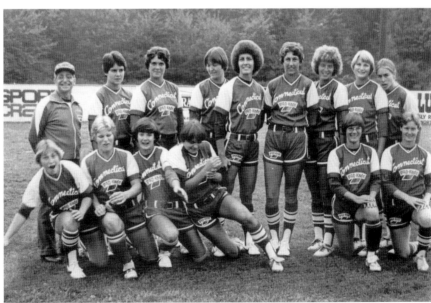

with southpaw Sandy Fischer, who posted a 12-6 regular season record with a 1.44 ERA.

Connecticut opened the scoring in the first inning when Stilwell walked, advanced to second on a wild pitch and scored on Linda McMorran's single. The Falcons then erupted for three runs in the fifth inning on a walk to Roze, singles by Rayla Jo Allison and Snooki Mulder and a three-run Compton double.

St. Louis finally got on the board in the sixth inning on a solo homer by Bobbi Mattingly. The Hummers added another run in the seventh on an RBI single by Stout. But that was their last scoring opportunity.

Fischer's ten-hitter bested St Louis and won game 3 and the 1978 championship.

WOMEN'S PROFESSIONAL SOFTBALL (WPS) WORLD SERIES, 1979

A Fourth Straight Championship

In a repeat of the 1978 WPS World Series, the Connecticut Falcons faced off against a tough St. Louis Hummers squad. St. Louis was a strong team blessed with power and speed. The Hummers were led by the pitching of Margie Wright and Cindy Henderson and the hitting of Pat Guenzler, Nancy "Boomer" Nelson and Vicki Schneider. The Falcons were the three-time defending champions, in search of their fourth straight World Series title.

Game 1—St. Louis 2, Connecticut 1

The Falcons' Margaret Rebenar faced off against Cindy Henderson of the Hummers.

Connecticut posted the first run of the game when Willie Roze led off the second inning with a double and scored on an error. St. Louis answered in the top of the sixth inning when Charlene Sennewald belted a home run off Rebenar with Susie Hiner on second base. The two-run blast proved to be all the runs St. Louis needed to win the game.

The game was highlighted by several sparkling defensive plays. In the top of the fourth inning, Stilwell saved two runs when she raced to the edge of

the infield dirt to grab a line drive off the bat of Carole Meyers with the bases loaded. In the top of the ninth inning, Connecticut's Snooki Mulder robbed Debbie Zoss of a possible double when Mulder ranged to her right and fell as she gloved the line drive. The Falcons did not help themselves at the plate, as they stranded twelve runners on base.

Henderson allowed six hits and walked five as St Louis took game 1 of the series.

Game 2—Connecticut 8, St. Louis 1

With the score knotted at 0–0, the Hummers finally posted a run when league home run leader and MVP Nancy Nelson homered. The lead was short-lived, however, when the Falcons' bats came to life led by Rebenar's booming home run. Other hitting stars for the Falcons were: Linda McMorran, Snooki Mulder, Kathy Stilwell, Joyce Compton and Willie Roze.

The Falcons knotted the series 1-1.

Game 3—Connecticut 2, St. Louis 0

Behind Sandy Fischer's five-hitter, Connecticut defeated Cindy Henderson and the St. Louis Hummers 2–0. The batting stars were Joan Joyce and Rayla Allison and Cindy Henderson.

With this win, the Falcons took the lead in the series 2-1.

Game 4—Connecticut 6, St. Louis 5

In a must-win game, the St. Louis Hummers gave the ball to pitcher Margie Wright. The Falcons countered with Margaret Rebenar. The game turned out to be a close contest between two powerful teams.

Joyce Compton's RBI single scoring Kathy Stilwell in the first inning began the scoring for the Falcons. This was quickly followed by Willie Roze's booming three-run homer over the left field fence.

The Falcons added another run in the second inning when Compton doubled and scored on another double by Joan Joyce. The Hummers' bats finally came alive in the sixth inning, and St. Louis eventually tied the score at 5–5. However, the tie was broken in the seventh inning when Joyce Compton

tripled and scored the winning run on Joan Joyce's sacrifice fly. The Falcons won this close-fought game 6–5.

Margaret Rebenar, the winning pitcher, gave up nine hits and walked three. In a losing effort, Margie Wright allowed eight hits and walked three.

The Connecticut Falcons won the 1979 WPS World Series and their fourth consecutive championship title.

SUMMARY OF THE WPS

The WPS league was made up of many powerhouse teams from around the country. The league existed for four years from 1976 through 1979, at which time the league was forced to close due to lack of funds. As Billie Jean King said when announcing the league's formation: "The WPS paved the way for girls and women in years to come."

The Connecticut Falcons, behind Joan Joyce, won the WPS Championship all four years.

Falcons celebrate after softball World Series Championship. *Courtesy of Joan Chandler.*

WPS MVP Awards for all four years were as follows:

1976—Joan Joyce (39-2, 494 strikeouts)
1977—Joan Joyce (24-4)
1978—Joan Joyce (18-1) and Donna Terry (15-2)
1979—Joan Joyce (20-6)

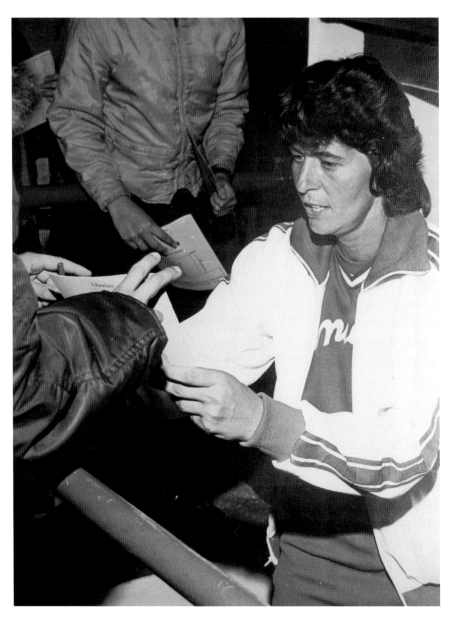

After every game, Joan was greeted by a crowd of autograph seekers. *Courtesy of Joan Chandler.*

THE GREATEST FEMALE ATHLETE IN SPORTS HISTORY

Babe Didrikson Zaharias got all the credit from the media, but Joan was even better. She knew no barriers. Joan was the greatest female athlete in sports history. Actually, she's one of the greatest athletes of all time—male or female.
—Jane Blalock, legendary golf professional

It would be a mistake to think of Joan Joyce as just a softball legend. She is a very gifted and hardworking athlete who has always felt that she could star in any sport. Actually, softball was just the beginning of her prowess in athletics. She was an overall outstanding athlete and starred in other sports, such as basketball, volleyball, bowling and golf. She even competed, on two occasions, in the ABC televised Superstars Competition, competing in a wide variety of sporting events against the nation's elite athletes. As if that was not enough, Joyce was a very highly regarded referee for many years. Furthermore, she has coached softball and basketball at all levels and is a very successful head coach at Florida Atlantic University. Joan Joyce has served in the coaching ranks of softball, basketball and golf for an amazing sixty years and counting.

BASKETBALL

My dad told me all the time that I was better in basketball than softball.
—Joan Joyce

As noted in the Connecticut Women's Basketball Hall of Fame tribute to Joyce:

> *Joan Joyce has to be one of the most incredible female athletes of all time. She has left an indelible mark on women's athletics—creating a legacy that has been instrumental in bringing women's athletics into the public spotlight. In basketball, Joyce was a four time Women's Basketball Association (WBA) All-American and a three time AAU All-American. In 1964, she set a national tournament single-game scoring record (67 points) and played on the 1965 U.S. National Team. Joyce was a highly regarded basketball official from 1958–1972. She officiated several CIAC State Tournament games and three college national championship games.*

Just as she did on the softball field, Joan Joyce demonstrated her pursuit of excellence on the basketball court as well. As further proof of her talent, versatility and competitiveness, Joan was a star player on numerous basketball teams. Joyce was the lead scorer for Crosby High School (Waterbury), the Libra AA (Waterbury), the New London Wheels, the Connecticut Grads (Bridgeport, Connecticut), the New Haven Collegiates, the New Haven Collegians and Stratford's Raybestos Brakettes basketball squads.

When Joan was a freshman at Waterbury's Crosby High School (in 1955), she played intermural basketball. As noted in Crosby's 1955 program,

> *Four teams were formed: Blue, White, Gold, and Violet. Their members were chosen by Miss Mae McKenna to ensure approximately equal strength. Lorraine Craig, Beverly Mulonet, Elaine Stollar and Barbara Thompson were elected Captains. The basketeers of the Blue and White teams had their playoff game on April 18, 1955. The Whites won the championship by a score of 25–17. Fourteen-year-old Freshman Joan Joyce received a letter for being high-scorer for the entire season of 1955.*

At age fifteen, Joyce joined the Libra Athletic Association (Libra AA) basketball team and played in the third annual Eastern Regional Women's Basketball Association Tournament. The games were played in Waterbury's

Wilby High School gym. As noted by Joan's brother, Joe, the Libra AA teams would play during half-time of the Harlem Globetrotters exhibitions.

While she was still a student at Crosby High School, Joan's dad drove sixteen-year-old Joyce down to Beardsley Park in Bridgeport to try out for the highly regarded basketball team known as the New London Wheels. She made the team and quickly became a star on the Wheels basketball squad, playing forward and wearing jersey number 0.

The Wheels played many of their games in Connecticut gymnasiums such as Stratford High School, Fairfield's Sacred Heart University, Waterbury's Crosby High School, Bridgeport's Brass Center, Waterbury's Wilby High School, Bridgeport's Sheehan Center and New London High School.

Joining Joyce on the New London Wheels were Brenda Reilly, Ann DeLuca, Sara Lou Beebee, Mary Hartman, Maddie Hartman, Joyce Keatley and Lou Kyvallos. Keatley, Reilly and DeLuca also were members of the Raybestos Brakettes softball team. Reilly led the New London Wheels in assists. Joan Joyce was the player the Wheels counted on to be the high scorer in each game, and she did not disappoint.

It didn't take long for Joan Joyce to make a name for herself on a national level. The phenom, at age sixteen, won the Most Valuable Player in the 1956 Women's World basketball tournament. The following year, the New London Wheels traveled to Buffalo, New York, to play in the National Women's Basketball Association tournament. On Sunday, April 7, 1957, the Wheels were beaten by Indiana's South Bend Rockettes 73–62 in the consolation game of the tournament. In this game, Joyce, at age sixteen, scored 44 points. The Chicago Starettes won the tournament by beating the St. Louis Caverns 49–40.

In a real nail-biter, the Wheels won the Eastern Seaboard AAU championship game in 1958 against the New Jersey Co-eds by a score of 53–52. In that game, seventeen-year-old Joan set a 1958 National AAU record by scoring 44 points.

The New London team continued their success for several more seasons, always led by their star forward Joan Joyce. On Sunday, February 9, 1958, the Wheels defeated the Hartford Debs 51–30, led by Joyce, who was the high scorer for the Wheels with 16 points. Joyce was again the Wheels' high scorer as the New London squad defeated the Hartford Laurelettes 65–34 (at the Bridgeport Brass Center) on Sunday, December 27, 1959. On January 24, 1960, the New London Wheels defeated the Paterson (NJ) Debs 41–38. Once again, Joan Joyce was high scorer for the Wheels with 22 points.

Top: New London Wheels. *Front to back*, Mary Hartman, Joan Joyce, Mattie Hartman, Sara Lou Beebee, Joyce Keatley. *Bottom*: New London Wheels basketball team with trophies. Joan Joyce, bottom row, third from left. *Both courtesy of Joan Joyce.*

Joyce joined the nationally known Connecticut Grads basketball team on January 6, 1962, and immediately traveled with the team to play a basketball squad in Irvington, New Jersey. As noted in the *Central New Jersey Home News*, the Connecticut Grads were "one of the outstanding female basketball teams in the country." Later in the month, the Grads played the Libra AA (Joan's former team) in Waterbury on January 22, 1962. Despite a 63–58 loss, Joyce was the high scorer for the Connecticut Grads. In a return match against the Libra AA on February 17, 1962, Joan again was the leading scorer for the Connecticut Grads with 26 points.

The Raybestos Brakettes women's basketball organization was very aware of Joan's athletic ability, having seen her heroics on the Brakettes softball team. Knowing she was still with the New London Wheels, they asked if Joan would play for their team on an intermittent basis in 1963. Joyce agreed and, predictably, became the Brakettes high scorer in the games she played in. In true Joan Joyce fashion, she was the lead scorer for the Brakettes in both games of a doubleheader on Saturday, March 2, 1963. In the first game, Joan scored 19 points against a strong Elmhurst, New York team. In the second game, Joyce scored 17 points against the New York City Met Life team.

After the Brakettes won the ASA Softball National Championship in the summer of 1963, Joan set her sights on California. There, she attended Chapman College and also joined the powerhouse Orange Lionettes softball team, both in Orange, California. When she got to California, she asked the Lionettes management if the school also had a basketball team and was surprised to learn it did not. In true Joan Joyce fashion, she started up a basketball squad, recruited some well-known players in the area (including several Lionettes softball players) and instantly became a star on the squad. Wearing uniform no. 10, Joan averaged over 30 points per game. The team she formed was quite good and very competitive—Joan would have it no other way. As Joan explains, "Well, I always played basketball in the winter after softball season ended. So I thought why should I change? When I found out that the Lionettes did not have a basketball team, I figured I'd go ahead and form one myself. So I did."

With Joan in the lead, the Lionettes traveled to Gallup, New Mexico, to play in the national AAU tournament in 1964. It was there that Joan Joyce really shined, and players, fans and the media took notice. In a game against the St. Joseph, Missouri team, Joan Joyce set a national tournament single-game record by scoring 67 points. To put things in perspective, Joan scored the 67 points without the benefit of the 3-point shot, which is

LIONETTE CAGERS _ Top row from left; Joan Joyce, Shirley Topley, Pat Kelly, Katie Hummell, Lou Albrecht, and Janie Oakley. Kneeling are - Sally Palmer, Carol Spanks, Sharon Backus and Nancy Ito. The Orange team was coached by Wayne Salmon.

Joan also played for the Orange Lionettes Basketball Team (Orange, CA). *Courtesy of Softball National News by Stormy Irwin.*

standard in today's basketball games. In the next round of the tournament, the Lionettes beat the team from Arkadelphia, Arkansas. The Lionettes eventually lost to the mighty Nashville Business College (NBC) team of Nashville, Tennessee, which went on to win the tournament. The NBC basketball team featured famed hall of famer and tournament MVP Nera White (No. 11). Nera was a six-foot, one-inch point guard known as an outstanding all-around playmaker, shooter, rebounder and defender. She was blessed with speed and an amazing leaping ability. (She purportedly was able to dunk a basketball, which was extremely rare in those days.) White also excelled as an ASA fast-pitch softball player, adept at several

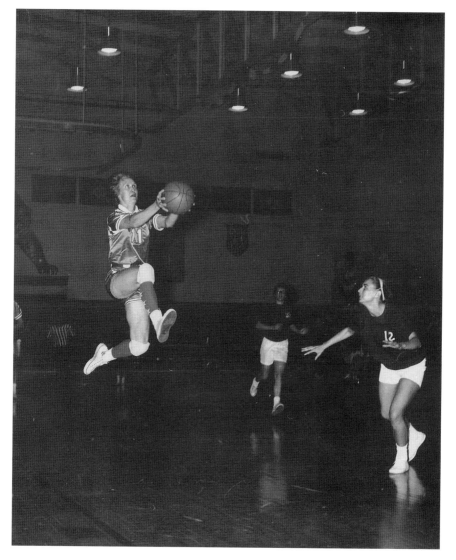

Nera White. *Courtesy of the Women's Basketball Hall of Fame, Knoxville, Tennessee.*

positions, including centerfield, shortstop and pitcher. As in basketball, Nera's biggest asset in softball was her speed. She was known to circle the bases in ten seconds flat. White once won a softball-throwing contest by tossing the ball out of a baseball stadium.

As mentioned, Joyce was a four-time WBA All-American All-Star and a three-time AAU All American All-Star. She was also an All-World All-Star

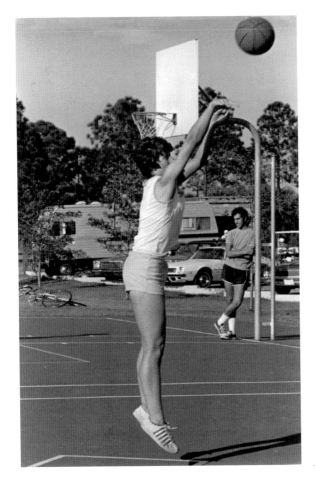

"Basketball was my favorite sport." *Courtesy of Joan Chandler.*

in softball. Thus, Joan became the only woman at the time to make both the basketball and softball All-Star teams at the same time.

Having graduated from Chapman College in 1966, Joan decided to return to Connecticut and rejoin the Raybestos Brakettes basketball and softball teams, much to the delight of the Brakettes fans.

The 1967 season was a very impressive and dominant basketball period for Joan and the Brakettes squad. The Brakettes, led by player/coach Joan Joyce, finished the regular season with a perfect 22-0 record. Joining Joan in the Brakettes frontcourt were Donna Lopiano and Brenda Reilly. In the backcourt were Ann DeLuca, Jo Riccio and Diane Wynus. Other members of the Brakettes were Willie Roze, Marge Whitehead, Stephanie Tenney and Debbie Paul. The Brakettes' opening game was held at the Stratford High School gym on Saturday, January 14, 1967.

Their opponent was the Springfield, Massachusetts women's team. The following day (Sunday, January 15, 1967), the Brakettes won both games of a doubleheader. In the afternoon game, the Brakettes traveled to Poughkeepsie, New York, and beat the Hudson Valley team 66–54. In this first game, Joyce scored 23 points, Lopiano tallied 18 points and DeLuca tallied 13 points. The Brakettes then drove back to the Stratford High School gym, where they walloped the Springfield, Massachusetts team 66–23. In this nightcap game, Lopiano scored 22 points, and Joyce scored 20 points.

In the process of winning twenty-two straight games, the Brakettes captured the New England Women's Basketball League Championship, the Northampton Invitational Tournament Championship and the Region One AAU title.

Earning a berth in the 1967 National AAU tournament by virtue of their undefeated season, the Brakettes increased their winning streak to twenty-four games by winning the first two games of the tournament. The second game was a huge upset over the Houston Jets on March 15, 1967, and earned the team the right to face a very tough Long Beach team in the quarter-finals. A Long Beach victory over the Brakettes on March 16, 1967, snapped the twenty-four-game winning streak and eliminated the Brakettes from the tournament. Despite being ousted from the tournament, the Brakettes made one of the best showings by an eastern team in the history of the National AAU women's tournament. Joan Joyce and Donna Lopiano were high scorers for the Brakettes throughout the team's successful season.

In November 1967, the Irish National Girls basketball team, sponsored by Air Lingus, toured the United States and played against teams in a number of U.S. states. The Irish team won 75 percent of their games in Ireland, Scotland and England. In their only appearance in Connecticut, the Irish team took on the Raybestos Brakettes women's team. The game was held on November 1, 1967, at Sacred Heart University (Fairfield, Connecticut). The Brakettes were victorious, easily defeating the Irish team 61–17.

In all the teams she played on, Joan raised the teams' caliber of play to a very high level.

For all her amazing achievements as a basketball player, coach and referee, Joan Joyce was inducted into the Connecticut Women's Basketball Hall of Fame in 1994.

VOLLEYBALL

Joan was one of the initiators of the modern game of volleyball in Connecticut and throughout the Northeast.
—Connecticut Women's Volleyball Hall of Fame

The sport of volleyball was invented by William G. Morgan in Holyoke, Massachusetts, in 1895. Morgan was the physical education director of the YMCA in Holyoke and wrote the rules of the sport. Morgan called the sport "mintonette" (derived from the sport of badminton). The name was changed to "volleyball" in 1896 when a professor at the International YMCA Training School (now known as Springfield College) observed the volleying nature of the game and proposed the name change. Volleyball is a team sport consisting of six players on each side of the volleyball net. It is a game of strategy with a number of techniques, including serving, passing, setting, digging, blocking, dinking (a fake spike) and spiking (overhand slam). In 1928, the United States Volleyball Association (USVBA) was formed.

When Joan Joyce was an elementary student attending Webster grammar school, she played a lot of volleyball after school in local parks in Waterbury such as Huntington Park and Fulton Park. While attending Waterbury's Crosby High School, Joyce became a star volleyball player.

In 1966, Joan attended the National Association of Girls and Women in Sport (NAGWS) in Indiana. It was there that she was introduced to the sport of "power volleyball." Returning from the NAGWS clinic, Joan joined a volleyball team in Trenton, New Jersey.

Determined to do things her way, Joyce started her own USVBA team in Connecticut in 1968 and was the player-coach. She called her team the Connecticut Clippers. Joan used all the new techniques and strategies that she learned from the NAGWS institute. The Clippers traveled extensively throughout the country, playing against many highly competitive teams. The Clippers were the best in the region and represented the region at the USVBA National Tournament from 1969 to 1974. Wearing uniform number 0, Joyce competed in four national volleyball tournaments and was named to the All-East Regional team.

The Connecticut Clippers competed in USVBA tournaments at various locations such as the Harpur Gym in Binghamton, New York (1971) and Harvard University. Other members of the Connecticut Clippers were Debbie Chin, Brenda Reilly, Louise Albrecht and Linda Hamm.

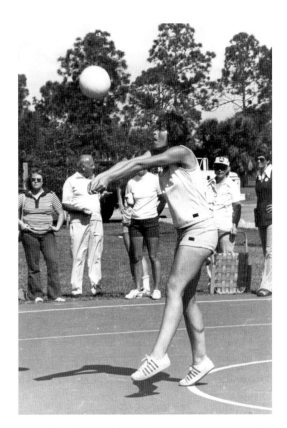

Right: Joan practicing volleyball during the televised ABC Superstars competition, 1975. *Courtesy of Joan Chandler.*

Below: Volleyball coach Joan Joyce (*first row, right*) of Waterbury Catholic High School, 1961. *WCHS Yearbook, author's collection.*

GIRLS' VOLLEYBALL

FIRST ROW: Karen Sanford, Beth Mullaney, Lynn O'Donnell, Karen Uzwiak, Eileen Ely, Jill Reedy, Sherry Andersen, Kathy Kidd, Miss Joyce (Coach). SECOND ROW: Sue Koester (man-ager), Joanne Jessen (manager), Janice Lauf, Cindy Chapman, Nancy Faust, Leslee Singer, Mona Beckett, Sue Hurley.

Wearing uniform number 3, the talented Debbie Chin competed in nine national tournaments and eventually officiated volleyball on a high school and college level for twelve years. Chin also had a very impressive forty-two-year athletic career at Connecticut's University of New Haven, during which time she was the head coach of UNH's volleyball, tennis, basketball and softball teams. Debbie Chin has been inducted into a number of halls of fame, including the Connecticut Volleyball and Basketball HOFs. Brenda Reilly eventually became a NAGWS volleyball referee and also coached Joan Joyce and the Connecticut Falcons pro softball team. Reilly was inducted into the Connecticut Women's Volleyball Hall of Fame in 2001. Louise Albrecht became a member of the Connecticut Women's Hall of Fame in 2000. Louise was also a fast-pitch softball star and was inducted into the National Softball Hall of Fame in 1985. Finally, Linda Hamm had an exceptional volleyball career as a player, coach and official. Hamm was inducted into the Connecticut Women's Hall of Fame in 2000.

The Connecticut Clippers played in the same tournaments as six-time All-American and Hall of Famer Mary Jo Peppler, star player for Sul Ross State (Alpine, Texas). Peppler was the MVP of the 1970 USVBA tournament.

Joan Joyce served as a volleyball official for a number of years. She officiated on many levels—high school, college and industrial leagues. For example, she was a NAGWS volleyball official from 1968 through 1975. She also served as a High School Federation volleyball official in 1991 and 1992. She officiated at the Association for Intercollegiate Athletics for Women (AIAW) Large College National Tournament at Brigham Young University in Provo, Utah, in 1973. In addition, Joan conducted many clinics for high schools and colleges throughout the Northeast.

Joan Joyce was inducted into the Connecticut Women's Volleyball Hall of Fame in 2000 in recognition of her excellence in the sport of volleyball. As noted during her induction, "During her playing days, Joan received many individual awards and accolades for her performance on the volleyball court. She was one of the initiators of the modern game for all those associated with the game in Connecticut and throughout the Northeast."

BOWLING

Joanie was a natural at bowling just like every other sport she played.
A true competitor!
—Joe Joyce

Beginning at an early age, Joan Joyce also excelled and was a natural at bowling. Joan bowled in the 180s to low 190s and was offered a professional bowling position, which she was not able to accept. Joan says she bowled for many years, usually for fun.

Joan's brother, Joe, recalls when his sister bowled against a professional bowler who was well known in the area: "Joanie was a natural at bowling just like every other sport she played. One day, Lakewood Lanes brought in famed Hall of Fame professional bowler Andy Varipapa to bowl against Joanie. Andy was a well-known, great pro bowler, who earned the titles 'The greatest one-man bowling show on Earth' and 'The Babe

Left: Joan won the bowling event on ABC Superstars competition 1975. *Right*: Joan receiving bowling trophy. *Courtesy of Joan Chandler.*

Ruth of bowling.' Joanie accepted the challenge, and wouldn't you know it?—Joanie beat Varipapa. Amazing!"

Joan Joyce also participated in two nationally televised Superstars Competitions on ABC—in 1975 and 1979—and won the bowling competition with a 181 average.

GOLF

Joan had the perfect temperament for golf, the perfect attitude. She had a mechanically sound golf swing. And such great touch and finesse, a great feel. I encouraged Joan to pursue a career in golf.
—Jane Blalock, LPGA

Joan took up golf later in life. Remarkably, she didn't receive golf instructions until age thirty-five. Joyce has given credit to Jane Blalock for identifying her golf potential.

Up until then, Joyce played golf on a leisurely, infrequent basis, since she was involved in numerous other sports over the years. However, Blalock realized Joan's natural talent, drive and determination and ability to effectively deal with the pressure that the golf game presents. Blalock was one of the Ladies Professional Golf Association's (LPGA) all-time leading money winners. She was also co-owner of the Connecticut Falcons softball team along with Joyce and tennis ace Billie Jean King. Jane witnessed firsthand Joan's natural athletic ability. Blalock discovered that Joan had an amazing ability to combine power and finesse. She recognized that Joan was a rare, natural and gifted athlete who was able to compete—at a very high level—in the sport of her choosing. Blalock felt that Joyce's raw talent as a golfer would be refined in the course of time by playing more often and receiving professional golf instructions. For these reasons, Blalock encouraged Joan to try out for the LPGA.

Showing her natural athleticism, Joan qualified for the LPGA at age thirty-seven (in 1977), just eighteen months after her first golf lesson. And this was while she was still pitching for the Connecticut Falcons pro team. She would play golf in the afternoon and pitch for the Falcons at night. She played on the LPGA tour for nineteen years (until age fifty-five).

Sunday, May 16, 1982, was not the ideal day for playing a round of golf at LPGA's Michelob Classic tournament in Atlanta, Georgia. On

that final day of the tournament, Joan was greeted with constant winds and thunderstorms looming all day long. Despite the inclement weather conditions, Joan was called to the first tee to play her final round of the tournament. It didn't take very long until Joan noticed something quite special was happening with her putting game. It seemed that almost every putt that Joan attempted was going straight into the hole, even several off the edge of the greens. Joan tells it this way: "After the 14th hole, I told one of the officials that I was going to break the putting record. She turned to me and said, 'You must be crazy!' So, I told her, well maybe, but I *am* going to break the record. I just knew it!!" And she was right. At the age of forty-two, Joan Joyce set an LPGA and (men's) PGA record for lowest number of putts in a single round of golf (seventeen), which amazed even the male and female pro golfers. This is a record which still stands today, over thirty-six years later. As Joan explains, "I chipped it in four times, one-putt eleven times, and two-putt the other three greens."

Joan finished in sixth place in the LPGA tournament three times (1981, 1982, 1984), including a round of sixty-six. She had the ability to drive a golf ball with power and accuracy, far exceeding most of her rival golfers.

On May 16, 1982, Joan broke the LPGA and PGA record of the least number of putts in a single round of golf, needing only seventeen putts. *Courtesy of Joan Chandler.*

While most of her fellow golfers on the LPGA began playing golf at a very early age (ten or twelve years old), Joan's golf accomplishments were that much more impressive given the fact that she began her golfing career after the age of thirty-five and never took golf lessons up until that time. Women's pro golf has grown tremendously since Babe Didrikson's era, and it is much harder to join the LPGA tour, particularly at age thirty-seven, as Joyce did. Incidentally, Babe was twenty-four when she began her golf career.

Joyce feels a sense of pride in helping to usher in the power era of women's golf, causing tournament officials to start marking golf courses differently. Former LPGA star Jane Blaylock concurs but takes it a step further:

Joan's power game was amazing and drew a great deal of attention. But the most impressive thing is that Joan took up the game so late in life and had not grown up as a golfer, so to speak. She had a great combination of power and finesse. And what's astonishing is the fact that she holds the record on the LPGA and PGA for fewest putts in a round. Joan Joyce was the athlete of the century in many people's opinion (including me). A lot of athletes try to take up the game of golf and do okay but certainly were not as successful as Joan was. Look at Michael Jordan. Look at Tony Romo. The success she had on the fairway was remarkable.

Joan chipping for a birdie. *Courtesy of Joan Chandler.*

Left: Joan's follow-through during a golf tournament. *Courtesy of Joan Chandler*.

Below: Joan Joyce (*first row, second from right*), Jane Blalock (*second row, left*) and fellow golfers on the LPGA tour. *Courtesy of Jane Blalock*.

Right: Joan Joyce and Jane Blalock share a laugh during an LPGA round. *Courtesy of Joan Chandler*.

Below: Joan Joyce and Joan Chandler (*photographer*) on golf course, 1999. *Courtesy of Joan Chandler*.

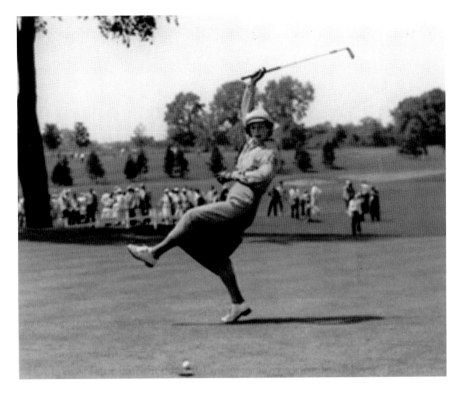

The great Babe Didrikson (Zaharias). *Courtesy of Joan Chandler collection.*

ABC-TV SUPERSTARS COMPETITION

Joan Joyce participated in two nationally televised Superstars Competitions on ABC. The 1975 preliminary events took place at the Houston (TX) Astrodome on December 21–22, 1974 (air date was January 19, 1975). The 1975 finalist events were held in Rotonda, Florida, on January 27–29, 1975 (air date was February 1975). Joan also participated in the 1979 Superstars Competition in Freeport, Bahamas. The 1979 events were held on January 29–30, 1979 (air date was February 25, 1979).

The Superstars was an all-around sports competition consisting of elite athletes from various sports. These were the best of the best. The athletes competed against one another in a series of sporting events, similar to a decathlon. The "draw" of the show was that the athletes were not permitted to compete in the sport of his or her profession. Thus, Joan Joyce was not allowed to compete in the softball and golf events, and volleyball was not

available to her. Joan won the bowling competition (181 average) and fared very well in the tennis (finished second), basketball, rowing, bike racing and swimming events. Here's how she describes competing in the tennis event: "I never really competed in tennis and I lost my first match in the Superstars competition. I was really upset. So I practiced a lot back home and when I came back I was a totally different tennis player."

Joyce finished sixth overall in the two Superstars appearances, competing against stiff competition from elite athletes. By the way, to prepare for the rowing competition for the second round of the Superstars Competition, Joyce practiced on a lake in her hometown. The only problem is that Waterbury in January can be cold, very cold. As Joan explains it, "I felt I needed to practice rowing outside for the upcoming ABC Superstars competition in Florida. So I took a rowboat to a lake up on Lakewood Road in Waterbury to practice. Anyone who is familiar with winters in Connecticut can tell you that the weather in January can be extremely cold and harsh. So it was really no surprise to see the lake icing up. But I was determined to practice rowing and used the oars of the rowboat to break through the ice. It was very cold, but I did manage to get some much-needed rowing practice in."

Joan Joyce (*left*) in track and field event in the nationally televised ABC-TV Superstars Competition 1975. *Courtesy of Joan Chandler.*

Left: Joan Joyce in tennis event on the nationally televised ABC-TV Superstars Competition. *Courtesy of Joan Chandler.*

Below, left: Joan Joyce and Jane Blalock shoot some hoops in preparation for the ABC TV Superstars Competition, 1979. *Below, right*: Joan practicing her basketball form for the Superstars Competition, 1979. *Courtesy of Joan Chandler.*

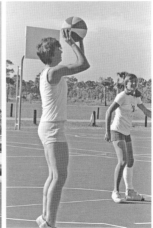

Above: Joan waiting her turn during the nationally televised ABC-TV Superstars Competition. *Courtesy of Joan Chandler.*

Left: Joan in swimming event in the nationally televised ABC-TV Superstars Competition, 1975. *Courtesy of Joan Chandler.*

Taking a break during the nationally televised ABC-TV Superstars Competition. *Left to right*: unidentified, Mary Jo Peppler (volleyball), Joan Joyce, Cathy Rigby (gymnastics). *Courtesy of Joan Chandler*.

Joan in the rowing event in the nationally televised ABC-TV Superstars Competition. *Courtesy of Joan Chandler*.

Arthur Ashe and Joan Joyce during filming of the nationally televised ABC-TV Superstars Competition, 1975. *Courtesy of Joan Chandler*.

Left: Joan Joyce softball card. Photo taken during the ABC-TV Superstars Competition. *Author's collection.*

Below: Joan Joyce after the qualifying round of the nationally televised ABC-TV competition in Houston, Texas. On her way to the finals in Rotunda Beach, Florida, 1975. *Courtesy of Joan Chandler.*

Left: Joan, still holding her golf club, "practicing" for the track and field event during break of the nationally televised ABC-TV Superstars Competition in the Bahamas, 1979. With her is Jane Blalock, sporting torn ligaments in her leg. *Courtesy of Joan Chandler*.

Below: Joan Joyce, Jane Blalock. A little horseplay during a break in filming the 1979 ABC-TV Superstars Competition in the Bahamas. *Courtesy of Joan Chandler*.

JOAN JOYCE'S COACHING AND OFFICIATING CAREER

Joan is a great coach. A teacher in the true sense of the word. She is a wonderful woman who loves each and every one of her students and quietly demands the best from them.
—Linda R. Finelli, Brakettes

One of the most overlooked aspects of Joan Joyce's legendary career is the great success she has had in the coaching and officiating ranks.

As if her phenomenal playing career wasn't enough, Joan also achieved notoriety as a coach and referee. Her coaching career began soon after graduating from Crosby High School in 1958. Joan coached at numerous local high schools and colleges, including Presentation High School (Stamford), St. Mary's High School (Greenwich), Bethel High School, Waterbury Catholic High School, Housatonic Community College (Bridgeport), Brooklyn (NY) College and Mattatuck Community College (Waterbury).

As a twenty-year-old, Joan coached a girls' softball team called the Waterbury Sunliners in 1961 (in the Town Plot section of Waterbury). On Monday, August 7, 1961, the Waterbury Sunliners played the Raybestos Robins for the Division B State Championship. Ironically, the Robins were coached by Joan's friend and fellow Brakette Brenda Reilly. The Robins won the State Division Championship by narrowly defeating the Sunliners 9–8. The Sunliners were state runners-up. Joan and Brenda were fiercely competitive, but throughout, they remained close friends.

Joyce was the player-coach for the New London Wheels basketball team, the Connecticut Clippers volleyball team, the Orange Lionettes basketball team, the Brakettes basketball teams and the Connecticut Falcons women pro softball team.

Joan also officiated at some of the high schools previously mentioned as well as important basketball tournament and championship games, as noted at her Connecticut Basketball Hall of Fame induction: "Joan Joyce was a highly regarded basketball official from 1958–1972. She officiated several CIAC State Tournament games and three AIAAW national championship games."

Amazingly, all of these coaching, teaching and officiating assignments were accomplished at the *same time* that Joyce was playing softball and basketball at a high level.

So, did Joan Joyce decide to settle down after her playing days were over? No way! Joan decided to take on a new challenge and became women's softball head coach at Florida Atlantic University (FAU) in Boca Raton, Florida, in 1994. Joyce is the only coach in the twenty-five-year history of FAU softball. Joan immediately worked her coaching magic with her FAU team. Under Joyce's guidance, the 1995 team posted a 33-18 record the first year, earning Joan her first Atlantic Sun Conference (A-Sun) Coach of the Year award, as well as the Palm Beach County Coach of the Year. She has guided FAU to thirteen conference championships, including eight in a row while in the Atlantic Sun Conference (1997–2004), and set a league record for titles in a sport. FAU has made twelve NCAA Tournament appearances under Joyce's direction.

Coach Joyce joined the prestigious 900 career wins club when her FAU team beat Western Kentucky University's softball team in 2017. In her twenty-four seasons at FAU, her coaching record stands at 945 wins, 568 losses and 1 tie.

Joyce has won eight conference softball Coach of the Year awards (A-Sun 1995, 1997, 1999, 2000, 2002; Sun Belt 2007; C-USA 2016 and 2018). On

Coach Joyce, FAU Owls. *Courtesy of FAU Athletics.*

Left: FAU coach Joyce interviewed by ESPN. *Courtesy of FAU Athletics*. *Right*: FAU coach Joan Joyce. *Courtesy of FAU Athletics*.

Left: FAU Owls *left to right* Chan Walker, Tatum Buckley, Emily Lochten, Joan Joyce, Summer Damiano (wearing fundraising bracelet), September 2016. *Right*: Chan Walker and Joan Joyce. *Both courtesy of FAU Athletics.*

FAU coach Joan Joyce. *Courtesy of FAU Athletics.*

October 22, 2018, she was inducted into the Atlantic Sun Hall of Fame, honoring her very successful twenty-four-year career as softball head coach at FAU. Assistant FAU coach Chan Walker showed her admiration and gratitude to Coach Joyce when she said, "I will always be grateful to Coach Joyce for giving me this amazing opportunity. I have seen FAU grow by leaps and bounds and I am honored for the opportunity to see that growth continue. Forever an Owl!"

Not satisfied with limiting her coaching to softball, Joan was a very successful head coach of the FAU women's golf team from 1996 to 2014.

In a tribute to Coach Joyce, FAU Athletics notes: "Joan Joyce has left an indelible mark on women's athletics and is creating a legacy that will help to define Florida Atlantic University, FAU athletics and collegiate softball for many years to come."

13

JUST PERFECT!

I never worry about the batter, except to make sure the ball goes where I know it will do the most good. When I'm going right, there's nobody who can hit me.
—*Joan Joyce*

Joan Joyce's career statistics are off the charts! To name just a few, Joan pitched 150 no-hitters, 50 perfect games, and had a career Earned Run Average (ERA) of 0.09. In her career with the Raybestos Brakettes, Orange Lionettes and the Connecticut Falcons, Joan struck out over 10,000 batters.

It was a common occurrence to see many batters leave the batter's box with their bats still on their shoulders, completely stymied by the speed and the movement of Joan's pitches. As one frustrated batter was heard to say after batting against Joyce, "It would help if I was able to see the ball!" There may be some truth in what Brakettes Coach Stratton has said of Joan's pitches, "The first time the batter would see the ball was when the catcher would throw the ball back to Joanie."

Ted Williams wasn't the only Major League great that Joan Joyce struck out. She also easily struck out Hall of Fame home run king Hank Aaron. In addition, as a sidelight to the Women's' Superstars Competition, Joan Joyce dueled baseball star Paul Blair while Blair was still a member of the Baltimore Orioles. The faceoff occurred on December 21, 1975, in Rotunda, Florida. Blair clearly missed all of Joan's pitches but did manage to foul off a few. When asked for her reaction to the duel, the perfectionist Joyce responded, "But don't forget, I hadn't pitched in five months."

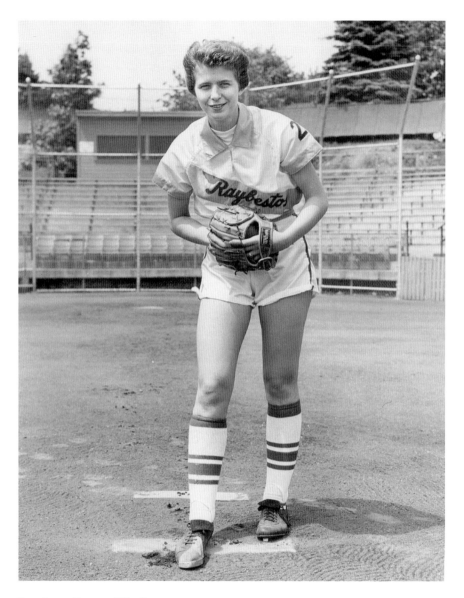

Joan Joyce. *Courtesy of Jim Fetter.*

Other notables also faced off against Joan and had the same results as Ted Williams, Hank Aaron and Paul Blair.

In his book *A Nice Tuesday*, Fairfield's Pat Jordan (former pitcher in the Milwaukee Braves' organization) writes,

It is difficult to describe just how great Joan Joyce was as a softball pitcher. Even her records, after 26 years of pitching, do not do her justice. All those strikeouts, no hitters, and perfect games. She was 42-2 one year, with 38 shutouts. (In her entire career) she lost only 42 games, while winning almost 800. She averaged 16 strikeouts every 7 innings. Joanie had a 119-mph fastball that never went in a straight line. It rose, or sank, or tailed in or away. (Joan) was described by an umpire who stood behind the plate during many of her performances as one of the three greatest fast-pitch softball players in the world. He added, "And the other two are men."

Joan Joyce was a sports phenomenon at a time when very few opportunities existed for female athletes. It made no difference to Joan that because she was a female she was banned from male-dominated sports. Joan was determined to find her niche in the sports world and strove for excellence in every sport she played. As Joyce has said, "I have played the game on my own terms. I've done the things in sports I wanted to do, and I didn't let anyone stop me."

Rosemary "Micki" Macchietto Stratton was a Brakette teammate and close friend of Joan's for many years. She was Joyce's catcher and was

Joan Joyce "freezes" rival batter during the Falcons' China tour. Most bats didn't leave the batters' shoulders. *Courtesy of Joan Chandler.*

Joan's reaction after one of many no-hitters. *Courtesy of Joan Chandler.*

Joan Joyce striking out Hank Aaron. *Courtesy of Joan Chandler.*

behind the plate for many momentous occasions, including one of the nights that Joan struck out Ted Williams. Several years ago, Micki was asked for her evaluation of Joan as a softball pitcher. Micki responded, "Joan Joyce dominated the sport for twenty-six years. Her name is the biggest name in softball ever. But Joan was tops at everything—basketball, volleyball, bowling, cards, shooting pool, ping-pong—you name it, it didn't make any difference. She would always beat you!"

Joan Joyce is a champion of women in sports and has propelled the national profile of women athletics for generations to come.

A BRIEF SUMMARY OF JOAN JOYCE'S ACCOMPLISHMENTS, STATISTICS, AND RECORDS

1. 753-42 win-loss record
2. 150 no-hitters
3. 50 perfect games
4. Lifetime earned run average of 0.09

5. 19 Hall of Fame inductions
6. 42 wins in one season (1974)—(set a Brakettes record)
7. Struck out every batter but one (who had walked) pitching a no-hitter against Australia in 1974 tournament
8. Struck out all but 2 batters in a single game on at least 8 separate occasions
9. 76 strikeouts in 36 innings—(a World Tournament record)
10. Lowest earned run average in a World Tournament (0.00)
11. Most consecutive scoreless innings in a World Tournament (36)—(a World Tournament record)
12. Most no-hitters in a World Tournament (3)—(a World Tournament record)
13. Most perfect games in a World Tournament (2)—(a World Tournament record)
14. Has struck out over 10,000 batters in her pitching career
15. Averaged nearly 2 strikeouts per inning
16. In Brakettes history, Joan had the most strikeouts in one season 11 times.
17. 2 perfect games in 1974 Women's World Championship tournament
18. 4 straight no-hitters (1968)
19. 70 scoreless innings in the 1974 ASA National tournament—in high-pressure games
20. Two no-hitters in her first two National tournament games. A no-hitter (at age 17) in the quarter-final game against Detroit and, after just turning 18, threw a no-hitter (relieving Bertha Ragan) in the 1958 National championship game, walking only 2 batters while striking out 19
21. 123 consecutive scoreless innings set in 1971 (set a Brakettes record)
22. 229 scoreless innings in 1975 and a winning streak of 52 games
23. 37-1 in 1973
24. 42-2 in 1974
25. 36-0 in 1975
26. Most shutouts in a season—38 shutouts—1974 (set a Brakettes record)
27. Career batting average of .327. Her highest single-season batting average was .406 in 1973.
28. Six-time Brakettes team batting champion—(1960, 1962, 1967, 1968, 1969, 1973)
29. National Tournament Batting Champion in 1971, with a batting average of .467
30. 18 straight years All-American (softball)
31. Led the Orange Lionettes to the 1965 National Championship (Orange, CA)

32. Eight-time Most Valuable Player in the softball National Tournament (set a Brakettes record). 1961, 1963, 1965 (with the Lionettes), 1968, 1971 (co-MVP), 1973, 1974 and 1975

33. Four-time Most Valuable Player (MVP) in the Women's Professional Softball league (1976–1979)

34. Two no-hitter games in National Tournament (four times)—(set a Brakettes record)

35. Most innings pitched in one game—29 in 1964—striking out 39 batters.

36. Struck out 40 batters in a 19-inning tournament game. In the triple-header the same day, Joan struck out 67 batters.

37. *Ranks first in entire Brakettes History in career doubles—record still stands. (Also set a Brakettes record with 22 doubles in one season.)*

38. *Ranks first in entire Brakettes history in strikeouts*—record still stands

39. *Ranks second in entire Brakettes history in career triples—67 (set a Brakettes record)*

40. *Ranks second in entire Brakettes history in hits*

41. *Ranks second in entire Brakettes history in games played*

42. *Ranks third in entire Brakettes history in RBIs (runs batted in)*

43. *Ranks third in entire Brakettes history in runs scored*

44. Surrendered only 102 runs in 476 games with the Brakettes

45. No. 4 on Hartford Courant's Best Athletes of the Century—highest female athlete chosen

46. No. 3 ranking of Athletes of the Millennium in Connecticut. Only female in top 3.

47. No. 2 ranked athlete in *Women's Sports National* magazine's Athlete of the Year (1976). Dorothy Hamill was ranked No. 1.

48. Connecticut Athlete of the Year—first woman selected by the Connecticut Sports Writers Alliance

49. First woman recipient of the prestigious Connecticut Sports Writers' Alliance's Gold Key Award and the first woman ever to be invited to the awards banquet on January 28, 1974. No woman had ever broken the barrier in 33 years up until then

50. Co-founder of the Women's Professional Softball League (WPS)

51. Player, coach, co-owner of the Connecticut Falcons professional softball team

52. Behind Joan's brilliant pitching, Connecticut Falcons won the Championship in ALL 4 years of the league's existence

53. Her pitches were extremely fast—equivalent to a 119-mph baseball, in terms of reaction time

54. Lifetime Sport Achievement Award from National Girls and Women in Sports (NGWS)
55. Eight-time College Coach of the Year while at Florida Atlantic University (Atlantic Sun Conference)
56. 945 victories as softball coach at Florida Atlantic University
57. 10 conference championships at FAU
58. FAU President's Talon Award for outstanding leadership (2016)
59. Palm Beach County (Florida) Coach of the Year
60. "Joan Joyce Day" proclaimed on August 15, 2015, in Waterbury, Connecticut
61. A softball field was renamed Joan Joyce Field. The field is part of Municipal Stadium, where Joan struck out Ted Williams on several occasions
62. Joan Joyce league formed in Joan's honor. One of the very few (if any) athletes to have both a field and a league named after her
63. Honored by the Greater Bridgeport Athletic Association on May 11, 2015, for her outstanding athletic career
64. Bill Lee Athlete of the Year—1975
65. Four-time Women's Basketball Association (WBA) All-American
66. Three-time AAU Basketball All-American
67. **Set a National Tournament Basketball single-game scoring record of 67 points in 1964**. Played on the 1965 U.S. National Team
68. **Set a National AAU Basketball record by scoring 44 points in the Eastern Seaboard AAU Championship (at age 17)**
69. Three-time AAU All-Star
70. **Averaged 30 points per game (basketball)**
71. Only woman to make both the Basketball and Softball All-Star teams at the same time
72. Player/Coach for the Raybestos Brakettes women's basketball team
73. Highly regarded basketball official from 1958 to 1972. She officiated several CIAC State Tournament games and three college national championship games.
74. Most Valuable Player in the 1956 Women's World basketball tournament at age 16
75. Formed the Connecticut Clippers Volleyball team—a United States Volleyball Association (USVBA) team in Connecticut
76. Volleyball player-coach for the Connecticut Clippers
77. Named to the All-East United States Volleyball Association Regional team

78. Set LPGA and men's PGA record of just 17 putts in one round of golf—a record that still stands today

79. Struck out Ted Williams on several occasions—all when she was in her early 20s

80. Struck out home run king Hank Aaron and Paul Blair (when he was still playing for the Baltimore Orioles)

81. Won the bowling competition (181 average) in the ABC nationally televised Superstars Competition

82. Beat famed Hall of Fame professional bowler Andy Varipapa in a one-on-one match at Lakewood Lanes in Waterbury

83. Finished second in the tennis competition in the National ABC televised Superstars Competition. Also fared very well in the basketball, rowing, bike racing and swimming events

84. Finished sixth overall in the two Superstars appearances, competing against very stiff competition from very elite athletes

85. In front of an overflow crowd of 45,000 in Lanzhou (Lanchow) China, Joan pitched a no-hitter, barely missing a perfect game. The only batter to reach base for the Chinese team was by a walk in the third inning

Left to right: Joan Joyce, Andy Robustelli (NY Giants), Bart Starr (Green Bay Packers). Joyce and Robustelli were presented awards. Starr was the guest speaker. *From the* New Haven Register.

1962 A.S.A. National All-Stars

Back Row (left to right) – Johnnie Brooks (Coach Whittier Gold Sox), Margo Davis (Manager Whittier Gold Sox), Audrey Betz (Reading), Sharron Backus (Whittier Gold Sox), Darlene May (Whittier Gold Sox), Shirley Topley (Orange Lionettes), Carol Lee (Whittier Gold Sox), Lou Albrecht (Whittier Gold Sox), Arlene Eischens (Minneapolis), Janet Dicks (Reading). Front Row (left to right) – Carol Gilmore (Orange Lionettes), Chris Miner (Erv Lind Florists), Marion Fox (Toronto, Canada), Millie Dixon (Stratford Brakettes), Joan Paulson (Minneapolis), Carolyn Fitzwater (Erv Lind Florists), Carol Spanks (Orange Lionettes), Joan Joyce (Stratford Brakettes)

ASA National All-Stars, 1962. Joan is in front row, far right. *Courtesy of Softball National News, Stormy Irwin, editor.*

Coach Joyce presented with game ball by Athletic Director Pat Chun after winning her 900th game as FAU softball head coach. *Courtesy of FAU athletics.*

86. The "Joan Joyce – Outstanding Pitcher Award" is presented on an annual basis at the Women's Major Softball National Championship tournament to the outstanding pitcher in the WMS tournament
87. Babe Zaharias Award
88. Bertha Tickey Award, 1973, 1974, 1975
89. A successful 34-year career as a basketball referee
90. An 18-year career as a college head golf coach (FAU)
91. A long and distinguished coaching career—for 60 years and counting!

*These are statistics as *just* a Brakettes player—Joyce broke up her time with the Brakettes when she spent four years in California playing with the Orange Lionettes.
** Keep in mind, when Joan played basketball, there was no 3-point shooting.

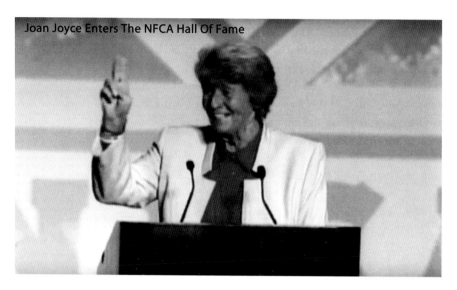
Joan Joyce Enters The NFCA Hall Of Fame

Joan accepting the NFCA Hall of Fame award. *Courtesy of Joan Joyce.*

HALL OF FAME INDUCTIONS

Throughout her career Joan Joyce has been a champion of women in sports.
—Connecticut Women's Hall of Fame.

Joan Joyce has been inducted into an incredible number of halls of fame—at least nineteen—including:

1. International Women's Federation Hall of Fame
2. Connecticut Women's Hall of Fame
3. International Women's Sports Hall of Fame (1989), one of only three Americans to be inducted
4. Palm Beach County Sports Hall of Fame
5. Connecticut Women's Basketball Hall of Fame
6. Hank O'Donnell Hall of Fame
7. Fairfield County Sports Hall of Fame
8. Greater Waterbury Hall of Fame—1997
9. Connecticut High School Coaches Association Hall of Fame
10. New England Sports Hall of Fame
11. Atlantic Sun Conference Hall of Fame
12. National Fastpitch Coaches Association (NFCA) Hall of Fame
13. Connecticut Sports Museum Hall of Fame
14. Florida Sports Hall of Fame
15. Connecticut Women's Volleyball Hall of Fame
16. National Amateur Softball Hall of Fame

17. Connecticut Scholastic Women's Volleyball Hall of Fame—November 21, 2000
18. Greater Waterbury Sportsmens Club Hall of Fame (formal induction in 2020)
19. USA Softball CT Hall of Fame

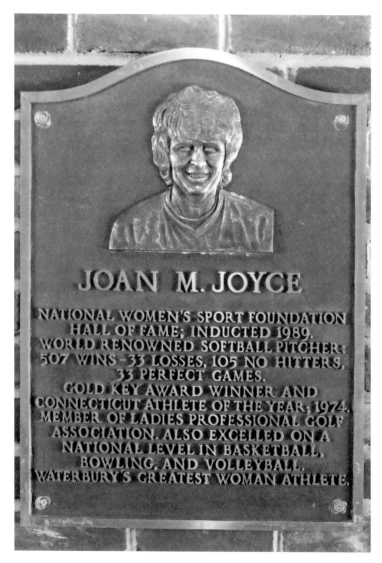

Plaque honoring the induction of Joan Joyce to the Greater Waterbury Sports Hall of Fame. *Photo by the author.*

Joan Joyce inducted into the Atlantic Sun Conference Hall of Fame. *Courtesy of FAU Athletics.*

Joan inducted into the Connecticut Women's Volleyball Hall of Fame, 2000. *Courtesy of Joan Joyce.*

Softball Hall of Famers honored at 1996 Olympics. *Left to right*: Joyce, Mickey Davis, Carol Spanks, Jeanne Contrel, Bertha Ragan Tickey. *Courtesy of Joan Joyce.*

Joan Joyce inducted into the NFCA Hall of Fame, 2013. *Left to right*: Rick Bertagnolli (California [Pa.]), Lori Meyer (Minnesota State, Mankato), Joan Joyce, Patrick Murphy (Alabama). *Courtesy of NFCA.*

Joan with Chrisina Sutcliffe, who introduced her at the NFCA Hall of Fame Banquet. *Courtesy of FAU Athletics*.

Joan Joyce inducted into the Fairfield County Sports Hall of Fame. Walter Luckett, left. *Courtesy of Fairfield County Sports Hall of Fame*.

AN ENDURING LEGACY

*When I grew up we had no choice but to idolize men like Mickey Mantle. Now
girls can grow up idolizing women in team sports.*
—Joan Joyce

Throughout her long and illustrious career, Joan Joyce never believed in
setting goals for herself. The only "goal" Joan ever had was winning
every game she was a part of, no matter what the sport. She backed up this
belief by her hard work, dedication and a fierce sense of competition. At the
same time, it was never totally about her. In talking to her teammates, Joan
was always a team player and was much more comfortable in giving credit
to her team than herself. Joan's entire career was encouraging others to be
the best they can be whether it was on the softball field, basketball court or
volleyball gym.

As both a player and as a coach, Joan would always encourage her players
to improve their level of play. As Joan puts it, "I think the best asset I have is
being able to analyze a sport and teach it. I just had a good head for playing
the games, understanding what needs to be done, and providing advice to
teammates and players I have coached over the years." Joan's coaching and
officiating career began soon after graduating high school. She coached and
officiated softball, basketball and volleyball at numerous high schools—all
while playing softball and basketball at a high level. As a twenty-year-old,
Joyce coached a girls' softball team called the Waterbury Sunliners in 1961
(Town Plot section of Waterbury). Joan also has participated in many clinics

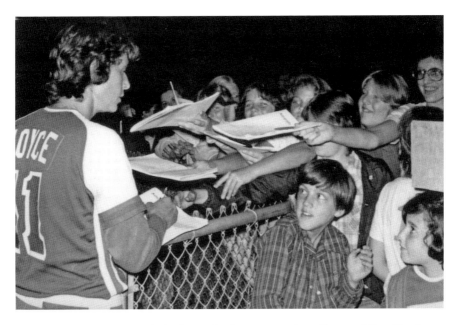

Joan Joyce has created an enduring legacy for future generations. *Courtesy of Joan Chandler.*

around the world. She has provided valuable advice and instructions as a player, team owner, coach and referee in the wide variety of sports that she has been involved in. After her playing days were over, Joan became the head coach for the Florida Atlantic University (FAU) women's softball and golf teams. Her current and former FAU players (to a person) speak very highly and lovingly of Coach Joyce for the inspiration and knowledge she has shared with her athletes (or, as Joan often refers to them, "my kids").

The FAU website recalls an interesting occurrence that highlights the admiration and respect Joan has received so often from young players:

> *In 1995, Joan took her young FAU first-year team to watch the U.S. women's softball team practice in Orlando, Florida. The team was practicing for the 1996 Summer Olympics held at the Golden Park in Columbus, Georgia. Besides observing the play of the U.S. team, the hope was that her players would get to meet some of the future Olympians and possibly get some autographs. But at the end of the practice, the U.S. players spotted Joyce, and immediately surrounded her, asking for* her *autograph. The U.S. players also asked Joan to demonstrate her famous slingshot delivery.*

Joan Joyce played sports mainly for the love of the game. She received very little or no remuneration during her entire playing career. To support herself over the years, Joan took on a variety of teaching positions and jobs in Connecticut (and New York), all while she was actively participating in a variety of sports. She used these job opportunities to encourage her students to be the best they could possibly be. And the students always accepted her challenges.

In her honor, several official accolades have been established in her name. (For example, a softball field was named after her, and a Joan Joyce league was formed.) On August 15, 2015, Joan Joyce was honored at Waterbury's Municipal Stadium. Mayor O'Leary proclaimed August 15, 2015, as Joan Joyce Day. The softball field next to Municipal Stadium was renamed Joan Joyce Field. (Municipal Stadium was the field in which Joan struck out Ted Williams on several occasions.) Speaking to the large crowd at the tribute, Joan Joyce stated, "I am so proud to be from Waterbury!"

Joan Joyce has created an enduring legacy that has been an inspiration to young children, both young girls and young boys. Several years ago, Joan Chandler (who was a photographer for the Falcons) told a story of one such boy. In Joan Chandler's words, "Six-year-old Richard asked Joan Joyce to wait until he grew up so he could marry her. Twenty-five years later he came to our reunion. I took a photo of the six-year-old when he presented Joan with a scrapbook he made of Joan's softball career."

When Joan pitched, parents made it a point to bring their young children to the games at Raybestos Field or Municipal Stadium to watch a true legend. Many stories have been told of the amazing and significant impact that Joan has had on young children (mainly little girls) who, after watching her pitch, dreamed of becoming the next Joan Joyce. As Joan has stated, "When I grew up we had no choice but to idolize men like Mickey Mantle. Now girls who grow up today can look up to and idolize female athletes who have excelled in team sports."

Above: Joan and her young fans Bridget (*left*) and Meghan. *Courtesy of Joan Chandler.*

Left: Six-year-old Richard shows Joan the scrapbook he made of her career. *Courtesy of Joan Chandler.*

Above: The look of admiration on these youngsters' faces says it all. *Courtesy of Joan Joyce.*

Left: Kerry Renzoni (*center, author's daughter*) presented with sports award by Joan Joyce (*left*) at Hamden High School (Hamden, Connecticut) in 2000. *Author's collection.*

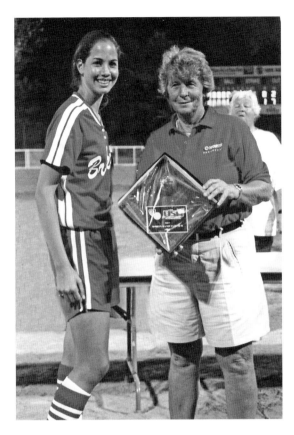

Left: Joan presenting the MVP award of the 2002 ASA National Tournament to Brakettes pitcher Cat Osterman. *Courtesy of Brakettes Softball Photo Archive.*

Below: Joan signing autographs for young fans. *Courtesy of Joan Chandler.*

Coach Joyce directing the action. *Courtesy of FAU Athletics.*

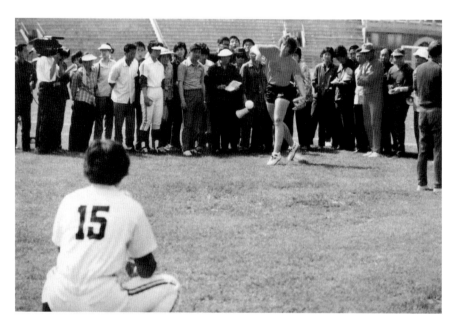

Joan in China participating in a clinic. *Courtesy of Joan Chandler.*

Joan Joyce, Steffi Call at DeLuca Field, 2011. *Courtesy of Kathy Gage*.

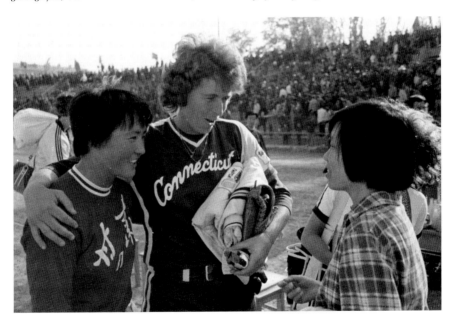

While in China, Joan took time to provide advice to many young Chinese girls. *Courtesy of Joan Chandler*.

Left: FAU's Courtney Shoff. Learning from a legend. *Courtesy of FAU Athletics*.

Below: Coach Joyce providing instructions to new recruits. *Courtesy of FAU Athletics*.

Miss Joan Joyce
Physical Education

Left: Joan was the physical education teacher and girls' basketball and volleyball coach at Waterbury Catholic High School (Waterbury, Connecticut) from 1961 to 1963. *WCHS Yearbook, author's collection.*

Below: Coach Joyce providing last-minute instructions to her St. Mary's High School basketball team, 1967 (Greenwich, Connecticut). *Greenwich Yearbook, author's collection.*

Coach Joyce provides pre-game pep talk to her Waterbury Catholic High School basketball team. *WCHS Yearbook, author's collection.*

Joan giving golf lessons, 2018. *Courtesy of Kathy Gage.*

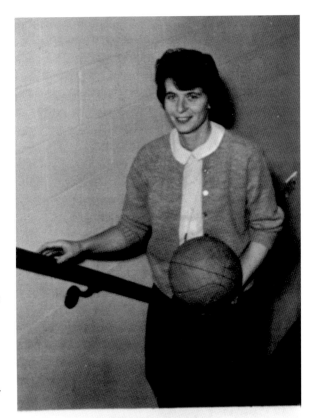

MISS JOAN JOYCE
Physical Education

Right: Joan was a physical education teacher and coach of basketball and volleyball at St. Mary's High School in Greenwich, Connecticut (1967). *Greenwich Yearbook,* author's collection.

Below: Coach Joyce and her Waterbury Catholic High School basketball team, 1961. *Courtesy of Patricia Lenti-Crane, Crosby Yearbook.*

Joan refereeing/coaching girls' 1963 basketball team at Waterbury Catholic High School (Waterbury, Connecticut). *WCHS Yearbook, author's collection.*

Coach Joyce with her Waterbury Catholic High School basketball team, 1962. *Courtesy of Patricia Lenti-Crane, WCHS Yearbook.*

One of Coach Joyce's players at FAU, Tatum Buckley. Tatum also played for the Brakettes from 2014 to 2017. *Courtesy of Kathy Gage.*

Left to right: Joe Joyce, Ginny Joyce, Joan Joyce, Jackie Ledbetter at Las Vegas Tournament 2016. *Courtesy of Jackie Ledbetter.*

Joan addressing a very enthusiastic crowd during Joan Joyce Day at Municipal Stadium, Waterbury, Connecticut. *Courtesy of Kathy Gage.*

Joan points the way for future generations of stars. *Courtesy of Joan Chandler.*

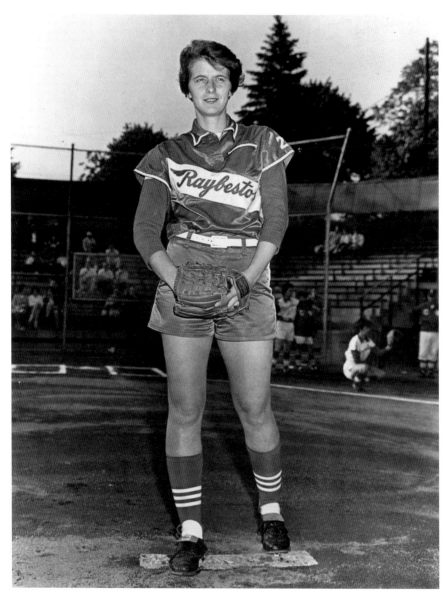

Joan Joyce. *Courtesy of Brakettes Softball Photo Archive.*

Appendix A

QUOTES AND PRAISE
FOR JOAN JOYCE

Joan Joyce is THE *legend in our great game of softball. She was an amazing athlete and is an incredible coach. She helped me tremendously during my playing career and this outstanding book pays tribute to her. This book is a must read to be "in the know" of the history of our sport and the legendary Joan Joyce!*
—MICHELE SMITH, *ESPN analyst, two-time Olympic Gold Medalist*

JOAN JOYCE IS ARGUABLY one of the most talented and skilled woman athletes in the history of sports. Joan was not exceptional in just one sport but many, including softball, golf, volleyball, basketball, bowling and any other sport she chose to play. Her success was not just at the regional or local level, but at the national and international level as well. Joan's wide range of success can be attributed to her motivation to succeed, her confidence in her execution and her ability to focus on the goal before her. Many put Joan in the category of Babe Didrikson Zaharias. What sets Joan apart from others is that not only was she a performer and successful athlete, but she also took her talents to the coaching ranks and has had many successful years coaching both golf and softball at the NCAA Division I level. Joan is a one-of-a-kind athlete, and I doubt there will ever be another one with her talents.

—Debbie Chin, retired associate vice president,
director of athletics and recreation, University of New Haven

I REMEMBER RUNNING HOME from Mass on Sundays because I knew my dad would take me to watch Joan Joyce pitch for the Brakettes. It was such a thrill to watch Joanie pitch. I really admired her talent, composure and determination on the mound. She was the absolute best and still is!

—Bobby Valentine, former MLB player and manager,
current athletic director at Sacred Heart University (Fairfield)

WHEN I PLAYED FOR the Lansing Laurels, it was a thrill of a lifetime when Joan Joyce and the Brakettes came to Lansing, Michigan, to play against our softball team. I was absolutely star-struck the first time I saw Joan. It wasn't until Joan came on the scene that I really had a female role model who inspired me to play team sports. She is the reason why I got into softball.

Batting against Joan Joyce was terrifying! Batters would go up there and just hope to make some sort of contact. The first time I got to bat against Joan, I fouled one off, and we all thought it was cause for celebration! It would be more fair to the hitters if we got five strikes against Joan, but I don't think it would have mattered. In my opinion she was not only the greatest female softball player, but you can put her in the same class as elite *male* players such as Sandy Koufax and Mickey Mantle.

Joan was an imposing figure on the mound. You can see the determination, confidence and grit on her face. She was the original badass!

I had the wonderful opportunity to play golf with Joan, and I marveled at her athleticism. In every sport Joan was involved in, she demanded the best not only from herself but also from her teammates, as if to say, "I'm going to do my part, so pick it up and do your part!"

Joan Joyce was the greatest female athlete on earth.

—Carol Hutchins, Hall of Fame head softball coach
of University of Michigan

JOAN JOYCE IS ONE of the greatest female athletes of all time. Her athletic accomplishments are legendary as she was an outstanding performer in softball, basketball, golf, volleyball and bowling. And today she continues to build on her storied career as a highly-successful college coach. Joan Joyce is widely recognized as the greatest softball player of all time.

—Fairfield County Sports Hall of Fame, 2006

JOAN IS A FRIEND, a great teacher of the sport, a wonderful woman who loves each and every one of her students and quietly demands the best from them. Starting from when I was little, I always wanted to be like her. She was my idol, and I am proud today to call her my friend.

In my rookie year with the Brakettes in 1971, we had an undefeated season 57-0. Dreams do come true, even for me! I've always known Joan to give 100 percent, whether it was playing fast-pitch softball, striking out Ted Williams, playing basketball, volleyball and golf.

Joan Joyce is the greatest woman athlete in sports history!
—Linda R. Finelli, Brakettes 1971–74

I FIRST MET JOAN Joyce when we were both eighteen years old. I had just signed a bonus contract to pitch in the Milwaukee Braves organization and Joanie was at the beginning of her legendary career with the Raybestos Brakettes. Joanie was the greatest athlete ever in sports. No other athlete that I know of—male or female—could dominate the sports world like Joanie. She did it all—softball, basketball, volleyball, golf, bowling—you name it. And she played all these sports at the highest level. She had the very unique ability to be able to transition from being dominant against women to being almost as successful against men. In other words, against women she would strike out nineteen out of twenty-one batters and against men she would be able to strike out fourteen out of twenty-one batters. Joanie has been my idol ever since I was an eighteen-year-old kid.
—Pat Jordan, former pitcher in the Milwaukee Braves organization and now a freelance writer living in Abbeville, South Carolina

I'VE BEEN IN THE golf business over forty years, working in both the LPGA and PGA tournaments, and have been associated with Callaway Golf since its inception. I've seen closeup what it takes in time and effort to play professional golf.

At a time when most professional golfers are thinking about retirement, thirty-seven-year-old Joan Joyce decided to join the LPGA Tour. Without any real background in golf, no credentials and very little training, she played three amateur tournaments and then qualified for LPGA. I can't stress enough what an unbelievable accomplishment that is! Tour players start playing at a very young age (ten to fourteen years old). Golf is a sport in which timing and tempo are important. Equally important are such variables

as dealing with nerves and learning from failed shots and performances. This process normally takes a long time to develop. Joan had none of that to fall back on as a golfer. What she did have was the athletic ability, confidence and determination to do something pretty special.

Even though we were both from Waterbury, Connecticut, I had never met Joan until I saw her hitting golf balls on the practice range at Mission Hills Country Club preparing for the Dinah Shore LPGA event that I was involved in. It was such an athletic and controlled swing. And it was fun to watch!

My college basketball coach (John Salerno) was general manager of her Connecticut Falcons Pro Softball Team, so we talked for a while about Joan and about her golf game. At one point, Joan had said that the toughest thing for her at the time was transitioning from the top of her swing with a golf club as opposed to the quick move with a bat. But she had the ability to do it—and did it.

The path to professional golf is unbelievably difficult. I'm coaching a high school girls' team in California. Several of the players have a chance to turn pro at some point. Unlike Joan Joyce, all these girls started at age ten and now at age fourteen and fifteen, they have "swing coaches," "workout coaches" and "mental coaches." They also play national events all over the country. If Joan had what these girls have, she certainly would have dominated the ladies' golf tours. What Joan did was an amazing thing that anyone that plays golf would be hard pressed to think could really happen. To me it's like a great sports fictional movie but you know it could never happen!

—Bruce Loman, Callaway Golf

HAVING GROWN UP IN Waterbury, Connecticut, in the 50s and 60s, softball (especially "fast-pitch" softball) was one of the most popular sports in the city. My dad (Nick Augelli Jr.) played fast-pitch softball in Waterbury's Town Plot league. He used to tell me about the time he played against Jimmy Piersall, who played in the Waterbury leagues when he was younger. I also believe that my dad played against Joanie's dad when he played for the Waterbury Bombers. The amateur teams drew big crowds, and as teenagers my friends and I aspired to play one day on one of the premier men's teams. Everyone knew of the Raybestos Brakettes women's softball team and especially Joan Joyce, since she was a Waterbury native. I believe Joan coached a girls' softball team in the Town Plot league one summer. I saw Joan pitch with

the Brakettes and the Connecticut Falcons quite a few times. I also saw her pitch to Ted Williams at Waterbury's Municipal Stadium. Joan Joyce was an incredible all-around athlete!

—Nick Augelli, Seminole, Florida

JOAN JOYCE WAS MY physical education teacher when I attended Waterbury Catholic High School (WCHS) in Waterbury, Connecticut. I played third base on an all-girls softball team at Town Plot field in Waterbury, and Joan was my idol growing up. I was in complete awe of Joan when she came to WCHS as our phys ed instructor. I knew she was an amazing softball player, but I never realized that she was also a fantastic basketball player. When she took basketball shots in the gym, she never missed!!

Thanks to Joan, we learned the value of good teamwork, dedication and a love for the game of basketball. She treated us with respect, encouraged us to do our best and gave everyone a chance to play. Her mantra to us was "You can do it!"

—Linda Bozzuto, WCHS class of '66

AS THE STATISTICIAN AND publicist for the Connecticut Falcons, I saw firsthand what an amazing world-class athlete Joan Joyce was. She was a terrific volleyball player, an outstanding golfer, a great bowler and a superior, talented softball player. Joan was way ahead of her time. There is no doubt that if she received the media coverage that athletes receive today, Joan Joyce would certainly be a household name in today's athletic circles. As a coach and administrator, she was unmatched in making her teams competitive and was solely responsible for getting the Mattatuck Community College women's athletic program off in the right direction. But most of all, she is a genuine, nice person striving to help other young athletes further their athletic careers and always a pleasure to be with.

—Jerry Di Pietro, former Mattatuck Community College sports information director, former Connecticut Falcons statistician/publicist

JOAN BECAME OUR PHYSICAL education teacher at Waterbury Catholic High School in 1961. Prior to that, we had an elderly phys ed instructor who wasn't really sports-minded. Our phys ed assignments consisted of things such as marching around the Maloney School gym and square dancing. It

was frustrating and boring. When Joan arrived at WCHS as our physical education instructor, it was like night and day. Under Joan, our phys ed classes were both fun and challenging. She always encouraged us to do more and to do it better. Joan was also our basketball coach and she taught us the value of teamwork. Joan Joyce was an integral part of our Waterbury Catholic High School community and was loved by all.

—Patricia Lenti-Crane, WCHS class of '62

JOAN JOYCE WAS MY physical education teacher at Waterbury Catholic High School (1960–62). She was only a few years older than we were. Joan was always warm and professional, a great teacher and eventually a good friend. She also coached our basketball and softball teams. In those years, WCHS and Notre Dame Academy were the only schools in town that had girls' basketball teams. So the team traveled all over to play. I did not play myself, but I had friends on the team. Of course, Joan was pitching no-hitters on a regular basis. She was amazing and always humble about her talent.

At this time, Joan also went back to school part-time at Southern Connecticut and began working on her degree. She was really encouraged in her pursuit of education by the religious women at WCHS, especially Sr. Jean Dwyer. Joan was a scholar athlete as well as just athlete.

Joan Joyce never sought attention for herself. She was always a team player and celebrated the gifts of everyone. Her quiet sense of humor and incredible work ethic inspired my generation of girls in high school.

—Sr. Pat McCarthy, CND

Left: Joan Joyce waving to the fans. *Courtesy of Kathy Gage.*

Below: Joan Joyce and author in West Haven, Connecticut. *Author's collection.*

Appendix B

INTERVIEWS

Interview with Joan Joyce

July 2, 2018

I would have hated to bat against me.
—Joan Joyce

TR: Joanie, thank you for agreeing to this interview.

JJ: My pleasure, Tony.

TR: Is it alright with you if I refer to you as Joanie?

JJ. Absolutely! I tell everyone down here in Florida that I am best known in Connecticut as Joanie Joyce. Down here, I'm known as Joan.

TR: First of all, I wanted to congratulate you on your outstanding career. I also wanted to congratulate you on your upcoming induction into the Atlantic Sun Hall of Fame in August 2018.

JJ: Thank you very much. The Division 1 Atlantic Sun conference (originally known as the Trans America Athletic conference) was the very first conference that my softball team at Florida Atlantic University played in. We dominated that conference. Then we went from there to the Division 1 Sun Belt, and then from the Sun Belt we went to Division 1 Conference USA.

TR: We have a couple of things in common. Like you, I was born and raised in Waterbury, Connecticut. I lived in the Town Plot section. I played baseball and basketball on fields and parks that you mentioned

in previous interviews, Fulton Park, City Mills, Town Plot Park, etc. Of course, I certainly didn't play ball on the level that you played. I guess one of my "claims to fame" was that Terry Tata umpired our games. He then went on to have a great career as a major league umpire. Also, growing up I was a big admirer of Mickey Mantle, who was your idol growing up in Waterbury.

JJ: I went to school with Terry Tata at Crosby. He lived right down the street from me in Waterbury. I knew Terry well. Great guy. And I have a photo of Mickey Mantle in my office. I had the pleasure of playing golf with Mickey.

TR: I saw the video of the renaming of a facility next to Waterbury's Municipal Stadium in your name. That was really cool.

JJ: Yes, it was. Municipal Stadium has two parts to it. They have the baseball field, and they have a softball field right next to it. That is the field that they named for me. It's a very nice field.

TR: Ok, I'd like to ask you a few questions about growing up in Waterbury, Connecticut. First of all, where did you live in Waterbury?

JJ: I first lived on Hill Street, and then when I was around eight years old my family moved to Tudor Street in Waterbury. Terry Tata lived down the street from me. And when I was in eighth grade, I actually helped a fellow build a house, about three or four houses up the street. For a time growing up, I wanted to be a carpenter. I was walking by, and the guys were building this house. And, of course, nosey me asked the fellow if he needed help. So it ended up that it was this seventy-five-year-old carpenter and myself who built the house. *Laughter.* I did everything. I put roofs on, I put tiles in the bathrooms, everything. And so, my parents ended up buying the house that the guy and I built. For helping to build the house, the contractor (Tommy Garafola) bought me a beautiful bicycle, which I loved. I would ride my bike around the neighborhood. As you know, Waterbury has these steep hills, so I had to stay on the flat streets around my house. So that's where I lived in Waterbury. Hill Street when I was really little and then Tudor Street.

TR: Where did your mom and dad work in Waterbury?

JJ: My dad, Joe, was a foreman at Scovill's factory. My mom (Jean) worked at Chase Brass & Copper Company. Actually, they worked different shifts so that one of my parents would be home to watch us kids. My father would work either the 11:00 p.m.–7:00 a.m. shift or 7:00 a.m.–3:00 p.m. He mainly worked the 11:00 p.m.–7:00 a.m. I remember him coming home in the morning bringing us donuts for breakfast. And then after taking

us to school, he would take my mother to work at 3:00 p.m. and then he would take my brother, Joe Jr., and I to the ballfield or basketball court. My sister, Janis, stayed home.

TR: I'm interested in your father playing both fast-pitch softball and basketball. Who did he play for and where did he play?

JJ: My father played for everyone! *Laughter.* But he mainly played for the Waterbury Bombers down at Waterbury's City Mills park. He played with guys like Tony Marinaro, Ike Icovone, Joe Byne and Dick Ierardi. They were all great! My father played third base for the Waterbury Bombers.

TR: I remember watching them play. They were great, an exciting team to watch.

JJ: Yep, they sure were. They were probably one notch below the Raybestos Cardinals, who were our men's team at Raybestos. They would be competitive against the Cardinals, but the Cardinals would end up winning, mainly because of the Cardinals' pitching. Tony Marinaro of the Waterbury Bombers was our mailman. In the summertime, I used to go up to the top of the hill to help him deliver. *Laughter.* In return, he would spend about twenty minutes with me to teach me softball. Tony Marinara actually was the one that told me about the Raybestos Brakettes.

TR: What team did your father play basketball for?

JJ: My dad played for a number of basketball teams. He played for Crosby High School, Waterbury Knights of Lithuania, Scovill's and the New Britain Cremos. In the winter, we would be going to games just about every night. I remember that whenever there was a time out or at half time, my brother Joe and I would immediately run out on the gym floor to make sure to be first to grab a basketball and shoot.

TR: Did your parents go to your games?

JJ: Oh yeah, they made a point to attend all my games. The only exception was golf. They didn't understand that game. One time my mother did go to one of my golf matches. My mother was sitting in a chair off the tenth green. After I finish putting, my mother says to me, "Joanie, I'll wait here until you get back." I tell her, "Mom, I won't be back here until tomorrow!". *Laughter.* My biggest fan was my dad (Joe Sr.). He would closely observe me whether I was pitching or hitting. Afterwards he would offer his advice. If I went three for four, a family member would ask, "Why didn't you go four for four?!" *Laughter.* Both my parents were very, very supportive! Up until his death in 2013, my father made a point to attend all my softball games, as a player and as a coach.

TR: What schools did you attend in Waterbury?

JJ: I attended Webster Grammar School, graduating in the spring of 1954. I then attended Crosby High School in September 1954 and graduated in the spring of 1958. Webster and Crosby High Schools are in Waterbury.

TR: Tell me about your experience with the Little League.

JJ: When I was twelve years old, my brother would take me down to City Mills where his Little League team played. So, I got to practice a lot with the boys on the Little League team. When the league began, I remember going up to a Little League stadium up on Watertown Avenue. So I played a game with the boys' Little League team. I was their catcher.

TR: How did you do playing on their team?

JJ: I knocked a couple of balls off the fence. I got a triple and a double in the game.

TR: Really?

JJ: Yep. But after the game, I was told by the administrator, "Girls are not allowed to play in Little League." I'm sure it was because I knocked some balls over the outfielders' heads. *Laughter.* They just didn't want me to show up the boys in the league.

TR: So you were kicked off the team after that one game?

JJ: Right.

TR: After playing the one game with the Little Leaguers and getting kicked out, did you play softball at age twelve?

JJ: Oh sure. I used to play softball at Fulton Park. In the summer, they would have a tournament with teams from all the parks in Waterbury. So our team (Fulton Park) would play against all the other teams from Waterbury Parks. The person who was our "coach" really didn't know anything about softball. So, I ended up being our coach! *Laughter.*

TR: Did you pitch when you played for Fulton Park?

JJ: Yes, that is where I first started to pitch. But it was the type of pitching where you would let all the kids hit. But still I got to pitch and play field a lot.

TR: So, when did you begin with the Raybestos Brakettes?

JJ: At age thirteen, right after playing for Fulton Park.

TR: At age thirteen?

JJ: Yep. I tried out for the Raybestos Brakettes at age thirteen, and I made the team.

TR: When did you learn to use the "slingshot" method of pitching?

JJ: When I was sixteen, a pitcher by the name of John "Cannonball" Baker happened to be up on a ladder, putting up bunting for a Raybestos game. "Cannonball" pitched against the Raybestos Cardinals. At one point he

looked down and saw me pitching, using the "windmill" delivery, which is a very common pitching method. So, "Cannonball" yells down to me, "Hey, why don't you use the slingshot delivery?" I told him I was not familiar with that delivery. So he came down from the ladder and began to show me the "slingshot." He encouraged me to use that method since I would be able to generate a lot more speed, power and accuracy using that delivery. I had been pitching for a year or two before that. But I was wild and would actually hit batters. I hated it. So, I began practicing the slingshot for twenty to thirty minutes, until I got comfortable. It didn't take long for me to adapt to that delivery method. As soon as I changed to the "slingshot," it was a *totally* different world. A totally different scene! That one year, it was unbelievable the difference in my pitching.

TR: So once he showed you how to use the slingshot delivery, how long did it take you to use that delivery method in a game?

JJ: I used it *immediately*! And what a difference it made. I was now able to pitch the ball with total accuracy, and I was able to generate a lot more power using the slingshot. Such a great feeling to be in total control of all my pitches.

TR: Sounds like "destiny" to me. I mean, what are the chances of someone like that being up there at that very moment—who was not associated with your team or even the men's Raybestos team—showing you an entirely different delivery method which would alter your pitching career forever?

JJ: Yes, it was definitely fate or destiny, or whatever you want to call it. These "destiny" things happened to me all my life! I guess part of it is being in the right place at the right time.

TR: Yep, but it's also acting on your gut feelings and working hard to perfect these suggestions, which obviously you did.

JJ: Yes, that's true.

TR: Did you get a chance to thank Cannonball?

JJ: Oh yeah, certainly.

TR: That must have been a turning point for you.

JJ: A *major* turning point!

TR: In 1956, Bertha Ragan joined the Brakettes after being the star pitcher for California's Orange Lionettes. What impact did Bertha Ragan have on the Brakettes?

JJ: It was a major impact. When Bertha joined the team, she changed the whole complexion of the team. She was so good. She changed everything not by words but by her actions. We began to really believe in ourselves, and our team became very competitive. Bertha led by example. I was

only fifteen years old, and my pitching delivery was completely different than Bertha's delivery. She was a figure-eight pitcher, so it was difficult for us to relate to each other from a pitching standpoint. But I was certainly influenced by Bertha's winning attitude.

TR: As a teenager what type of music and recording artists did you listen to?

JJ: I was at the age of watching Elvis come on the scene. But you know what? My absolute favorites were Johnny Mathis and Bobby Vinton. I think I still have every one of their albums, and I still play their songs. "Chances Are," by Jonny Mathis, such a wonderful song!

TR: So you graduated from Crosby High School in 1958. Did you go to school after that?

JJ: Yes, I attended Southern Connecticut State College but left after a year because I wanted to get a job. So I worked at Raybestos for about a year. Then I worked at Lakewood Lanes bowling alley in Waterbury for about six months. All the while, I was officiating girls' basketball. The day after I officiated a game between Waterbury Catholic High School and Stamford Catholic High, I got a call and was offered a job coaching the WCHS girls' basketball team for the 1960 season. The following year, 1961, I became the phys ed teacher and coach of the girls' basketball and volleyball team at WCHS. I did this at WCHS from 1961 to 1963. In 1963, I decided I wanted to go away for a while but at the same time pursue my college and softball careers. I thought to myself, where can I go that would have a softball team that was almost as successful as the Brakettes? That's when I decided to join the powerhouse Orange Lionettes and attend Chapman College, which were both located in Orange, California. This was in September 1963.

TR: When did you return to Connecticut?

JJ: I graduated from Chapman in the spring of 1966. I then returned to Connecticut after my 1966 season with the Lionettes.

TR: Did you face Ted Williams other than your encounters at Waterbury's Municipal Stadium?

JJ: I actually faced Ted Williams several times. The first time I pitched to Ted was at his camp in Lakeville, Massachusetts. This was in May 1961. I had a sore shoulder when I faced him in Lakeville so I didn't want to throw hard and allowed all the batters to hit, including Ted. At the camp, Ted mentioned that he was asked by some promoters to bat against me in August at Municipal Stadium in Waterbury. So I faced him again in August 1961. Actually, I pitched to Ted several times, the event in Massachusetts and several times in Waterbury. Our last matchup was in 1966.

TR: Jumping ahead in your softball career, what was the "Joan Joyce Rule"?

JJ: That was when I pitched for the Connecticut Falcons. The Falcons were part of the Women's Professional League (WPS). The WPS league organizers said I was too dominant against other teams so they decided to move the pitcher's mound back four feet, from forty feet to forty-four feet. The reason they gave was that by moving the mound back four feet, it would make it a bit easier to hit against me. They called it the "Joan Joyce Rule." So I had to relearn how to pitch, and I made the adjustment to the point where I became comfortable pitching at that distance.

TR: I would say so, because I know there were games right after they moved the mound in which you pitched some great games. Which batter was the toughest for you to get out?

JJ: Carol Spanks. She had a good batting eye. In my opinion, she was one of the best hitters in the game. I actually developed a special screwball pitch just for her (down and in) to get her out.

TR: In the very first game of the 1976 WPS World Series, you pitched against the San Jose Sunbirds. The Falcons won the game 3–0. Charlotte Graham was the pitcher for the Sunbirds. What do you remember about that first game?

JJ: The first game was held at Meriden's Falcon Field. Going into the championship, I was 39-2 in the regular season. Charlotte and the Sunbirds were very good, but we were confident about our chances of winning, especially after having done well in the playoffs. The one thing I remember about Charlotte is that she dug a hole in front of the pitcher's mound so deep that I was afraid I would break my ankle if I stepped into it. *Laughter*.

TR: In 1979, the Falcons traveled to China on a goodwill tour, playing softball and participating in clinics. What was the experience of playing in China like?

JJ: It was a phenomenal experience! I was told that the Connecticut Falcons were the first organized team to play in mainland China. We played in front of massive crowds. *People* magazine sent a reporter there to cover our experience in China. They had cameras on me everywhere and filmed all of my pitching deliveries. They actually asked me to go back to China for six months and teach them more about pitching, but I said no. I think I would have really starved because I could not adapt to the food there. I mean I was on chocolate the entire time there! *Laughter*. My room overlooked the street, and every morning a truck would pull up and the driver would toss meat at the entrance to the place we were staying in, pigs

and whatnot, and someone would drag the meat into the kitchen. So that was the end of me eating the food there. I stuck with my chocolate bars! *Laughter.* I brought my golf club with the hope of practicing my golf game while I was there. Boy, was I surprised because there was no grass there! Actually, I was hoping to drive a golf ball over the Great Wall of China but I forgot to bring my club. And, anyway, I'm not sure the authorities would have let me do that! *Laughter.* But, overall, it was such a one-time phenomenal experience!

TR: You had so many no-hitters and amazing games as a pitcher. What was your worst game as pitcher?

JJ: I would have to say it was a game in Buffalo, when I pitched for the Falcons. We were playing the Buffalo Breskis that night. I remember that it was a beautiful day in Buffalo. It was so warm that I didn't even bring my jacket to the game. About an hour before game time, the weather changed dramatically. The temperature dropped at least thirty degrees, with the wind blowing very strong. We suddenly experienced the wind effect coming off the lake in the Buffalo area. We went from short sleeves to being freezing. The wind gusts were blowing from home plate to center field. Pop ups were blowing out of the park. I know because I popped a ball up myself and it flew out of the ballpark for a home run. *Laughter.* I asked our coach Brenda (Reilly) to take me out of the game. Brenda replied, "No, I think it would be good for you to experience one game in your life in which you knew what it was like to get your butt kicked!" *Laughter.*

TR: Let's say it's tie score, bases loaded, last inning, two outs, and the count is 3-2, which pitch would you throw?

JJ: Depends.

TR: Would it depend on whether it was a right-handed or left-handed hitter or the type of hitter?

JJ: The type of hitter. For example, Shirley Topley, who was a very good player, could hit my rise ball but not my drop. So if I needed a strikeout, Shirley would get nothing but drops.

TR: But did you have a "go to" pitch in key situations?

JJ: No. I trusted both my rise ball and drop ball enough to throw in any situations. I threw hard enough that either the rise ball or drop ball would not only reach the plate fast but would move dramatically. In all honesty, I would have hated to hit against me. You almost had to guess what I would be throwing. And you had to be ready to swing when you immediately saw the ball leaving my hand. Otherwise, you weren't

going to hit it. *Joan snaps her fingers.* That's how fast the pitch is and how much time you had to swing!

TR: How fast did you throw?

JJ: I have no idea. And, of course, there were no radar guns in those days. I'm told the pitches were 119 miles per hour, in terms of reaction time. When I was pitching in California, there was this gal (Fran Shaftma) who did her doctorate at USC on softball pitching. She brought all of the top pitchers in from the Pacific Coast League and she put us through different tests for three days at Long Beach State College. In that study, it showed that my pitches were coming into the batter with a reaction time of a pitch coming in at 119 miles per hour.

TR: You once said in a newspaper interview that you were so competitive that if your mother or father wanted to bat against you, that you would have to strike them out. If your dad did step up to the plate, what pitch would you throw him to strike him out?

JJ: *Laughter.* Well, I'll tell you, I actually did pitch to my dad once. He came home from work one day and started needling me, saying "I can hit you." I told him, "Oh no you can't." So he gets his bat and says, "Ok, let's see what you got." So I throw him a rise ball. On the first pitch, my dad fouls the ball off and it goes right through our house window. My mother wanted to kill us! *Laughter.* So that was the only time I threw a pitch to my father. We didn't want any more broken windows! *Laughter.*

TR: Ok, so what pitch would you throw to your mother?

JJ: Oh, that wouldn't even be a contest! A very slow ball, I guess. *Laughter.* I think the only sport my mother played was bowling. She liked that.

TR: Did you play softball during the winter?

JJ: I never threw once during the wintertime. After the softball season ended, it was time to concentrate on other winter sports like basketball, volleyball, even bowling. I don't know that I would have liked playing one sport all year long. I would have been bored to death.

TR: Let's turn to basketball. Did you play basketball in school?

JJ: Yes. When I was a freshman at Crosby High, I played intermural basketball. We actually played a six-player game. One day, I saw in the newspaper that there were tryouts for the Libra AA Women's Basketball team in Waterbury. So I asked my father if I could try out. He said he would take me there but he would have to see what it's all about. I was only fifteen at the time. So I tried out and I made the team. I played with Libra AA for about a year. When I was a junior at Crosby High I tried out and made the New London Wheels women's basketball team in New London,

Connecticut. It was a very good team. They asked me to play in a national tournament. I believe I was sixteen at this time. I know I didn't have my license yet. A friend of mine from Hamden also was on the New London Wheels. So she would have to pick me up and drive to the games. We competed in several national championships of the Women's Basketball Association (WBA). For women at the time, the six-player basketball game was always used. The WBA was unique because it was a five-player game, a precursor of how the game would be played in years to come.

TR: What position did you play in basketball?

JJ: I played forward.

TR: It sounds to me that you really liked basketball.

JJ: Oh yeah, that was my favorite—by far. I loved playing basketball. My dad told me all the time that I was better in basketball than softball.

TR: Wow! That's saying a lot!

TR: When did you take up bowling?

JJ: I bowled right along, during the whole time. In the wintertime, I bowled in numerous leagues. Friday nights "pots" down in Ansonia, where we bowled for money. I remember when I was a student at New Haven's Southern Connecticut State College, going to Ansonia and bowled pretty much all night. We didn't start bowling until 11:00 p.m. or midnight. Actually, that was big-time stuff. I remember bowling in some very big money leagues.

TR: I heard that you once bowled against a very popular singer. What's the story behind that?

JJ: I was working at Raybestos at the time. My father read about a new ten-pin bowling alley in Waterbury, I think it was Lakewood Lanes. This was in 1960. So, my brother, Joe, my father and myself decided to bowl there. At 5:30 p.m., there were cars all over the place and a large crowd to get into the bowling lanes. I went to go in and make reservations for us to bowl later. However, a policeman stopped me and said I could not go in because it's the grand opening at the bowling lanes and they were having a big private party. The officer said they would be open to the public at 8:30 p.m. Then, somebody spots me, brings me inside and has me meet all these people, including the owners of the bowling alleys, who were from Massachusetts. One of the owners suggested that they put on a contest between myself and the special party guest singer Brian Hyland. Brian had a No. 1 Billboard hit in 1960 with his song "Itsy Bitsy Teenie Weenie Yellow Polka Dot Bikini." So he was extremely popular at the time. But I told the owners no, because I was a duckpin bowler and only

bowled ten-pin bowling once in my life. But they insisted. I told them ok, but first I had to pick up my father and brother, and I would be back. So now here I am in a ten-pin contest with Brian Hyland. Like I said I only bowled with ten-pin once, so I had to figure out how to bowl properly. Anyway, I bowl 130 and he bowls 99. The owners said give him another chance and bowl another game. So we bowl another game. This time, I bowl 199 and I trounced him! *Laughter.* Brian is a great guy! After we were done, the owners call me into the office and offer me a job to become a professional bowler. My job was to bowl twenty games a day and I would get paid for it. At the time I was a basketball official, so after the basketball game I would go to the bowling alley at night until 2:00 a.m. or 3:00 a.m. Now, the wife of the manager of the bowling alley happened to be the best bowler in Waterbury. However, soon after I started bowling ten-pin, my bowling average topped hers. So now she is not too happy about this. *Laughter.* And then she started putting all these restrictions on me and made it miserable. Finally, I told the manager I can't do this any longer. So I left. *Laughter.*

TR: How did you get involved in volleyball?

JJ: I left Orange, California, and returned to Connecticut in September 1966. In October, I attended the National Association of Girls and Women in Sport (NAGWS) in Indiana. I was delighted to find out that Hall of Famer Patsy Neal was in charge of NAGWS. It was there that I learned "power volleyball." Returning from the NAGWS clinic, I was recruited to play for a team in New Jersey. So I brought Donna Lopiano and Brenda Reilly down with me to play on the team. At that time, I was also the player/coach for the Raybestos Brakettes basketball team. Our basketball team was pretty good, Donna Lopiano and people like that. We played in a league that was all over New England. We would have to drive all the way up to New Hampshire to play basketball. And we would slaughter everybody! I mean, we would beat everyone by thirty or forty points! *Laughter.* And then we would go to the national tournament. But we would get beat because we would play against all the big teams, like the very strong Tennessee National Business College team. We just never played at that level of competition. Raybestos didn't want to sponsor the basketball team to that level because it would cost a lot more money. So then I decided this isn't fun, going all the way up to New Hampshire and beating teams by thirty or forty points. So then I said, why don't we try volleyball. We started by playing all over in the USVBA—in Connecticut, New Jersey, New York, Pennsylvania, Ohio, Canada. We played in some

national tournaments. We drove all over the place. We would drive to Ohio on Friday, for instance, and play until three or four in the morning, sleep for a few hours, play volleyball all day on Saturday and then have to drive home on Sunday. Most of the kids who played were teachers. So we had to get back by Sunday night to get to the schools for Monday morning. So we did that for a few years. And so I decided to start my own volleyball team and called them the Connecticut Clippers.

TR: Tell me about your experience with the Superstars Competition.

JJ: I was in the Superstars Competition on ABC TV in 1975 and 1979. They wouldn't let me get into the softball throw or golf because you couldn't participate in any event that you were a "star" in. And volleyball was out. So softball, golf and volleyball were events that I had a chance to win, but I wasn't eligible. Wonderful to compete with so many great athletes.

TR: Tell me about being inducted into the Connecticut Women's Hall of Fame.

JJ: It was an *unbelievable* Hall of Fame! I was impressed and honored being inducted into the Connecticut Women's Hall of Fame.

TR: Since you were not a paid athlete for most of your career, where did you work when you returned to Connecticut in 1966?

JJ: I was a teacher and coach at Presentation High School (Stamford), St. Mary's High School (Greenwich), Bethel High School, Brooklyn (NY) College and Mattatuck Community College in Waterbury.

TR: What sports did you coach at these schools?

JJ: I was the coach of the basketball, volleyball and, in the case of Brooklyn and Mattatuck Colleges, the girls' softball teams.

TR: I also read that you owned your own travel agency. Is that true?

JJ: I was employed as a part-time travel consultant at Paradise Travel in the mid-1960s. Later, I started my own travel agency (Joan Joyce All-Star Travel Agency), renting space in the Trumbull Shopping Plaza. My sister, Janis, ran the agency.

TR: Joyce Compton, your teammate with the Brakettes and Falcons, also worked at Mattatuck College, is that right?

JJ: Here's what happened there. When I was at Brooklyn College, I saw an ad for a coaching position at Mattatuck College in my hometown of Waterbury. I called, and I spoke with John Salerno, who was the athletic director and men's' basketball coach at the college. John informed me that there was an opening for a coach, but it was a part-time position. I told John that I couldn't take the job because I needed full-time employment

like I had in Brooklyn. John called me back and said he spoke with the college president and they decided to make it a full-time job and offered me the position. So I ended up being the women's athletic director and coach of the softball, basketball and volleyball teams at Mattatuck College. Towards the beginning of 1975, I figured the time was right to pursue a new challenge—golf. So I told John and the Mattatuck president that this was a challenge I felt I must pursue. I made plans to go down to Florida and start taking golf lessons. But I didn't want to leave John hanging with no coach for the women's teams. So I asked Joyce Compton if she was interested in taking my place, and she said she was very interested. Joyce was a great athlete, so I knew she would fit in fine at Mattatuck. So that is how that happened.

TR: How old were you when you first took up golf on a serious basis?

JJ: I took my first golf lessons a few months after my thirty-fifth birthday. I worked at golf very hard. I joined the LPGA tour when I was thirty-seven years old.

TR: I heard you hit the ball very long. Do you recall how long your drive was?

JJ: No, I don't remember that. I only know that Jane Blalock said I hit the ball longer than anyone else on the tour at the time. So if Jane said that, it must be true. I was told that by others also. The official who marked the courses once told me that she actually had to change the markers on the course because of the length of my drives. So I guess they were pretty long. I was also told by many people that I changed women's golf to a certain extent because I caused other girls to have to hit their golf balls longer in order to compete.

TR: On May 16, 1982, you broke the LPGA (and PGA) record of the least number of putts in a single round of golf. You beat Beverly Klass's record of nineteen putts by needing only seventeen putts. Tell me about that.

JJ: That was unbelievable. I chipped it in four times, one-putt eleven times and two-putt the other three greens. After the fourteenth hole, I told one of the officials that I was going to break the record. She turned to me and said, "You must be crazy!" So, I told her, well maybe, but I *am* going to break the record. I just knew it!! *Laughter*.

TR: I should note that Beverly Klass began her golfing career at age six, whereas you began taking golf lessons at age thirty-five.

JJ: Yes, I did begin my golf career a bit late. *Laughter*.

TR: John Stratton told me that you were also great at ping-pong. Is that true?

JJ: *Laughter.* I adapted to that game pretty well. One time when we were on the road, several of my FAU players started needling me and said they can beat me at ping-pong. My assistant coach Chan (Walker) challenged me to a game of ping-pong at the Tampa hotel where the team was staying. I told Chan, "You don't want to do that!" But she kept needling me saying she can beat me. So we played, and I beat her the first game. Chan tells me, "You got lucky. Let's play another game." So I beat her the second game. I tell Chan, "What, did I get lucky again?" *Laughter.*

TR: When you were playing sports such as softball or basketball, what goals did you set for yourself?

JJ: I never set *any* goals when I was playing. I know people set goals and stuff and it may work for them, but I never set a goal in my life. I never sat down and said this is gonna be my goal for the year, I never did that. It was one pitch at a time or one shot at a time, and whatever that produced at the end of the game is what it was. I spent my whole life doing that, just one pitch at a time or one shot at a time, and it turned out pretty good.

TR: Do you think that coaches today run the risk of "over-coaching" their players?

JJ: Depends on the coach. I personally have witnessed coaches who would yell out instructions to each player during the game on everything the player was doing on the field. That's not allowing the kids to think for themselves, and they don't learn the intangibles of the game. For me, it all goes back to my experiences at Waterbury's City Mills park, learning for myself, and learning the instincts necessary to be a good ballplayer, things like knowing when to run to third base on a base hit to the outfield.

TR: I heard that you provide sports training to your nieces and nephews?

JJ: That's right. My brother, Joe, and his wife, Ginny, have five grandchildren (Morgan, Joey, Brooke, Patrick and Teagan). Whenever I visit Joe and Ginny I have the four kids stop over Joe's house for sports "camp." So what I do is take each child separately and concentrate on the sport that they are most familiar with. I then take them as a group and give training tips on sports such as basketball, lacrosse, etc. I should also mention the other grandchild, three-year-old Teagan, who is a real "spit-fire." I am blessed to have such wonderful nieces and nephews who always take advice from their Aunt Joan.

TR: What advice would you give to an eight-year-old girl who would like to be the next Joan Joyce?

JJ: I would advise the young girl to play a variety of sports, love those sports and work really hard on those sports. Besides softball, the child should be

involved in other sports such as basketball, volleyball, soccer, until at least she is out of high school. Be an all-around athlete. But, be a kid. Have fun. And you gotta love every sport you are involved in. Learn by doing but don't involve yourself in only one sport twelve months out of the year.

TR: You have been compared to the great Babe Didrikson Zaharias by many sports experts, the media and fans as the Greatest Female Athlete in Sports History. How do you feel about that?

JJ: No question that Babe was a great athlete. And she played a variety of sports as I did. However, in talking to people who knew Babe and in reading about her, my understanding is that Babe was not a very well-liked individual. I have spent my entire adult life not only striving to be a great all-around athlete, but to be a good teammate, teacher and coach.

TR: I have often wondered how it is that you had this amazing ability to perform so well in high-pressure situations in all sports that you were involved in (softball, golf, etc.). I discussed this with Debbie Chin, a talented athlete herself, who had an athletic career at the University of New Haven for over forty years and is your close friend. Debbie calls this ability of yours an "innate sports ability."

JJ: If Debbie calls it that I would certainly believe what she said. I know that throughout my playing and coaching career (even to this day) I have always welcomed a challenge. I always wanted to be challenged and welcomed pressure situations. For whatever reasons, I was always able to remain calm in these pressure situations. I guess it is similar to Mariano Rivera coming into a game with the bases loaded and no outs or John Havlicek wanting the ball in a tie game with five seconds left.

TR: How would you sum up your amazing sixty-five-year career in sports?

JJ: Fun. I mean, how many people can say they have gone through their entire life having fun in what they were doing? I'll let all my accomplishments speak for themselves. But to me, I loved every sport I was involved in and whether it was as a player, a referee or a coach it has all been fun.

TR: How would you like to be known in history books—your role in the history of sports?

JJ: A great all-around athlete, a dominant pitcher, a great teammate, an effective teacher and a successful coach.

TR: I really hope that people who read this book come away with the same conclusion as I have had for many years. In my opinion, you are the Greatest Female Athlete in Sports History and it has been my honor to tell your story.

JJ: Thank you, Tony, I can't tell you how much this all means to me!

INTERVIEW WITH JANE BLALOCK

September 22, 2018

I knew of her phenomenal career. At the same time, I saw someone who was totally down to earth—humble and normal. She was just someone you wanted to be around. A very charismatic person.

TR: First of all, congratulations on your great golf and business career.

JB: Thank you very much, Tony.

TR: Where were you born and raised?

JB: Born and raised in Portsmouth, New Hampshire.

TR: What schools did you attend?

JB: I attended Haven Elementary School in Portsmouth, then Portsmouth High School and then graduated from Rollins College in Winter Park, Florida (class of 1967), with a degree in history.

TR: Did you play sports in any schools?

JB: I played on a boys' baseball team. Evidently, I was way ahead of my time. *Laughter.* I was their pitcher. In high school, there wasn't much sports-related opportunities but I did play pick-up basketball. It was a six-on-six basketball team where the only girl allowed to cross the mid-court line was the "rover." In those days, it was believed that girls did not have the stamina to play full court. So, half the team played offense and half the team played defense, and only the rover was allowed to cross mid-court. I was the team's "rover." *Laughter.*

TR: Does Joanie know that you were a pitcher?

JB: *Laughter.* I'm not sure. Unlike her, though, I threw overhand.

TR: Were any of your relatives involved in sports?

JB: I have a picture of my mother (Barbara) playing basketball for the Penacook Aces in New Hampshire, and her coach was the famous Red Rolfe of the Yankees. Other than that, I don't believe there was anyone else really involved in sports in the family.

TR: How did you become interested in golf?

JB: Well, I grew up in a neighborhood of mainly boys. So I would play basketball and even football with the boys. When the old Portsmouth Country Club opened up, all the boys would go there to caddy, and they brought me along because I was their buddy. This was in 1958 when I was thirteen years old. My parents didn't play golf, but one of our neighbors was a very good golfer. So he would bring his clubs over to the house, and

we would hit whiffle balls in the yard. He noticed that I had a natural golf swing and convinced my parents to take me down to the golf course. The golf pro at the club hosted a golf clinic for nine kids, including me. So that in combination with the golf tips from our neighbor was how it started for me. I picked up the game of golf pretty quickly. I didn't have a lot of lessons. I just kind of emulated a lot of the men and women at the club who were good golfers. I would caddy for a lot of them and observed them. I learned to play golf the old-fashion way, without a lot of training. I would go out to the golf course every day, and eventually my father learned to play golf. I would play my father (Richard) for ten cents a hole, and that's how I made my allowance. *Laughter.*

TR: At what age were you comfortable playing golf?

JB: When I was fifteen, I went to the finals of the State Amateur. My first year playing I won the New Hampshire Junior. I won the State Amateur when I was sixteen.

TR: Were you comfortable in all aspects of your game?

JB: Yes, as I mentioned I picked up the game quickly. From the very beginning my putting was very good, I feel. I always had a good touch, a good feel for the game. Playing golf in New Hampshire meant that I had to play in windy conditions on the golf course. But that actually worked to my advantage because I became an excellent wind player.

TR: Growing up, who was your golf idol?

JB: I would have to say Babe Didrikson Zaharias. She was very talented and quite a character!

TR: When did you begin to play golf?

JB: At age thirteen.

TR: When did you start winning tournaments?

JB: I won the New Hampshire Amateur tournament in 1965, 1966 and 1968. I also won the Florida Intercollegiate Championship in 1966.

TR: When did the biggest break occur for you to get you on track for your great golf career?

JB: The biggest break for me was being trained by Bob Toski, who has always been a great teacher of golf. After graduating from Rollins College, I became a schoolteacher and wasn't sure what I would do when I grew up. My mother convinced me to pursue golf and to take lessons because "you never want to go through life thinking 'what if.'" So it was Bob Toski who encouraged me to join the LPGA.

TR: When did you join the LPGA tour?

JB: In 1969, when I was twenty-four. I was Rookie of the Year.

TR: When did you win your first professional tournament?

JB: Won my first professional tour victory in 1970 in Atlanta, Georgia.

TR: What was the highlight of your golf career?

JB: Winning the Dinah Shore tournament in 1972 because that tournament was so much bigger than any of the previous ones, especially with the celebrity appeal. That was an important one. Also, I once went into a four-year slump but I came back in 1985 and won the Kemper tournament, making a ten-foot putt and beating Pat Bradley on the last hole. That comeback after a four-year drought felt really good.

TR: You hold the world record for "most consecutive cuts" made on a professional golf tour.

JB: Yes. 299 consecutive cuts.

TR: Joan has given credit to you for identifying her golf potential. What did you see as far as potential?

JB: Joan picked up the golf game so very quickly. That was phenomenal. Joan had the perfect temperament for golf, the perfect attitude. I knew the athletic talent was there. She had a mechanically sound golf swing. And a natural touch. You can't really teach someone to putt. She had such great touch and finesse, a great feel. I encouraged Joan to pursue a career in golf.

TR: Joan's seventeen-putt round of golf set an LPGA and PGA world record. When she was on the fourteenth tee, Joan turned to an official and said, "I'm going to break the record for fewest putts, I just know it." Does that sound like Joan to you?

JB: *Laughter.* Totally! Totally! Absolutely sounds like Joan. *Laughter.* Her confidence level was unbelievable!

TR: And she was forty-two years old when she set that record.

JB: *Laughter.* Yes, I know. Incredible!

TR: When did you first meet Joan?

JB: I first met Joan at the women's Superstars competition in December 1974.

TR: Did you ever see Joan play basketball or softball?

JB: Yes, I did see Joan play softball, especially with the Falcons. I was at the World Series game when they won the World Championship and saw Joan pitch. Nine pitches to three batters and three outs! She was so dominant as a pitcher, far superior than anyone else. She was so fluid in her delivery. I remember talking to some of the players who batted against her. They all told me that they had to guess because the ball would be coming to the plate so fast, and the ball moved so dramatically!

TR: What was your first impression of Joan Joyce?

JB: I knew of her phenomenal career, and when I first met Joan I saw someone with this wonderful personality. At the same time, I saw someone who was totally down to earth—humble and normal. She was just someone you wanted to be around. A very charismatic person.

TR: How did you become part owner of the Connecticut Falcons, with Billie Jean King and Joan?

JB: We all met at the Superstars contest at the Houston Astrodome. Billie Jean and I decided to become investors in the Connecticut Falcons. We became very good friends.

TR: When did you retire from golf? What are you involved in now?

JB: I retired in 1986. I am the founder and CEO of both the Legends Tour for veteran female LPGA golfers and the PGA Golf Clinics for Women (formerly the LPGA Golf Clinics for Women). My company JBC Golf Inc. began in 2004

TR: What is your impression of Joan Joyce as an athlete?

JB: Well, Babe Didrikson Zaharias got all the credit from the media, but Joan, in my opinion, was even better! Joan knew no barriers. No one was going to tell her that she was too old to start the game of golf!

TR: What advice would you give to an eight-year-old girl who would like to become a golf star?

JB: Play all sports, don't focus on one sport. Be a kid and have fun. Golf will be there forever. It's not like other sports where you're over the hill at twenty-five years old. Enjoy your childhood and play the game because you enjoy it, not because your parents want you to play golf. And practice as much as you can.

INTERVIEW WITH JACKIE LEDBETTER

September 14, 2018

Her catchers would never know where the pitch was going. She had a wicked rise ball and a wicked drop ball. Her stuff was so incredibly good.

TR: Thank you for taking the time for this interview.

JL: You're welcome, Tony

TR: Where were you born and raised?

JL: San Diego, California.

TR: What schools did you attend?

JL: I attended Lemon Grove Elementary school in Lemon Grove (California), Granite Hill High School in El Cajon (California), and I went to Cal State University (Sacramento). My major was phys ed.

TR: When you were in grammar school, did you play any sports?

JL: My dad was president of the Skyline Little League, and because of that I was allowed to try out for the Little League Baseball team. I practiced with them and made the team—only to be told that girls were not allowed to play in Little League.

TR: So what did you do then?

JL: My family moved to El Cajon (California) that had a Bobby Sox league, which was a girls' baseball league.

TR: How old were you when you began playing in the Bobby Sox league?

JL: I was eight years old, and I played with that team until I started high school. While in high school I tried out for the San Diego Sandpipers and made the team. At that time, I was so very young, so I decided not to play with the team.

TR: At Granite Hills High School, you starred in softball, basketball and volleyball. Which sport was your favorite?

JL: Softball by far. Still is my favorite sport.

TR: When did you begin playing for the Santa Ana Lionettes, and what position did you play with the Lionettes?

JL: I began playing for the Lionettes at age seventeen. This was in 1977. I was a catcher and right fielder on the team.

TR: And you joined the Connecticut Falcons a year later?

JL: Yes, I played with the Connecticut Falcons in 1978 and 1979. I was one of their catchers.

TR: How did you decide to become a catcher? That's a tough position to play.

JL: Because at Granite Hills High School, we had a pitcher that nobody could catch. Her name was Francesca Pietila. I was a left-handed shortstop at that time. The coach asked if I would try catching, and I said sure. So, from that day on I was a catcher.

TR: Is there any downside to being a left-handed catcher?

JL: They say there is one. That being when a runner is on third base and dealing with that and making sure the runner doesn't score on a fly ball. Actually, I think it's an advantage because a runner sliding into home plate wouldn't slide into your glove and knock the ball out. And also, it was an easier throw to first base. So I didn't see any disadvantage to being a left-handed catcher.

TR: I believe you traveled to China with the Falcons to play on the tour there.

JL: Yep, that was in 1979. I was twenty years old at the time. An amazing experience, both good and not so good. *Laughter.*

TR: What are your memories of playing in China?

JL: Oh, it was incredible. They were so disciplined. We were there to teach and prepare them for the Olympics. I was so inspired by the Chinese players because they work out so hard. We would have breakfast, lunch and dinner and practice for a couple of hours. The Chinese players would practice sunrise to sunset. They became very good in a very short period of time. They were pretty good for being new at the game. Another thing I remember is that they had no refrigeration, so that was rather gross. So every meal they would bring out a stack of sliced bread, but nobody would ever eat it. And for the next meal they would do the same, and we wouldn't eat what they brought out. We were not used to the kind of food they would serve. So we were getting really hungry. Brenda Reilly, our coach with the Falcons, couldn't take it anymore and kind of lost it. She said she was so hungry and began shoving all the bread in her mouth. *Laughter.* Also, Joan Joyce brought her golf clubs to China so she could practice there. But there was no grass in China! So that was a bummer for her! *Laughter.* But it was a fun trip filled with a lot of memories. We brought along one CD, *Donna Summer Live.* That was the only CD we had, and we listened to that CD over and over and over, the entire time we were in China.

TR: I read that when you were introduced to the large crowd at the stadiums, instead of the National Anthem they would play "The Wedding March (Here Comes the Bride)," which was later replaced with "Auld Lang Syne."

JL: That is absolutely true. We were about ready to walk around the stadium and when we got to the entrance, instead of the National Anthem they played "The Wedding March (Here Comes the Bride)—in Disco!" *Laughter.* It was funnier than heck when we heard that!

TR: How was it like catching for Joan Joyce?

JL: Dangerous! Very dangerous! *Laughter.* She can throw a ball that was going directly to the strike zone and it would then completely stop and then hit me. She had an incredible change up that was very, very deceiving. So all you could do is to get your chest protector up and try to stop it. Her catchers would never know where the pitch was going. She had a wicked rise ball and a wicked drop ball. Her stuff was so

incredibly good. It was an experience—one that I would never trade for anything—it was great!

TR: In a critical situation—say the score was tie with the bases loaded in the last inning—what was her "go to" pitch?

JL: Oh no, she did not have a go-to pitch. She would throw anything she and I agreed to throw. All her pitches were effective. I remember when Pat Willis (a good player for the Buffalo Breskies) came up to bat against Joan. She and Joan were good friends. So, I called one of those change ups that would just disappear on a batter. Pat swung and missed. She then thought a fastball was coming. So I called another change up, and Pat swung and missed. So on the third pitch I called still another change up. Pat swung and missed again, striking out. She was SO mad! *Laughter.* It's not often that a pitcher would throw three straight change ups. But Joan could do the impossible. Those kind of things to me are just so funny as heck! *Laughter.*

TR: Your decision on what pitch should be thrown, would it depend on the batter, the situation, the runners on base?

JL: All of that. It all depends on who was up, whether you wanted a ground out, a pop out, a strikeout, there are so many variables. I was trained to call pitches by Donna Lopiano, the pitcher for the Lionettes at the time. I was seventeen and playing for the Lionettes. I didn't know how to call the game at the time. Donna replied, "Well, we're going to learn together." So I learned a lot from Donna, and I felt very comfortable when I went over to the Connecticut Falcons.

TR: Did you catch any of Joan's perfect games and no-hitters?

JL: Oh gosh, yes. Absolutely. She threw so many of them, so it was not uncommon. I felt no pressure if it looked like she was going to pitch a perfect game or a no-hitter. It almost got to be routine, and it was very common. Well, you probably saw Joan's career ERA (.09). *Laughter.* I kind of expected to catch a no-hitter from Joan. But also Margaret Rebenar was very capable of pitching a perfect game. In fact, all our pitchers had the potential of throwing a no-hitter. We had an incredible pitching staff!

TR: What was *your* best game with the Falcons?

JL: My best game was in St. Louis on June 2, 1978, against the St. Louis Hummers. They had stopped playing me because I was the young one, so I sat on the bench for a couple of days. I was spitting mad that I had to miss some games! Finally, they put me into the game, and I got up to bat. I hit a grand slam home run and got seven RBIs in the game. We were all so competitive! So the coach put me back into the rotation, needless to say.

TR: What are your memories of playing with the Falcons?

JL: I loved the fans, and they loved us. We were like super humans to them. Because of our winning reputation, we drew thousands of fans each game, which was great. They knew us by name. It was so exciting playing in front of large crowds and playing up to their expectations. I think the fans and our relationship with them is my fondest memory of playing in Connecticut. Also, we had a reunion of the Falcons about ten years after the league disbanded, and that was fun to see everyone again. I was so lucky. I was in the right place and had fortunate opportunities.

TR: At the time you were playing, did you ever think of the impact you and the rest of the team had on the women's movement? The Falcons were so great and so successful, and so many young girls grew up to emulate you. As one of the game's "pioneers" did you realize the effect you had on young girls who for the first time could dream of becoming a member of a professional softball team?

JL: In all honesty, no. I was so young I didn't think of anything like that at the time. My concentration was on being the best softball player I could be. It wasn't until I became like sixty years old that people would come up to me and tell me that! *Laughter.*

TR: What did you do after the pro league disbanded after the 1979 season?

JL: I had a very bad knee injury that tore up my entire knee. I had fifteen surgeries and had to get a knee replacement. So I had to get out of sports for a while, and that was very difficult. I went into electronics and learned all about computers. I then became the assistant women's softball coach at the University of California at Berkeley. From there I taught computers for a while. I eventually retired at age fifty-four.

TR: What is your advice for young girls who would like to grow up to be softball fast-pitch stars?

JL: Just keep playing. Like in San Diego, we would take November off but then play all year round. So, keep playing. Do well in school. Listen to your coaches, and do what they say. Keep going through the ranks. And have fun doing it. And even when you graduate from high school, you may not be able to become a professional but you can get a scholarship to college. Education is most important. So that's what I tell young kids. Get good grades. Get a scholarship, and then it will turn into whatever it's meant to be. Not everyone is destined to become a professional softball player.

INTERVIEW WITH MARY LOU PENNINGTON

September 17, 2018

I was in complete and total awe of Joan. I consider Joan Joyce the greatest pitcher of our generation and quite possibly the greatest pitcher of all time. If you put Joan Joyce on any team, that team would win the Championship. She was that good! Whatever team Joan played on, that team won.

TR: Thank you Mary Lou for agreeing to this interview

MP: Thank you, Tony.

TR: Where were you born and raised?

MP: I was born in Arkansas, and my family moved to Rio Linda, California, where I was raised since I was six years old.

TR: What schools did you attend?

MP: I went to Vineland Elementary School in Rio Linda and attended Rio Linda High School, graduating in 1969. I started college in the spring of 1969, attending American River College and then Sacramento State College.

TR: Did you play any sports when you were in grammar school, high school and college?

MP: At American River College, I played field hockey, volleyball, basketball and softball. At Sacramento State, I played softball and basketball.

TR: Were you allowed to play baseball in Little League?

MP: Oh, no. Girls were not allowed to play Little League in those days.

TR: Did any of your family members play sports? How did you get involved in sports?

MP: I was involved in sports ever since I was a little kid. I can remember when I was in elementary school, I couldn't wait to go out and play softball with the other kids. I have three sisters and two brothers, and we would play a lot of sports three on three. That's what we did when we were kids, whether it was softball or some other sport. We played a lot of softball in our backyard. My sister Rose Ann was a great shortstop. She could have gone pro herself. Because I was not allowed to play Little League baseball, I joined a Bobby Sox softball league, which allowed girls. Rio Linda started a Bobby Sox softball league when I was fourteen years old.

TR: Did you have any sports idols when you were growing up?

MP: Yeah, I was a big Willie Mays fan. I loved the Giants and would always listen to their games on my transistor radio. Yep, Willie Mays in baseball and Rick Barry in basketball.

TR: How did you decide to become a catcher?

MP: It was out of necessity. When I was fifteen years old, I played third base for the Rio Linda Pixies. But the team needed a catcher and asked me if I could handle the position. I told them I could. Once I got back there that was it. I continued to be a catcher on all the teams I played with.

TR: When did you begin playing women's fast-pitch softball?

MP: I became involved with women's fast-pitch in 1966 playing for the Rio Linda Pixies. I also played for the Roseville Lassies in 1970.

TR: When did you play for the Sacramento Sonics and Santa Clara Laurels?

MP: I played for the Sacramento Sonics in 1971. In 1972, I played for the Los Gatos Wildcats. I rejoined the Sacramento Sonics in 1973. I then played for the Santa Clara Laurels in 1974. My sister Rose Ann Pennington played with me when we were with the Roseville Lassies and Sacramento Sonics. She was our shortstop. She then got married and stopped playing softball.

TR: Who did you play for in 1975?

MP: In 1975, I had a shoulder operation, and I was out for the entire year.

TR: Did you play in the WPS? If so, what teams did you play for?

MP: In 1976, I played for the San Jose Sunbirds. My teammates included stars such as Charlotte Graham, Diane Kallium and Brenda Gamblin. The Sunbirds won the Western Division Playoff series by sweeping the Santa Ana Lionettes in three straight games. This enabled us to play against the Connecticut Falcons in the WPS Championship. We had a good team and played the Falcons tough, but the Falcons prevailed and won the 1976 WPS title.

TR: I read that you were awarded the MVP in the 1976 All-Star Game. Is that true?

MP: Yes. Actually, I was the co-winner of the MVP for the first WPS All-Star game.

TR: Who did you play for in the 1977 season?

MP: In 1977, I played for the Santa Ana Lionettes, along with Charlotte Graham, Donna Lopiano and Jackie Ledbetter. We won the Western Division playoff series 3 games to 1, earning the right to play the Connecticut Falcons for the 1977 WPS championship. We beat Joan Joyce and the Falcons in the first game behind the fine seven-hit pitching of Donna Lopiano. We then dropped the next 3 games, including the final game that we lost 1–0 despite Charlotte's (Graham) five-hit pitching. With that win, the Connecticut Falcons won the 1977 WPS Championship title.

TR: Who did you play for in 1978?

MP: I didn't play in 1978. The Lionettes had folded, and I was reassigned to the Buffalo Breskies. But at the time, I couldn't leave my job to go to Buffalo. So I didn't' play in 1978.

TR: Did you play in the WPS after 1978?

MP: Yes, I played for the New York Golden Apples in 1979, the final season of the WPS league. Charlotte Graham was my teammate on this team.

TR: Did you catch for Charlotte Graham? If so, what was her "go to" pitch in critical situations?

MP: Yes, I was pretty much Charlotte's exclusive catcher. She was a great pitcher and a great competitor. Charlotte was a speed pitcher. Her "go to" pitch was the rise ball.

TR: When did you first play against Joan Joyce?

MP: I first played against Joan Joyce when I was with the Roseville Lassies. What I remember from that game is that Joan hit me on the wrist with one of her pitches and sent me to the doctor. I think I got a taste of a Joan Joyce rise ball. *Laughter.* Thought I broke my wrist.

TR: You should have had her sign the softball!

MP: *Laughter.* You're right, but I was in too much pain to think!

TR: What was your first impression of Joan Joyce?

MP: I was in complete and total awe of Joan. I consider Joan Joyce the greatest pitcher of our generation and quite possibly the greatest pitcher of all time. If you put Joan Joyce on *any* team, that team would win the championship. She was that good! Whatever team Joan played on, that team won.

TR: What are your memories of playing with the teams you were on?

MP: I enjoyed playing on all the teams I was on. I love team sports. I enjoyed every minute of fast-pitch softball.

TR: After the WPS disbanded in 1979, were you involved in sports?

MP: After 1979, I began working for the state. I played a lot of slow-pitch co-ed softball. That was a lot of fun!

TR: What advice would you give to an eight-year-old girl who would like to become a fast-pitch softball star?

MP: Go out there and play that game, and enjoy that game! Young girls now have so many opportunities waiting for them. Get your education, maybe get a scholarship. Practice, practice, practice!

INTERVIEW WITH CHRISTINA SUTCLIFFE

September 19, 2018

I remember playing in tournaments and it would take us an hour to get out of the stadium because so many people would approach her and ask for her autograph. We all knew we were playing for someone special!

TR: Thank you for agreeing to this interview.

CS: You're very welcome, Tony.

TR: I'd like to begin by asking some background questions, if that is alright with you. First of all, where were you born and raised?

CS: I was born in Illinois, and then my family moved to Indiana when I was two years old. I was raised in Crown Point, Indiana.

TR: What schools did you attend?

CS: I went to Porter Lakes Elementary School in Hebron, Indiana. I then attended Boone Grove High School in Valparaiso, Indiana. When I was going into my senior year of high school, I was recruited by Florida Atlantic University (FAU).

TR: What was your major at FAU?

CS: I had a double major as an undergraduate—mathematics and K through 12 education. My master's degree is in curriculum and instruction.

TR: Did you play sports in elementary school and high school?

CS: Yes. I began playing travel softball when I was twelve years old. In high school, I played basketball, volleyball and softball.

TR: How did you become interested in softball?

CS: I had an older brother who played baseball, so I became interested watching him play.

TR: When did you begin playing softball? What teams did you play softball on?

CS: The first team I played softball with was called the Brat Pack. It was a fast-pitch girls' softball team and I was a pitcher on the Brat Pack from age twelve to age sixteen. I played in the Nationals with that team. I then played for a team called the Tomboys and pitched on that team when I was seventeen and eighteen years old. After that, I pitched for the FAU women's softball team from 1996 to 2001. I had the amazing opportunity of having Joan Joyce as my coach at FAU.

TR: What was your pitching delivery—windmill or slingshot?

CS: I used the windmill.

TR: What was your "go to" pitch in critical situations in a game?

CS: That would be my change-up.

TR: What was your best game at FAU?

CS: I can't think of any one game, per se. I know I had a couple of no-hitters. I guess I would have to say it was my performance during conference tournaments.

TR: What are your memories of Joan Joyce?

CS: I would have to say it was listening to all the great stories that Coach Joyce shared with us during our road trips. When I would hear her talk on road trips or in her office about her career it was an eye-opening experience for me. Also, I remember playing in tournaments and it would take us an hour to get out of the stadium because so many people would approach her and ask for her autograph. *Laughter*. We all knew we were playing for someone special!

TR: Were you aware of Joan Joyce's amazing athletic career when she was your coach?

CS: Absolutely! I know that I and my teammates were well aware of Coach's amazing accomplishments not only in softball but also in basketball, volleyball, bowling, golf and any other sport she was interested in. We were all in awe of Coach Joyce.

TR: How would you rate Joan Joyce as a coach?

CS: Absolutely the best! Coach was always fair. She expected all of us to give our best in every situation and held us to a very high standard when we played. When you have someone with her legendary status, it kind of makes you want to play better. She taught us to respect the game. Coach was just fun to be around. It's not only what Coach did for us while we were playing, but more importantly what she does for us AFTER we stopped playing for her. She has always followed my career and kept me under her wing, always looking out for me. She goes to her former players' weddings, visits our children and things like that. It's not just a four-year deal with Coach. When you sign with FAU you sign for a lifetime of her in your life. And, I think that's really what makes her special. Coach is one of the most important people in my life, and she means the world to me. She is my mentor, my second mom, and inspires me daily. Coach is part of the reason I continue to coach. I am eternally grateful to have Coach Joyce in my life!

TR: Christina, congratulations on your wonderful career both as a player and a coach.

CS: Thank you very much Tony and Thank You for doing this for Coach Joyce.

INTERVIEW WITH JOYCE COMPTON

September 21, 2018

My first impression of Joan Joyce was that it was much better to play on her team than play against her. She was as great as what I had heard and read. As good as she was, she realized that she needed the entire team to win. She didn't have a big ego.

TR: First of all, congratulations on your wonderful career both as a player and as a coach.

JC: Thank you, Tony, I appreciate it.

TR: Where were you born and raised?

JC: I was born in Trenton and raised in Robbinsville, New Jersey.

TR: What schools did you attend?

JC: I attended Windsor Elementary School in Windsor, New Jersey, and then transferred to Sharon Elementary School in Robbinsville, New Jersey. I graduated from Allentown High School in Allentown, New Jersey. I graduated in 1972 from Trenton State College (now known as College of New Jersey in Ewing, New Jersey).

TR: Did you play sports in elementary school, high school and college?

JC: We really didn't have anything sports related at the time in either elementary school or high school. We lived out in the country at that time. When I got to college, I played basketball, softball and volleyball. I played forward on the basketball team and first base on the softball team.

TR: When was the first time you played organized softball?

JC: Probably in 1965 when I was fifteen years old. I played first base for the women's Trenton All-Americans fast-pitch softball team. From there, I was recruited by the New Jersey Shaeferettes fast-pitch team and played with them for a few years before joining the Brakettes in 1973.

TR: What got you started in fast-pitch softball?

JC: I was always a tomboy. I would play catch with my dad in the backyard all the time. I saw an ad in the paper about the Trenton All-Americans and asked my dad if he would drive me to the games. And that's how it started for me.

TR: Were any of your relatives involved in sports?

JC: My dad (George) had played first base in minor league baseball for a while, and I enjoyed throwing the baseball around with him. So I guess that's what first inspired me to play softball.

TR: Tell me about your coaching career.

JC: When I got out of college, I coached at Piscataway High School (New Jersey) from the 1972–73 season to the 1974–75 season. I coached basketball, field hockey and softball. Then, from 1976 to 1982, I coached at Mattatuck Community College in Waterbury, Connecticut. I coached volleyball, basketball and softball at Mattatuck. The volleyball team captured the National Junior College Athletic Association New England crown in 1975 and 1976. The softball team went to the Nationals in 1979. Actually, I replaced Joan Joyce as the coach at Mattatuck. John Salerno was the athletic director at Mattatuck College. From 1983 to 1986, I was the softball coach at the University of Missouri. From there, I became a coach at the University of South Carolina from 1987 to 2010. I retired in 2010.

TR: When did you play with the Brakettes?

JC: I played for three full seasons with the Brakettes, 1973 to 1975.

TR: When did you first meet Joan Joyce?

JC: That would be when I first got picked up by the Brakettes in 1973.

TR: What were your first impressions of Joan Joyce?

JC: Well, my first impression of Joan Joyce was that it was much better to play on her team than play against her. *Laughter.* She was as great as what I had heard and read. As good as she was, she realized that she needed the entire team to win. She didn't have a big ego. No matter how good or how bad her pitching was in a game (which in Joan's case wasn't very often) her attitude never changed. She was out to win and left everything on the mound. And yet, she was always down to earth, even with the amazing career she was having. What you saw was what you got—she was just Joan. Joan Joyce was very competitive, probably the most competitive person I ever played with.

TR: How was it like playing with Joan?

JC: Joan was the absolute best—especially in pressure situations! I recall the two games we had to win to earn the 1974 National Championship. Those were both high pressure games because we had to dig ourselves out of the loser's bracket and needed to win both of those games. Despite the pressure, Joan was simply outstanding, pitching every inning of both of those games to lead us to the 1974 Championship. She was a terrific teammate, which made us all feel good. We knew we had the best pitcher in the world on the mound, so if we scored one run we felt that was usually enough. People sometimes would refer to us as "JJ and company." We liked to say it was "company and JJ," and Joan preferred it that way. She never

sought notoriety at all. As I mentioned, she was the most competitive person I've ever known. Everything you read about her probably doesn't touch the surface of what she actually did. We didn't have the media coverage that you have now. If we had the coverage back then, Joan Joyce would certainly be a household name, and people would understand why she is referred to as the greatest female athlete in sports history. We never had real TV coverage or book coverage back then. Which is why I feel it's so great that you are writing this book.

TR: Thank you Joyce. Yes, that is one of the main reasons why I am writing this book. I really believe it is high time that Joan and all her teammates receive the credit they deserve!

TR: You obviously took part in many of her no-hitters and perfect games. Were they different than any of her other games?

JC: Not really, there were so many of them. And don't forget they were quite a few one-hitters also. When we played in the pro league, they purposely moved the mound back four feet because of her dominance in previous years. But that didn't affect Joan, who was just as dominant playing for the professional Connecticut Falcons teams. It certainly wasn't a detriment to Joan.

TR: What are your memories of playing in China?

JC: We were one of the first, if not the first, U.S. team to play in China. So we were a novelty to the Chinese people, who probably never saw Americans before. We were treated super well by everyone. One of my best memories was when we traveled to Lanzhou on a bus. Everywhere we went we were followed closely by many curious Chinese people. I remember when some of us went into a small store to shop. About forty to fifty Chinese people walked into this tiny store with us! *Laughter.*

I also remember the massive crowds that would attend our games. When we did our clinics with them they had so many questions, wanting to learn more about softball from us. When Joanie gave a clinic, they would actually bring out measuring sticks to measure where her foot would land after throwing the ball. They were so in-tuned in wanting all the knowledge that they could get from us. When we sat down for dinner, they would bring out a dictionary of sports terms and have us explain what certain sports expressions meant such as "taking the collar" or "choke." We would have to explain these terms to them, which was fun. *Laughter.* I also remember Joan telling us that she looked out the window in the morning and saw someone throwing a pig towards the entrance to the restaurant. Probably my favorite thing was visiting the Great Wall. Phenomenal. We actually played catch at the Great Wall. *Laughter.*

TR: With you winning all the time, was the team "all business" or were there times when you would kid around a bit and play jokes on each other?

JC: Oh, we would always kid around and tease each other. I can remember when one of the girls carried an extra bra in her sports bag. Well, we knew Joanie always left her glove in the same spot in the dugout before putting it on to go to the mound. So, we stuffed her glove with this bra. So, when Joanie got to the mound and put her hand in the glove she takes out this bra on the pitcher's mound and looks at us and starts to crack up on the mound! *Laughter.*

TR: What is your advice to an eight-year-old girl who would like to grow up to be a fast-pitch star?

JC: Just be a kid. Don't specialize in one sport. Do what you enjoy doing. Work hard, practice, but have fun. Don't limit yourself to one sport. That is so important to me. If you don't have fun playing the sport, don't do it. We had fun.

INTERVIEW WITH JOHN STRATTON

October 2, 2018

Ted Williams once told me that he couldn't hit any of her pitches, especially the riser and the drop. Joanie's pitches were extremely difficult for batters to hit. I said at the time that the first time the batter would see the ball was when the catcher would throw the ball back to Joanie.

TR: Thank you for agreeing to this interview.

JS: Anytime, Tony.

TR: John, where were you born and raised?

JS: Right here in Stratford, Connecticut.

TR: What schools did you attend?

JS: I graduated from Stratford High School. I then received my undergraduate degree in phys ed from University of Bridgeport (UB) and a master's degree from UB.

TR: Did you play any sports while in school?

JS: No, I had to work. I worked seven days a week, earning fifty cents an hour. *Laughter.* I also mowed lawns and shoveled snow. So I was able to pay for my education with the money I earned. I would either take a bus to

school or hitchhike. My parents didn't have the money to pay for school, so I had to earn the money. But I did play baseball and basketball in the summer because I was able to adjust my work schedule. I played baseball on the Lordship Little League team from 1947 to 1951 at the Raybestos field. The league was sponsored by Raybestos. I went on to play baseball for the American Legion and Sterling House leagues. I pitched and played infield. I pitched for a lot of teams in the area. I even played a few games with the Raybestos Cardinals when they needed another player. They asked me to join the team, but I had to turn them down because I had to work and couldn't travel with the team. I also played a lot of basketball locally.

TR: How did you get involved with the Brakettes?

JS: I was playing Little League ball, but I also followed men's fast-pitch softball at the time. The Raybestos Brakettes and the Raybestos Cardinals were just starting up. My dad asked me if I wanted to see the women's Brakettes team play. I was very curious since I never saw a women's softball team. I was amazed at how good they were. At one point, the Brakettes team asked me to be their batboy. I said sure. I was nine years old. Actually, my main job was chasing foul balls because the officials really needed to get those softballs back. *Laughter.* So I did that for the women's team and the men's team. Every night after the game my pay was one of the softballs. So I would get the softballs and throw them into a drawer. When I became seventeen years old, my mom said, "Hey, get these softballs out of the kitchen, I need the drawer space." I had collected two hundred softballs, so I decided to start my own softball team. *Laughter.* I learned how to pitch from the great Raybestos Cardinal softball pitcher Johnny Spring, who also helped out Joanie [Joyce] for a while. I used to pitch batting practice to the Brakettes players when I played for the Raybestos Cardinals.

TR: When did you first meet Joan Joyce?

JS: It was probably around the time that Johnny Spring was helping us both out. I know I have known Joanie from at least 1958. We have been very close friends ever since.

TR: What was your first impression of Joanie?

JS: She was a heck of an athlete. She had a fluid pitching delivery. I just loved watching Joanie play.

TR: What was your assessment of Joanie's pitching?

JS: Super. She would make that ball move like nobody else. Riser, drop, curve and sometimes change up. All effective and all devasting. Her riser was unhittable, and her drop would roll right off the table. Ted Williams

once told me that he couldn't hit any of her pitches, especially the riser and the drop. Joanie's pitches were extremely difficult for batters to hit. I said at the time that the first time the batter would see the ball was when the catcher would throw the ball back to Joanie. *Laughter.* Her drop would roll right off the table. The movement on her pitches was unbelievable. Let me tell you, at that time the balls were not conducive to making the pitches move like that, because the balls had no real seams. But she somehow knew how to make that ball do what she wanted. And she was so accurate. I would catch her once in a while and would put my glove down and tell her to hit the glove. Well, she would hit the glove nine times out of ten and I would tell her how come you didn't make ten out of ten? She would get so mad and then make sure she did make ten out of ten. That's how competitive she was. Also, nowadays the seams of the balls make it easier to throw those pitches. But in Joanie's day, there were very little seams on the balls, and Joanie had to work very hard to make the ball move. But she was also a great batter and a great baserunner. Joanie was fairly slow on the base paths, but she could read the play better than anyone and knew when to run. She knew whether the ball would drop in the outfield or whether it would be caught. Super baserunner with great instinct. She was a thinker. She never got thrown out. Joanie never got rattled in any sport she played—she was always in complete composure. Joanie never thought she was better than anyone else. She was a great teammate who excelled in every sport she played. If she promoted herself, she would be a household name.

TR: What was the greatest game that you saw Joanie pitch?

JS: All her games were terrific and fun to watch. If you wanted to beat Joan Joyce you had to hit her in the first inning, otherwise you didn't have much of a chance. I remember a twenty-nine-inning game that she pitched, which was great. For me, the greatest game was probably the 1974 national championship game in Orlando Florida against Sun City. The pressure of the game plus the Florida heat made it very challenging, even for Joanie. The Florida heat made it difficult to make the ball move so she had to be very accurate, which she was. It was an extra inning game, and Joanie said all she needed was one run. She won the game and the championship by the score of 1–0. But, really, all her games were wonderful to watch.

TR: When did you become the manager of the Brakettes?

JS: I became a coach for the Brakettes in 1971. I managed the team on a temporary basis in 1976 and then permanently from 1995 to the present.

TR: You had mentioned that in those days there were very little seams on the balls. Would Joanie know the difference in the seams from one ball to the other?

JS: Definitely. Before every game I would put six new softballs on the ledge in the dugot. Joanie would pick up a ball and say "This is a no-hit ball. Wait, this is a perfect game ball. Save this one for me."

TR: What are your memories of the Brakettes during the time that Joan Joyce played?

JS: Just being around such wonderful and talented athletes. Every game was a treat. Also traveling with the team, whether within the United States or in Europe, was memorable.

TR: Your wife, "Micki" Macchietto (Stratton), was Joanie's catcher for many games. What are your memories of Micki as a player at that time?

JS: Micki was a great catcher, a terrific hitter and a great teammate. She was a great "slapper" and bunter. Micki was the first Brakette to be inducted into the National Softball Hall of Fame, which says a lot. More importantly, Micki was a wonderful person and my best friend. She and Joanie were good friends, and they both were instigators of certain pranks played on us. I remember we were on the road and Joe Barber was the Brakettes' general manager. Micki and Joanie went into his room and took everything in the room and shoved it into his shower—mattresses, pillows, everything! When Joe walked into his room there was absolutely nothing in the room—it was all in the shower! *Laughter.* After that I told several of the girls "don't let anyone in my room." *Laughter.* But the girls had a lot of fun on the road—water balloon fights, things like that.

TR: What advice would you give to an eight-year-old girl who wants to become a fast-pitch softball star?

JS: I always tell my players when they first come up that I rather them do something right once than something a thousand times wrong. Hard work doesn't necessarily mean breaking a sweat. Doing it right is the hard work. Make your motion perfect, make your spin perfect. Same thing with hitting. Never swing up, never be late on the swing, swing even and level. Simple things like that. Learn to do it right and do it right every single time. Do it right once than a thousand times wrong.

TR: How would you rate Joanie as an all-around athlete?

JS: Joan Joyce is the greatest female athlete in sports history. Heck, she's one of the greatest athletes, period—male or female. She was the greatest because of her competitiveness, her mental composure and her

athletic ability. I don't care what it was, softball, basketball, volleyball, bowling, golf—she was tops in everything. And it didn't stop there. Heck, you wouldn't want to play ping-pong or cards with her—she was so competitive. *Laughter*.

INTERVIEW WITH JOE JOYCE JR.

December 3, 2018

During batting practice, the guys on deck that were due up next to bat would always leave their gloves on the bench nearby. And so either Joanie or I would grab the glove and go to the outfield to catch fly balls. And always when the batter would finish hitting, he would ask "Where the heck is my glove?" and someone would shout "One of the Joyce kids must have it!"

TR: Thank you for agreeing to this interview.

JOE: My pleasure, Tony.

TR: In talking with Joanie, it appears to me that when you were growing up, you and Joanie were kind of "joined at the hip," very close.

JOE: Definitely. We were very close growing up, and even to this very day we are very close.

TR: Where were you born and raised?

JOE: Joanie and I were both born in St. Mary's Hospital in Waterbury. We lived with our parents on Waterbury's Hill Street and then moved to Tudor Street. So we were both born and raised in Waterbury. I am a year and a half younger than Joan.

TR: Joanie told me the story of how when she was little she helped a carpenter build a house that was up the street from you on Tudor Street.

JOE: *Laughter*. Absolutely. Joanie would go up there every single day working on the entire house. She loved carpentry, and when she was little she wanted to grow up to be a carpenter. One day I was walking past the house they were working on, and there's Joanie on the roof putting shingles on the house. *Laughter*. She was determined to do as much as the carpenter, and she did!

TR: Joan mentioned that she received a nice bike from the contractor for helping him out. Being familiar with Waterbury and all the hills there, I

asked her if she biked down those hills or stayed on flat ground. She said she would ride in front of the house on flat ground.

JOE: Yes, the builder was Tommy Garafola. We did have a good deal of flat ground where our house was on Tudor Street that stretched about three to four hundred yards. So it was there that Joanie rode her bicycle and where she and I would play a lot of baseball. We also played quite a lot of basketball because one of our neighbors put up a basketball hoop on one of the poles. We did take advantage of the big hills in Waterbury by going sledding up in Fulton Park.

TR: I understand that your mom and dad worked different shifts so one of them would be home with you.

JOE: Yes, Dad would usually work the 11:00 p.m.–7:00 a.m. shift at Scovill's and would always bring home these delicious donuts from Ed's Bakery on Walnut Street. Mom would make supper for us before my dad took her to work at Chase Brass & Copper. Her afternoon shift began at 3:00 p.m. Then, after that, Joanie and I would go to all Dad's softball or basketball games. He would play many games at City Mills Lane, which was very close to our house.

TR: Your dad was a great ballplayer. I remember him playing on the Waterbury Bombers fast-pitch softball team.

JOE: Yes, he was very good in softball and basketball. In Waterbury, if you wanted to play fast-pitch softball, you had a great opportunity to play because there were a good number of fast-pitch leagues there. I remember that my dad played in the same league as Jimmy Piersall, who was also a Waterbury native. In fact, when Waterbury honored Jimmy Piersall some time ago, Jimmy walked over to shake my dad's hand because he remembered playing against my father.

TR: One of the Waterbury Bombers was Tony Marinaro, who was also your mailman.

JOE: Yep, Tony would stop by every day during his lunch break, and we would go out in our back yard. Tony would teach Joanie how to pitch, and I was the catcher. Let me tell you, my hand was swollen, between Tony throwing the ball and Joanie throwing the ball. It was only a half hour, but boy they could both throw it hard. *Laughter.*

TR: Joanie was saying that you and she would go out on the ballfield or basketball court whenever there was a break in the action.

JOE: Absolutely. During batting practice, the guys on deck that were due up next to bat would always leave their gloves on the bench nearby. And so either Joanie or I would grab the glove and go to the outfield to catch

fly balls. And always when the batter would finish hitting he would ask, "Where the heck is my glove?" and someone would shout "One of the Joyce kids must have it!" *Laughter.*

TR: When Joanie was very young, she used to practice pitching by throwing the ball against the house. Your mom would get a headache and finally told Joan to go in the back yard to practice pitching. Does that sound familiar?

JOE: Oh yeah, it certainly does. Our house on Tudor Street had fairly new aluminum siding. But you would see dents about ten to fifteen feet up the house from Joanie throwing the ball against the house. When she first started, she was a bit wild with her pitches. *Laughter.*

TR: Did you attend the same schools in Waterbury as Joanie?

JOE: Yes. My father actually wanted us to go to St. Thomas school but there was only one opening. Dad wanted us to go to the same school so that's how we ended up in Webster Elementary School. And then we both attended Crosby High School.

TR: How did you get to school?

JOE: We always walked to Webster school. Every school day at lunch time we would walk back home because they didn't serve lunch in school at that time. And then we walked back to school. We also walked back and forth to Crosby High School, which was in downtown Waterbury.

TR: So, your dad, Joanie and you played basketball at Crosby?

JOE: Yes. My dad was basketball captain at Crosby in 1935, Joanie was Crosby captain in 1957–58 and I was captain in 1960. I played basketball in high school all four years.

TR: Did you play any sports other than basketball at Crosby?

JOE: Yes, I played two years of football in high school. I graduated from Crosby in 1960.

TR: Did you play sports after high school?

JOE: After high school I worked in Waterbury's American Brass for a couple of years. I played a lot of fast-pitch softball with that club. We had some great teams at American Brass and went to the state championship. I played basketball and volleyball, too, when I was at American Brass. Prior to going into the service, I played fast-pitch softball for Sabol's Texaco on Watertown Avenue, and our team played for the Class B championship in August 1963. We lost to Electric Boat in a very close game, 2–1.

TR: When did you go into the service?

JOE: I joined the Air Force in late 1963. The Vietnam War was just starting up. I played a lot of fast-pitch softball with the Eighty-Fifth team, and we traveled around a lot.

TR: When did you get out of the service? Did you play softball when you returned home from the Air Force?

JOE: I got out of the service in 1967. In 1969, I played fast-pitch softball for the Waterbury All-Stars, a team comprised of players from Waterbury.

TR: Did you ever bat against Joan?

JOE: Yes. In the early 1970s, Waterbury honored Joanie and had a fundraiser in Town Plot Park in Waterbury. As part of the exhibition, several well-known hitters from the area were asked to bat against her. I remember it was Ken Coviello, Johnny Messup, Bobby Imbimbo and myself. We tried our best, but she struck all of us out—easily—much to the delight of the fans!

TR: How was Joanie at bowling?

JOE: She was great. Joanie was a natural at bowling just like every other sport she played. One day, Lakewood Lanes brought in a professional bowler by the name of Andy Varipapa to bowl against Joanie. Andy was a well-known, great pro bowler. She accepted the challenge and, wouldn't you know it? Joanie beat Varipapa. Amazing!

TR: Were you able to go to Joanie's games when she played softball?

JOE: Yes, the whole family would make every effort to attend as many games as possible. My mom and dad made a point to go to all her games. I actually missed the first week of my freshman year at Crosby in 1956 because my Dad and I drove all the way down to Clearwater, Florida, to watch Joanie play in the World Tournament. She was only fifteen years old at the time.

TR: Does any one particular game of Joanie's stand out to you?

JOE: They were all great and fun to watch, especially the tournament games. One of the most amazing games I saw was when the Brakettes played Japan for the World Championship before a sold-out stadium. None of the Japanese players wanted to strike out against Joanie so every one of the batters bunted against her! I never saw anything like that! *Laughter*. Talk about respect for a pitcher!

TR: I am amazed at how Joanie was able to switch so easily from one sport to another, sometimes in the same day.

JOE: You're so right. One day, Joanie was playing golf in Missouri, finished the golf, and on the same day flew back to Connecticut to pitch the second game of a doubleheader for the Falcons in Meriden, Connecticut. That's just one example out of many.

TR: Are any other members of your family involved in sports?

JOE: Absolutely. I have five grandchildren: Morgan, Joey, Brooke, Patrick and three-year-old Teagan. Whenever "Aunt Joan" comes up to visit

she always takes the "older" grandchildren aside to give them training on whatever sports they are involved in. Recently, Joan visited us to help celebrate Ginny and my fiftieth wedding anniversary. It was ninety degrees outside, and Joan was giving eleven-year-old Brooke some pitching pointers. Joanie must have worn my granddaughter down because Brooke came inside to get a glass of water and said, "I don't know if I want to be a pitcher, it's hard work." *Laughter.* We call Brooke "Little Joanie" because her intensity and athleticism is so similar to her aunt Joan. She plays multiple sports and excels at each of them.

TR: What word would best describe your sister Joan?

JOE: The word that best describes Joan both as a person and as an athlete is *generous.* Joanie goes out of her way to share her time, expertise, energy and hospitality with others. Joan is a truly dedicated coach, sister, aunt and friend.

BIBLIOGRAPHY

Books

Connecticut Falcons Official Yearbooks, 1976–1979.
Crosby High School Yearbook, Waterbury, Connecticut, 1955.
Crosby High School Yearbook, Waterbury, Connecticut, 1957.
Crosby High School Yearbook, Waterbury, Connecticut, 1958.
Jordan, Pat. *A Nice Tuesday: A Memoir*. New York: Golden Books, 1999.
Joyce, Joan, and John Anquillare. *Winning Softball*. Chicago: Henry Regnery Company, 1975.
Littlewood, Mary L. *The Path to the Gold: An Historical Look at Women's Fastpitch in the United States*. Columbia, MO: National Fastpitch Coaches Association, 1998.
St. Mary's High School Yearbook, Greenwich, Connecticut, 1967.
Waterbury Catholic High School Yearbook, Waterbury, Connecticut, 1961.
Waterbury Catholic High School Yearbook, Waterbury Connecticut 1962.
Waterbury Catholic High School Yearbook, Waterbury, Connecticut, 1963.

Articles

Boston Globe. "Can Big Leaguers Hit This Pitcher?." February 16, 1975.
Bridgeport Post. "Brakettes Win 4th Straight Crown." September 1, 1974.
Central New Jersey Home News. "The Connecticut Grads [Are] One of the Outstanding Female Basketball Teams in the Country." March 15, 1962.

Chicago American. "The Largest and Most Comprehensive Tournament Ever Held in Softball Has Swept the Country Like Wildfire." May 1933.

ConferenceUSA.com. "Waterbury Softball Field Named after Joan Joyce." August 18, 2015.

ESPN.com. "Joan Joyce: The Best Ted Williams Ever Faced." August 5, 2011.

FAU University Press. "FAU Softball Coach Joan Joyce Crafted Her Legendary Career with Her Competitive Will." February 28, 2013.

Hartford Courant. "Connecticut Was Once Host to a Hall of Fame 'Battle of the Sexes.'" July 14, 2014.

———. "The Pitch Is Key in Fast-Pitch." August 10, 1993.

Lansing State Journal. "Joan Joyce: The Greatest Athlete Since Babe Zaharias." June 10. 1979.

LeCompte, Michael. "The 1933 Chicago World's Fair and the Birth of Big Softball." Theolballgame, May 21, 2015. https://theolballgame.com/2015/05/21/the-1933-chicago-worlds-fair-and-the-birth-of-big-softball.

Naugatuck Daily News. "Sportlight: Joan Joyce Is One of the Greatest Athletes in Sports History." August 17, 1977.

New Haven Register. "Raymond's Former Players Reflect upon His Legacy." April 25, 2019.

New York Times. "Joan Joyce Enjoys Moments of Glory." May 30, 1981.

Orlando Sentinel. "Orlando to Knock Old Stadium Down for Parking Needs." January 2, 1986.

Waterbury Republican American.

Women in Softball newsletter. "Championship Final Game." September 1974.

Women Sports publication. "Athlete of the Year Awards." June 1977.

WPS references and information from IWPS website (used with permission).

Personal Communications

Ackers, Marshall (*To Tell the Truth* expert). Email correspondence with author, January 5, 2018.

Augelli, Nick. Interview and personal communications with author, September 18, 2108.

Blalock, Jane (golfer). Interview and personal communications with author, September 22, 2018.

Bozzuto, Linda. Interview and personal communications with author, October 1, 2018.

Chin, Debbie. Email correspondence with author, November 25, 2018.

Compton, Joyce. Interview and personal communications with author, September 21, 2018.

DiPietro, Jerry. Interview and personal communications with author, October 29, 2018.

Finelli, Linda (softball). Interview and personal communications with author, September 21, 2018.

Gage, Harlan. Personal communications and email correspondence with author, October 16, 2018.

Gage, Kathy. Personal communications and email correspondence with author, October 16, 2018.

Hutchins, Carol. Personal communications and email correspondence with author, September 30, 2018.

Hyland, Brian (singer, songwriter). Email correspondence, March 6, 2019.

Irwin, Stormy. Email correspondence with author, June 25, 2018.

Jordan, Pat (player, author). Email correspondence, November 27, 2018.

Joyce, Joan (player, coach). Interview and personal communications with author, July 2, 2018, and numerous other dates.

Joyce, Joe Jr. Interview and personal communications with author, December 3, 2018.

LaVicka, Ken (ESPN). Email correspondence with author, June 8, 2019.

Ledbetter, Jackie (player). Interview and personal communications with author, September 14, 2018.

Lenti-Crane, Patricia. Email correspondence with author, November 1, 2018.

Loman, Bruce (golfer). Interview and personal communications with author, September 18, 2018.

Mathis, Johnny (legendary singer). Email correspondence with author, February 15, 2019.

McCarthy, Pat, Sr. Email correspondence with author, November 1, 2018.

Pennington, Mary Lou (player). Interview and personal communications with author, September 17, 2018.

Smith, Michele (ESPN analyst, gold medalist). Email correspondence with author, June 10, 2019.

Stratton, John. Interview and personal communications with author, October 2, 2018.

Sutcliffe, Christina. Interview and personal communications with author, September 19, 2018.

Valentine, Bobby. Interview and personal communications with author, December 19, 2018.

Websites

ASUN Conference, www.asunsports.org. (Used with permission.)

Book review, "A Nice Tuesday: A Memoir, by Pat Jordan." Society for American Baseball Research. https://sabr.org/cmsFiles/Files/jordan.pdf.

Brakettes Softball, www.brakettes.com. (Used with permission.)

Brian Hyland, www.brianhyland.com.

Connecticut Falcons Women's Pro Softball, https://sites.google.com/site/iwpsfalcons. (Used with permission.)

Connecticut Women's Volleyball Hall of Fame, www.ctvballhall.org.

Florida Atlantic University, www.fau.edu. (Used with permission.)

Freemantle, www.fremantle.com.

Greater Waterbury Sportsmen's Club, https://www.greaterwaterburysportsmensclub.org.

Hartford Courant, www.courant.com.

International Women's Professional Softball, https://sites.google.com/site/iwpsoftball. (Used with permission.)

Jane Blalock, LPGA Tour Champion. www.janeblalocklpga.com. (Used with permission.)

Johnny Mathis, www.johnnymathis.com.

Michele Smith Fast Pitch, http://www.michelesmith.com.

National Fastpitch Coaches Association, https://nfca.org.

Silas Bronson Library, www.bronsonlibrary.org/hall.

Softball National News Past & Present, https://sites.google.com/site/softballnationalnews. (Used with permission.)

The Superstars, www.thesuperstars.org.

To Tell the Truth, www.ttttontheweb.com.

Vanderbilt News Archive, https://tvnews.vanderbilt.edu/about.

Women in Softball, https://sites.google.com/site/womeninsoftball. (Used with permission.)

INDEX

ABOUT THE AUTHOR

Tony Renzoni is the author of the well-received book *Connecticut Rock 'n' Roll: A History*.

Tony had a thirty-eight-year career with the federal government. As district manager in Connecticut's Fairfield County, he oversaw the operations of four field offices, serving over 100,000 beneficiaries. Tony wrote over one thousand weekly columns that were published in the *Connecticut Post* newspaper and on the paper's website. Tony was a recipient of more than forty awards, including his agency's highest honor award.

A lifelong resident of Connecticut, Tony lives on the Connecticut shoreline with his wife, Colleen. Tony Renzoni is a graduate of Waterbury's Sacred Heart High School and Sacred Heart University in Fairfield, Connecticut.

 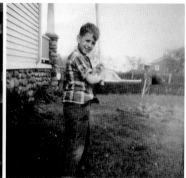

Present-day photo by Mary Ellen Blacker.

Also by this author:

ISBN: 9781625858801

6 x 9 • 224 pages • $21.99

Find it at www.arcadiapublishing.com or wherever books are sold.